Finding Your Style In Paste

AuthorHouse™
1663 Liberty Drive
Bloomington, IN 47403
www.authorhouse.com
Phone: 1-800-839-8640

Published by AuthorHouse 10/17/2012

ISBN: 978-1-4772-7135-3 (sc)
 978-1-4772-7136-0 (e)

Library of Congress Control Number: 2012917404

author HOUSE®

Finding Your Style In Pastel **By Jean Hirons**

Designed by Elroy Williams

Dedication

This book is dedicated to all of the many fine artists with whom I have had the privilege and joy to teach. Without them, I could not have written this book.

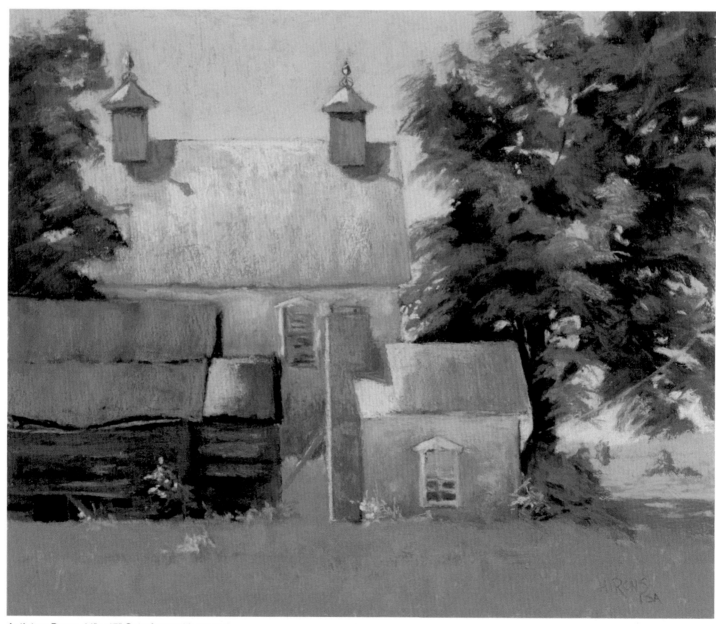

Antietam Barns, 14" x 17" Gatorfoam with ground.

Sunrise from Crescent Beach, 18" x 24" Pastelbord.

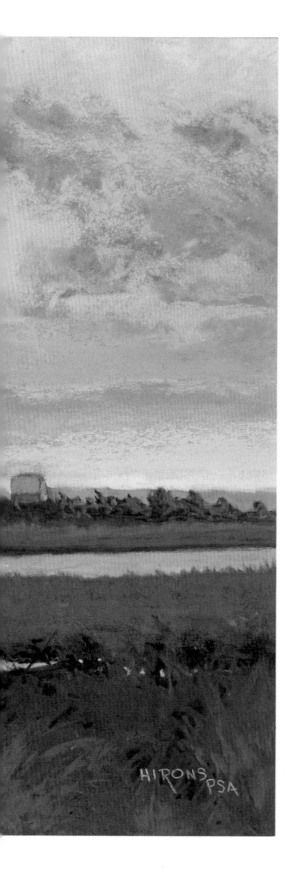

Acknowledgements

I begin a long list of thanks with the wonderful teachers with whom I have studied. I have been fortunate to work with some of the top pastel landscape painters in the country. Their guidance has helped me to be both a better painter and teacher, and was invaluable in the writing of this book.

A book on diverse styles cannot depend on the work of one artist. I particularly want to thank the many fine pastel painters from around the country who contributed their work and comments so that the book could be more complete. A special section at the end gives more details on these artists. I have also included selected paintings from some of the many talented artists in my class.

Working on the book was made more joyful by having talented friends assist at every stage. The major editing of the book was accomplished by Susan Foster and Cathy de Lorimier, who brought both pastel knowledge and editing skills to the task. Additional editing was done by Karl Readel and my husband, John Hansman. The beautiful design was done by Elroy Williams, a friend and fellow pastel artist, as well as being an award-winning designer by trade. My long-time friend and photographer, Greg Staley, took many of the photographs.

An earlier version was reviewed by Dawn Capron, and, in part, by Catherine Nickel, Linda Tilden, Sharon Butrymowicz, and Carol Greenwald.

Thanks to my colleague Michaele Harrington for sharing her course materials on color theory. Even after discussing color theory in my classes for years, I still found various aspects confusing and her guidance was invaluable.

Special appreciation goes to Duane Wakeham for his encouragement and expert advice. And a very special thanks to my husband, John, for his patience and support throughout the entire process.

Contents

Preface

As artists, we have choices. There are very few rules that apply across the board. We can create highly realistic paintings, or perhaps more expressive paintings, or paintings that have very little basis in reality, including those that are totally non-representational. We can record color as we see it or as we'd like it to be.

As pastel artists, we have even more choices. We can use a wide variety of pastels, strokes, surfaces, and techniques to create many different looks.

The choices we make form the framework of our individual style, our *signature* as artists.

Any subscriber to *The Pastel Journal* realizes how varied the medium of pastel can be. For the experienced artist, these articles are stimulating, offering possible ways to experiment with alternative approaches. For the beginner, the panoply of choices can be overwhelming.

Painting is primarily an intuitive process. But intuition is gained through study and experience. Part of my impetus in writing this book has been to create a more structured approach to help those fairly new to the medium understand its many possibilities. The book is aimed at all levels of pastel artists. Beginners will find a wealth of helpful information and intermediate artists will gain insight into how to take their work to another level and develop a style. Many advanced artists teach pastel; the organization of ideas and the exercises included should be of assistance. I offer a variety of suggested approaches and sometimes make up terminology to describe my experiences with the medium.

The instructions in the book are based on my preferences and the guidance that I offer my students. The diversity of styles and techniques evident in the paintings of contributing artists should make it clear, however, that there are many ways to successfully work in pastel.

Having acknowledged the many *possibilities*, I want to note a few *musts*.

Representational paintings must be well-drawn. Poor drawing skills cannot be overcome with lovely color or great technique.

Likewise, paintings must have strong compositions, regardless of whether they are realistic, abstracted, or non-representational.

Values must be properly interpreted to produce strong compositions and to use pastel to its full effect.

And finally, pastel paintings must sing! Whether the applications are light and airy, or rich and painterly, it should be clear that the artist is in control of the medium and is using it to produce his or her desired look.

For years I have resisted suggestions that I write a book. As a landscape painter, I knew that there were more authoritative books already available. And the growing popularity of pastel has led to so many resources, including online blogs, a biennial convention, and the wonderful *Pastel Journal*, mentioned above. What could I add to this?

My personal training in pastel has been from week-long landscape workshops with some of the leading pastel painters in the country. As a teacher in a community college, I am not teaching a particular style nor focusing on specific subject matter. Some of my students work with the landscape, but others do portraits or figurative

work, while others prefer still life, or work abstractly. In dealing with this mixture, I've realized that there are different ways to approach one's use of color, and this formed my first idea for creating a book.

Furthermore, as a teacher, I've spent time experimenting with different surfaces, pastel brands, and techniques in order to make suggestions to students to help them find the look they want to achieve. I do not teach students to paint the way I do, but instead, try to share my experience and help them develop their own individual style.

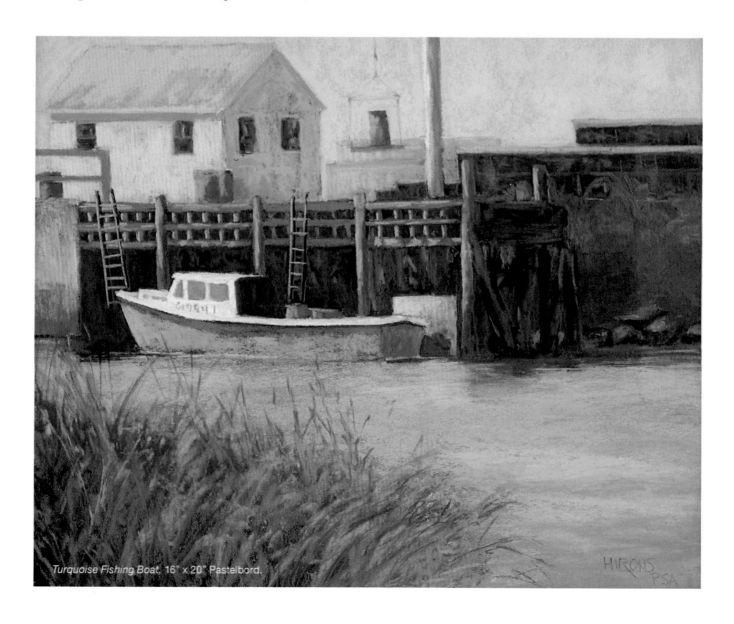

Turquoise Fishing Boat, 16" x 20". Pastelbord.

PART ONE

Achieving A *LOOK:* Materials And Techniques

Pastel is the purest of painting media, consisting of pure pigment and a binder. It does not darken with age or crack, nor will it fade if good materials have been used. For this reason, it is, to my mind, the most beautiful of painting media. The small crystals of pigment catch the light and glow.

The uses of pastel are many, as are the various *looks* of the resulting paintings. Because pastel is a dry medium that comes in various shapes, sizes, and degrees of hardness, it can be applied in many more ways than wet media, such as watercolor or oil. You can draw, paint, or do a combination of the two. And the ever-growing variety of surfaces on which pastels are applied makes it possible to achieve many different effects, from the very tex-

tured to the highly blended. Thus, I believe that pastel artists face more choices in personal style than artists working in most other media.

Materials

Today's pastel artists have a wide variety of pastel brands and surfaces to choose from. A good selection of pastels in varying degrees of hardness and in a wide range of values is needed. However, within each category (hard, intermediate, soft), the particular brands are not as critical, with one exception. The intermediate category contains a variety of pastels that are quite different from one another. Surfaces, however, are another matter. Each surface has individual characteristics that react differently to the varying types of pastel. For this reason, I give more attention to individual brands and types of surfaces in Chapter 2 than to the individual brands of pastel in Chapter 1.

Buy the best materials you can afford. Avoid inexpensive sets often found in craft shops as they have a high degree of chalk and far less pigment. The less pigment, the less lightfast the pastels will be. If you intend to eventually sell your work, good pastels are a must, and without quality surfaces, you will never experience the full potential of pastel.

Techniques

Just as there are many materials to choose from, so are there many ways in which the pastel can be applied. However, they can be broken down into two basic categories:

Direct application of pastel: this is preferably done on a toned surface, either purchased or toned by the artist; however, some artists work directly on white.

Underpainting followed by applications of pastel: this is most often done on a white or very lightly-toned surface. The underpainting defines the basic shapes and values of the composition. It may be wet or dry.

Chapter 3 discusses the variety of strokes that can be applied, and ways of layering pastel. Chapter 4 addresses the techniques of toning and underpainting, including various surfaces and media that can

be used.

Finally, in Chapter 5, I define a variety of *looks* that can be achieved. They can be broadly grouped into two categories:

Broken color describes a technique of applying the pastel so that the underlying surface, underpainting, or earlier layers of pastel show through. This may be caused by the texture of the surface or the particular stroke of pastel.

Painterly color describes strokes of opaque color that are more akin to the brush strokes of oil paint. The pastel may or may not be blended.

To more fully appreciate the variety of looks in paintings created by today's pastel artists, it is useful to examine how the medium has developed over recent years.

Prior to the 1990's, there were fewer brands of pastel in local art stores, and most of them were fairly hard, such as Grumbacher and Rembrandt. Pastel surfaces were even more limited and many artists used surfaces designed for other purposes, such as watercolor and printmaking papers. Artists who be-

gan using pastel during this time learned to work with harder pastels and either highly-textured or low-tooth surfaces. As a result, their paintings often exhibit a *broken color style*. In this book, Duane Wakeham, Lee Kimball and Elroy Williams exhibit this style.

With the development of sanded papers, such as Wallis, and more brands of soft pastel, such as Great American, Unison, and Terry Ludwig, artists beginning in the medium since the 1990's are more likely to paint with a *painterly color style*. Most of the other artists represented in the book, including me, fall into this category.

Both of these styles can be used to create beautiful paintings. However, while there is a prevalence for painterly color among many of today's artists, a number of pastelists are once again exploring alternative surfaces and techniques that enable more broken color and individual expression.

Chapter 01 PASTELS

Pastels range from hard to soft, thin to thick, square to round. Some aren't sticks at all, but pressed pigment or pencils. The pastel artist should have pastels in a range of values and degrees of grayness for each of the colors on the color wheel. In addition, one needs to have pastels in differing degrees of hardness and softness. Fortunately, the major brands are now available in half sticks, enabling affordable purchasing of a greater assortment.

While having good quality pastels is important, you do not need to have all of the brands that are available. Within the soft pastels, for example, it really doesn't matter whether you have Schmincke, Great American, or Terry Ludwig. They are similar in softness and will yield good results in paintings. Yes, we have our favorites, for sure. But what is more important is to understand how the various hard, intermediate, and soft pastels interact with each other and on different surfaces.

CATEGORIES OF PASTELS

The term *soft pastel* is misleading. It is often used as a generic term to distinguish *chalk-type* pastel from *oil pastels* (a different medium that is not covered in this book). In reality, *soft pastels* come in three variations: hard, intermediate, and soft, and it is important to understand this before purchasing them. A complete set of one of the hard pastel brands is advisable, in addition to a good selection of intermediate and soft pastels.

The following table arranges pastel brands based on the way I use them. Others may have different perspectives. For example, Dakota Art Pastels[1] places Girault and Holbein in the soft category.

Table 1-1

Hard	Intermediate	Soft
NuPastel	*Medium hard*	Unison
Faber-Castell	Rembrandt	Great American
Polychromos	Art Spectrum	Schmincke
Cretacolor	Daler-Rowney	Sennelier
	Holbein	Terry Ludwig
	Grainy soft	Diane Townsend
	Girault	Mount Vision
	Henri Roché	
	Art Spectrum Extra	
	Soft tinted whites	

1 Dakota Art Pastels is a leading online supplier of pastels. See Appendix C. for more information.

However, I use them as intermediates between hard and soft. In addition to the brands listed below, some art supply companies, such as Blick and Richeson, also produce their own pastels in varying degrees of hardness. Dakota has also produced its own brand of Blue Earth pastels.

Hard pastels

Many pastel artists begin their paintings using hard pastels for a variety of reasons. The first is that the harder pastels allow for more layering of colors on *toothy* or rough papers. The harder pastels are also less expensive than the softer sticks, so using them to fill in the initial masses of the composition is an economical way of working. For these reasons, hard pastels are often used in underpaintings. Due to their narrow and often square shape, they are easier to control in your fingers than the bulkier, soft pastels. They deposit thinner layers of pastel when dragged across the paper on their sides, and their edges can be used for fine details at any stage in the painting process.

Because hard pastels are often used for the first layers of a painting, and since it is best to begin a little darker and apply lighter values on top, hard pastel sticks tend to come in darker

Fig. 1-1. A selection of hard pastels. On the left are pieces of NuPastels; on the right, Faber-Castell Polychromos.

Fig. 1-2. Intermediate pastels. At top: broken pieces of Daler-Rowney. On the bottom left: Girault; middle: Holbein, and at the right: a Rembrandt and a Daler-Rowney.

Fig. 1-3. Art Spectrum "Extra Soft" tinted whites.

Fig. 1-4. Soft pastels. Top, left to right: Unison, Schmincke, Great American, and Sennelier. Middle: Terry Ludwig, Mount Vision, and Diane Townsend. Bottom: Henri Roché.

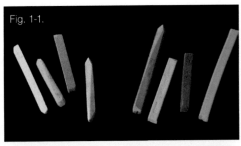
Fig. 1-1.

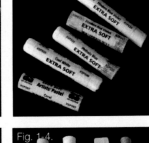
Fig. 1-3.

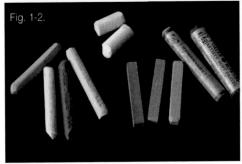
Fig. 1-2.

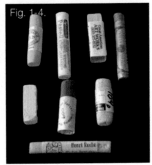
Fig. 1-4.

shades. This is particularly true of the Faber-Castell Polychromos. NuPastels contain a wider range of values that enable mixing complements and colors of the same value.

Be forewarned that some hard pastels are not completely lightfast. The NuPastel magentas and pinks, particularly, can be a problem. If you are using hard pastels in the initial layers with other pastels on the top, does lightfastness matter? I have been told that it does, although I have not seen evidence of fading in any of my pastel paintings. But be aware of this concern and use conservation glass when framing paintings.

Intermediate pastels

I label this category *intermediate* because these pastels fall somewhere in between the hard and soft categories. It includes two distinctively different types of pastel: *medium hard* and *grainy soft*. The pastels in this category come in a much wider variety of bright and grayed colors, as well as degrees of darkness and lightness, than do the hard sticks. For this reason, they are sometimes used in place of hard pastels at the beginning of the painting process.

Many manufacturers label these brands as "soft." Those listed as medium hard in the table are not as soft as those in the second category. But all are useful for gradually building layers of pastel.

Medium hard. The most commonly used brand in this category is probably Rembrandt, which has been on the market for years. Rembrandt offers wonderful colors for portraits.

The other brands are quite similar, with Art Spectrum being the hardest.

Grainy soft. Pastels in this category are softer than the medium hard but are not buttery, making them excellent for layering and transitions. Girault pastels are a favorite of mine and many artists. They are soft enough to produce painterly effects, while not building up thick layers too quickly. This makes them very useful for initial or secondary layers, as well as for providing transitions and nuance. On some sur-

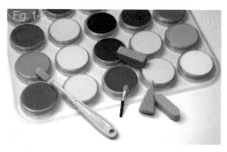

Fig. 1-5. Pan-Pastels and applicators. The pastels have been placed in separately-purchased trays which make them much easier to use.

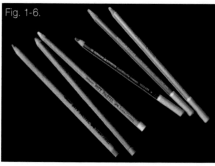

Fig. 1-6. Two brands of pastel pencils: Faber-Castell Pitt on the left and Stabilo Carbo-othello on right. The Stabilo are softer.

faces that really *grab* the pastel, I prefer using Girault to soft pastels. I prefer these to the medium hard as an intermediate pastel.

The Roché pastels are the brand that Degas used. They are similar to Girault but quite expensive. (One is pictured in Figure 1-4.) The Art Spectrum "extra soft" tinted whites are very useful pastels that are also soft with a grainy feel. They come in sets of six cool and six warm colors. I use them for snow, clouds, and white houses.

Soft pastels

Soft pastels can be used for highlights, intense passages of color, or for the entire painting. If you want to produce pastel paintings that are similar in appearance to oil paintings, the softer pastels do this nicely. But be careful—the secret to using soft pastels is a light touch. A painting can quickly become overworked and *cakey-looking* if soft pastels are not applied judiciously (see Chapter 5).

Soft pastels can be purchased in sets of varying sizes and characteristics. Great American and Terry Ludwig have sets chosen by and named for famous painters, such as the "Richard McKinley set" and the "Doug Dawson set." They may also be grouped according to subject matter, such as a landscape or a floral set. In addition to the subject-based sets, Unisons are sold in various mixed sets and boxes by color family, such as blue green, yellow green earth, blue violet, and so forth. Many of these brands also have sets of lights, darks, and grayed colors.

Other types of pastel

PanPastels. These are a recent innovation. The pastel is contained in small round pans, similar to pressed cosmetic powder or rouge. The pastel may be applied with an assortment of tools. You can use them to lay in initial layers or to build an entire painting.

Pastel pencils. I use pastel pencils primarily to sign my paintings. Other artists make broader use of them. Some pastel pencils are very hard, making it difficult to apply them over applications of softer pastel. When a fine line is needed, I find it easier to use the edge of a hard pastel. Many pastel pencil brands do not fit well into pencil sharpeners and they are easily broken during sharpening. A friend recommends the Dahl 155 sharpener.

Every type of pastel has its enthusiasts. Try them out to determine what works best for your particular subject and style. A sampler of the different pastel brands is available from Dakota Art Pastels.

GETTING STARTED: Purchasing Pastels

As you begin to build your pastel collection, I recommend Unisons as a good choice for a soft pastel. Though not as soft as Schmincke, Great American, Sennelier, and Ludwig, they layer beautifully, are completely lightfast, and are available in half stick sets. As you expand the collection, it may be economical to have more of the dark and mid-valued colors in the hard or medium hard pastels and to limit the purchase of the more expensive soft pastels to mostly lighter and purer colors useful for highlights and pieces of saturated color. Rembrandt, Schmincke, Unison, Sennelier, and Great American all sell economical half stick sets.

Recommended pastels to consider for "starter collections" include:

Hard:

NuPastels 96

Faber-Castell Polychromos 60

Intermediate:

Girault's Elizabeth Mowry "poetic landscape" set

Rembrandt half sticks by subject category

Soft:

Unison half sticks 120 (good for landscapes)

Sennelier or Schmincke half sticks

Ludwig, Unison, or *Great American* sets

by subject or color

Inexpensive:

Faber-Castell Goldfarber Studio Soft Pastel

student set" (quite inexpensive)

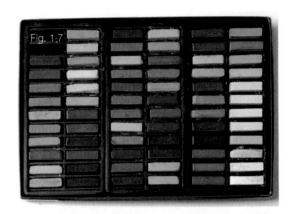

STORING AND TRANSPORTING PASTELS

When getting started with one or two sets of pastels, it is easiest to leave them in the boxes in which they were purchased. As more sets are acquired, you will want to combine them into some form of *working* box. Break each pastel in half, place the half without its wrapper in the working box, and retain the other half in the original box for storage.

It is important to keep the pastels in a single layer in the working box, so they can be seen in relation to their neighboring sticks. If you are working solely at home, a purchased or hand-made box can be used. However, if transporting pastels to a work-

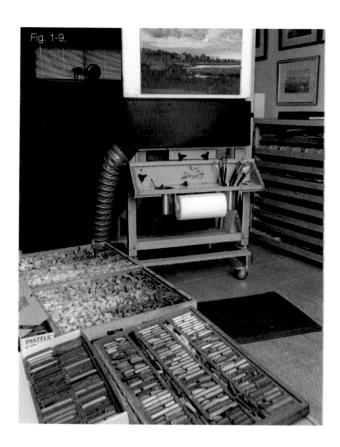

Fig. 1-9.

Fig. 1-7. The 72 Goldfaber Studio soft pastels from Faber-Castell

Fig. 1-8. Large Heilman box with the working collection of soft pastels used in my studio. Note that the box does not include hard or intermediate sticks. I store hard pastels in an Art bin, and keep Giraults separate for easy identification. I also have smaller travel boxes from Heilmann and Dakota.

Fig. 1-9. Easel with pastels. The table contains Giraults (at bottom) and the large Heilmann box. An Artist's Air system on my easel helps control pastel dust generated while I am painting. The cabinet at right was constructed by my husband, using shallow drawers purchased from IKEA. This is where I keep the storage boxes of pastel.

shop or outside to paint, it is a good idea to have a *travel* box that holds your pastels securely until you reach your destination.

Excellent travel boxes are available from Dakota Art Pastels, Jack Richeson (Roz box), and John Heilmann. The Dakota box has foam separators for the individual sticks. The Roz box is metal and contains separate foam-lined slots for the pastels. The Heilmann box, depending on size, is divided into six or eight columns. Tabs hold covers down over the pastels while in storage or transit, and hinges keep the box securely closed during travel or open while you are working. A layer of memory foam helps keep the pastels clean and secure.

There are many ways to organize a box. I sort first by hue, with cooler colors on the left and warm-er colors on the right. Within each column, I sort by value, with the lightest colors at the top and darkest at the bottom. On the far right is a column of gray and brown neutrals; other grayed colors are mixed with their appropriate hue. This arrangement makes it easy to select the right pastel when painting and return it to the right location in the box after use.

WORKING SAFELY AND CLEANLY WITH PASTEL

Pastel is a messy medium. As it is applied to a surface, dust is created that floats in the air and lands on everything near by. This can be a safety concern, because of hard metals like cadmiums in some pigments, as well as a constant housecleaning challenge. Do not have open water bottles or coffee mugs next to the easel while working because ingesting pastel may be a hazard.

Work at an easel, not a drawing table, and position the easel so that it is straight up or even tilted a little forward. This will prevent the dust from landing

on the painting. It is also a good idea to begin at the top and work down, so that pastel dust doesn't fall on a completed area.

To catch the fallen dust, place a long trough of folded wetted paper towels or aluminum foil right beneath the painting. When your day is done, throw them out, wipe down the easel with a wet rag, and clean the floor.

I have Artist's Air installed on my easel. Previously, I had an air filter in my studio. But using good ventilation and cleaning up regularly can be enough. If you are concerned about breathing in the pastel dust, wear a mask. If you have asthma or other such problems, watercolor or acrylic are safer media for you.

Some other safety measures are to resist blowing bits of dust off your painting or brushing off large areas of unwanted pastel while indoors. *Never* use most fixatives when you are inside due to their flammability and toxicity (see more on this below).

There is also the matter of the hands. Mine become an awful shade of green very quickly! Some pastel artists use gloves. There are good barrier creams, such as *Gloves in a Bottle*. Wiping hands often with paper towels or Wet Ones, washing hands using moisturizing soap, and having a nail brush for more thorough cleaning are all helpful practices.

Because your hands are often dirty, the pastels will become dirty, too. I place the sticks being used in plastic sandwich boxes containing a shallow layer of corn meal. When I shake the box gently from side to side, the pastels are cleaned. This system has the advantage of isolating the sticks you are using and reusing in a particular painting so that the palette is kept as limited as possible. If you work on more than one painting at a time, have a separate box for each painting.

OTHER USEFUL MATERIALS

In addition to having paper towels and other items listed above, it is also good to have the following supplies and materials in stock.

Backing boards and tape: Pastel paper needs to be taped to a slightly larger surface for stability during the painting process. Foam core provides a softer surface than a masonite drawing board. It is best to have multiple boards so that paintings can be stored on them.

Bristle brushes: These are used to brush unwanted pastel layers off your work and to create wet underpaintings. Do not use expensive brushes on rough pastel surfaces.

Glassine: This is a paper, similar to wax paper, which is used to cover paintings for long term storage and for transport before they are framed. (Do not substitute wax paper because the heat of the sun in a hot car will melt the wax onto the pictures!) Because glassine is slick, it picks up very little of the pastel, and it can be wiped off with a paper towel and used again. Once it becomes wrinkled, throw it out. The creases will interfere with the picture. Glassine is sold by the sheet or roll in most art supply stores.

Apron: Always a good idea.

Sketching materials. The pastel artist should have sketchbooks of various sizes, drawing materials, markers or pens for values studies, and a viewfinder for seeing the composition when painting from life. The 3-in-1 Picture-perfect viewfinder (Figure. 7-1) is available in some art supply stores.

Fig. 1-10. Pastels in corn meal.

Fixatives. Workable fixative can be useful for restoring the tooth of your paper or for intentionally darkening a painting. I use it over a dry underpainting and like the tooth that is provided. When applied over a layer of pastel it can prevent mixing with superimposed pastel layers. Final fixatives can spot and darken the work. They are never a substitute for glass on the framed painting. Good fixatives include Lascaux, Sennelier LaTour, and Spectrafix brands. The latter is a casein-based fixative that is safe for indoor usage. You may want to try them out. I do not apply final fixatives to my work, choosing rather to give the painting a few good raps outside to knock off any loose particles before framing.

Blending tools. Rubber-tipped shapers are useful for occasional blending and achieving clean edges. For minimal blending, I prefer my little finger as it is easy to control and always available! Styrofoam packing peanuts and pipe insulation are used successfully by some artists.

S U M M A R Y

- Purchase the best pastels you can afford.
- Collect pastels in a variety of hardnesses.
- Half-sticks are a less expensive option for building your collection.
- Begin a collection by purchasing sets specific to your preferred subject matter.
- Organize and store your pastels in working and/or travel boxes.
- Make sure to work as safely and cleanly as possible.
- Stock your studio with useful supplies and material.
- Do not forget to purchase other essentials, such as glassine.
- Final spraying of pastels is not necessary, though some artists chose to do so.

Chapter 02 SURFACES

Pastel surfaces range from rough sanded papers to smoother surfaces that enable fine details. They can be purchased as paper or precut boards, and many are available in white, neutral tones, and a variety of colors. You can also make your own surfaces.

Choosing the appropriate pastel surface can be critical to creating successful paintings and development of a personal style. Some artists always use the same surface; others select one based on the subject matter and techniques to be employed in a particular painting. If you like to have options, it is a good idea to have a variety of papers and boards available in white, as well as other colors. Dakota Art Pastels sells a paper sampler that is an inexpensive way to try out many of the surfaces currently available.

The term *surface* is used in this chapter to refer to the product, either purchased or hand-made, that will receive applications of pastel. Some surfaces are papers, such as Canson Mi-Teintes. Most are coated papers or coated boards that consist of a substrate (e.g., watercolor paper, Gatorfoam, hardboard) and a ground. If the substrate is rigid enough, the surface will not need to be pre-mounted for use in wet underpaintings. The ground consists of a gel or liquid containing some form of grit (pumice, marble dust, silica) that the producer applies to the substrate. Some grounds can be purchased separately for the preparation of surfaces.

There are three considerations when choosing a surface:

• texture,

• color or tone,

• whether or not it will accept wet applications.

I discuss all three in this chapter but the focus is on texture. Further information is contained in Chapters 4 and 11.

TEXTURE OR FEEL OF A SURFACE

Because pastel is applied with the hands, the texture or feel of the surface is very important. The main criterion is that pastel surfaces must have *tooth* in order to hold the layers of pastel.

When choosing a surface texture, you should consider the following:

• style and desired look of the painting,

• types of pastels you will be using,

• level of detail desired,

• amount of layering you wish to do,

• type of stroke that will be used.

Based on my experience with a variety of surface textures, I have divided pastel surfaces into four categories, displayed in Table 2-1.

In order to define the texture of the various brands of surfaces, I use the following terms to describe how the surface feels when applying pastel. There are two aspects:

Hardness or Softness of a Surface

A *soft* surface is one that readily accepts any kind of pastel. Hard sticks make a richer stroke on soft surfaces. Soft pastels have to be lightly applied. The softest surfaces, such as Wallis paper, are sometimes said to *grab* the pastel. A *hard* surface is one that is more resistant. I consider Ampersand Pastelbord to be a relatively hard surface. Some surfaces combine both qualities. For example, La Carte is fairly resistant to

hard pastels, qualifying it as a hard surface. However, soft pastels go on very easily and must be sparingly applied.

Roughness or Smoothness of a Surface

The roughness or smoothness of a surface is critical to the application of strokes. Do you want a bold stroke of color, or do you want to lightly layer one stick over another, allowing each individual color layer to show through? Rougher surfaces enable more layering, while smoother surfaces enable more saturated strokes of pastel. You can layer and achieve saturated strokes on all good surfaces; but it's helpful to know which surfaces make these techniques most successful. An example of a rough surface is Richeson Premium Pastel Paper. Pastelmat is an example of a smoother, less abrasive surface.

I illustrate the application of different kinds of pastels to each kind of surface in Figures 2-1 through 2-19. These illustrations, except where noted otherwise, employ a hard pastel (either green NuPastel or blue Polychromos), medium hard Rembrandt and grainy soft Girault intermediate pastels, and soft pastel (green Great American or blue Schmincke).

GRITTY SANDED SURFACES

These soft surfaces accept many layers of pastel and are often said to *grab* the pastel. They range in degrees of roughness. It is often best to start with hard or intermediate pastels on these surfaces and use a light touch when applying the softer sticks.

Wallis Sanded Papers. Wallis manufactures probably the best known sanded papers. Wallis paper takes applications of hard pastels beautifully. The surface feels very rough, but it is consistently so. Pastel blends nicely on Wallis but over blending may cause bloody fingers.

Wallis paper is produced in two grades: professional and museum grade. Both are dependably archival, likely to last hundreds of years. The museum grade comes only in white and has a substantial feel to it. At this time, the professional grade comes in white and in "Belgian gray." The white papers may need to be mounted for use with wet underpaintings (see section on mounting below). It is best not to use alcohol as a solvent on Wallis; water and mineral spir-

Table 2-1

Gritty Sanded Surfaces	Layered Sanded Surfaces	Smoother Surfaces	Irregular or Highly-Textured Surfaces
• Wallis sanded papers • UART sand papers • Richeson Premium Pastel surfaces • St.-Armand Sabretooth	• Art Spectrum Colourfix and Supertooth • Ampersand Pastelbord • Canson Mi-Teintes "Touch"	• La Carte pastel card • Pastelmat • Art SpectrSuede • Townsend paper • Velour • Canson Mi-Teintes (smooth side)	• Surfaces hand-made with a ground applied to a substrate, that may or may not have its own texture

Fig. 2-1. Wallis "Belgian gray," also called "Belgian mist." Clockwise: Nupastel, Rembrandt, Girault, Great American.

Fig. 2-2. UART 600 grade. Clockwise: Polychromos, Rembrandt, Girault, Schmincke.

Fig. 2-3. UART 280 grade. This rougher surface grabs the pastel more than the finer 600 grade. Clockwise: Polychromos, Rembrandt, Girault, Schmincke.

its work well, however.

UART Sand Paper. UART has the look and appearance of real sandpaper and, basically, that's what it is. However, it is PH-neutral and archival. It comes in different grits. The lower grit numbers are rougher and the higher numbers are finer. If trying this paper, consider your style and subject matter when selecting an appropriate grit. UART comes only in light beige. It accepts underpaintings using all types of solvents.

Hard pastel is easy to apply to UART 600 grade (Figure 2-3). A very light hand leaves only little points of color. Soft pastel goes on very readily, quickly producing a saturated stroke. Still, there is plenty of tooth for additional layers. Note the linear texture that is not seen in the 280 grade (Figure 2-3).

Richeson Premium Pastel Surfaces. Richeson surfaces are very soft, and they are very rough in grit.

They are excellent for layering, but harder for achieving fine detail. The surfaces are available in many sizes and colors and on three substrates: paper, Gatorfoam, and hardboard. Interestingly, each has a slightly different feel, which is an indication that the substrate really matters. The Gatorfoam and hardboard are good for wet underpaintings, but the paper warps unless dry-mounted.

St. Armand Sabretooth. This highly textured Canadian paper is one of the roughest and toothiest papers I have tried. It tolerates both water and solvents. The coating is an acrylic-based sanded gel that has been rolled on. If you want to use a lot of layering while retaining the ability to rework and scrub your painting, this paper is a good one to try.

Fig. 2-4. Richeson "terra cotta" paper. Notice the rough, gritty appearance of this surface. It is definitely a *pastel grabber* because it is so toothy. Clockwise: Nupastel, Rembrandt, Girault, Great American.

Fig. 2-5. St. Armand Sabretooth. Clockwise: Polychromos, Rembrandt, Girault, Schmincke.

Fig. 2-6. Colourfix "ultramarine blue." Clockwise: Nupastel, Rembrandt, Girault, Great American.

LAYERED SANDED SURFACES

While the manufacturers call these products "sanded" surfaces, their feel is very different from those previously described. Instead of the tiny rough bumps of grit felt on the gritty sanded papers, these surfaces feel more like tiny overlapping layers. The difference in texture makes it possible to apply many layers of pastel as these surfaces are not *pastel grabbers*. They are good for both direct applications of pastel and for underpaintings.

Art Spectrum Colourfix. Colourfix paper is slightly harder than sanded surfaces such as Wallis. Hard pastels can be applied beautifully on this surface, but it doesn't grab them in the same way. It is easier to achieve broken color on Colourfix. It is available in many colors in a wide range from dark to light. A nice feature is that Colourfix paper is produced with a white uncoated border, making it easy to tape the paper to a backing board and paint right to the edge

of the coated surface. The Colourfix Liquid Primer can also be purchased as a gel, useful in preparing your own surfaces. It comes in colors and white, as well as a clear gel that you can tint with your own color.

Art Spectrum Supertooth. Supertooth paper contains double the amount of grit used in Colourfix papers. Though it is excellent for layering, it is more difficult to achieve fine detail. It comes only in white and on a very rigid surface (300 lb watercolor paper), so it does not need to be mounted. Thus, it is a good choice for wet underpaintings.

Ampersand Pastelbord. Pastelbord consists of a coating of ground that has been applied to a fairly heavy hardboard. Since it is sturdy, it can be used without a backing board, and the white is great for toning or underpaintings. It is available in a variety of precut sizes and, at this time, in white, sand, gray, and green. The texture of the surface is similar to Colourfix, but it has more depth, from my perspective. Pastelbord feels harder than pastel papers. The hard pas-

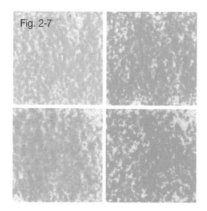

Fig. 2-7. Art Spectrum Supertooth. Clockwise: Nupastel, Rembrandt, Girault, Great American.

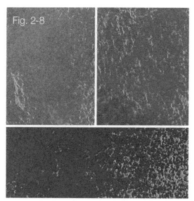

Fig. 2-8. Ampersand Pastelbord "sand" with strokes of NuPastel, Girault, and Schmincke.

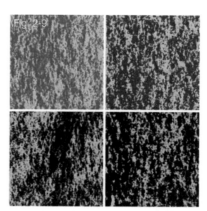

Fig. 2-9. Canson Mi-Teintes "Touch." Clockwise: Polychromos, Rembrandt, Girault, Schmincke.

tel doesn't go on quite as readily as on Wallis and the grittier surfaces. In layering soft pastels, a light touch allows for many subsequent applications, while a little more pressure creates a strong saturated stroke.

Canson Mi-Teintes "Touch." A new addition to the growing number of pastel surfaces, Touch comes in a number of lovely colors and with a white border that makes it easy to tape down. While it is listed as a "sanded" surface, the feel is similar to Colourfix. If you want more tooth than the traditional Canson, but not too much, this is a good surface to try. It is a *hard* surface for hard pastels, but soft pastels can be easily applied. It can be purchased as boards which can take wet underpaintings without being mounted.

SMOOTHER SURFACES

These surfaces are smoother to the touch than those previously described. In general, they offer less resistance when applying soft pastels. Interestingly, three of these surfaces are produced in France, which may be indicative of current French pastel painting styles. They are not sanded surfaces.

Sennelier La Carte Pastel Card. The surface of La Carte is composed of vegetable fibers that will dissolve if water is applied — thus, *no wet underpaintings with any solvent may be used.* La Carte is toothy without being very rough and it holds many layers. I consider it to be a *hard* surface for hard pastels, as it seems resistant to them. This makes it possible to gently apply many layers of hard pastel, slowly building up to applications of the softer sticks which go on readily. Pastels blend so readily on Pastel CardLa Carte, you have to be careful not to over do it or accidentally create smudges. This paper comes in many colors, including at this time, a large number of browns.

Pastelmat. This surface is quite remarkable in that it feels like there is no tooth at all. Yet, when the pastel is applied, none of it falls off! It accepts hard pastels very nicely. Soft pastels can be boldly applied

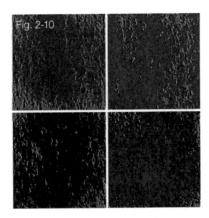

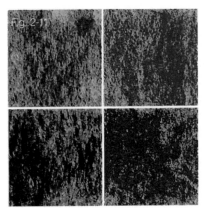

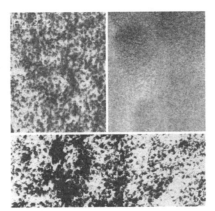

Fig. 2-10. La Carte Pastel Card. Clockwise with applications of Polychromos, Rembrandt, Girault, and Schmincke.

Fig. 2-11. Pastelmat "sand." Clockwise: Polychromos, Rembrandt, Girault, Schmincke.

Fig. 2-12. White Art Spectrum Suede with applications of NuPastel, PanPastel, and Schmincke.

without a lot of resistance. Be aware, however, that it may be hard to blend or to brush it off. Pastelmat is produced on a very rigid substrate that accepts wet underpaintings without mounting. It comes in a number of colors, my favorites being sienna and brown. When purchased in pads, you have the added feature of glassine attached to each sheet.

This is a lovely paper, but currently one of the more expensive on the market. It comes in sizes that are not standard for plein air frames. Purchasing a large sheet and cutting it to size might be a good idea, unless you will be matting and framing to size.

Art Spectrum Suede. Feeling somewhat like Pastelmat, this surface has the texture of Colourfix, only smoother. It comes in white, black, "brown paper bag," as well as in colors with interesting Australian names: "jacaranda" (dark blue violet), "kalangadoo" (light gray), "kangaroo gray," and "outback blush" (peach). It is a good surface for the use of PanPastels, as Pastelmat would also be, but can be used for any type of pastel painting.

Townsend pastel paper. Made by Diane Townsend, who also creates a variety of pastels, this is a reliable paper for dry applications of pastel as well as for blending. It comes in several cream and gray tones. The substrate is Rives BFK printmaking paper. It needs to be mounted for wet applications.

Velour. If you want to avoid texture altogether, this is your surface! The pastel blends automatically when applied—no hard edges. The paper is made in Germany, comes in many colors, and can be purchased mounted on a board. Its lack of texture makes Velour appealing to portrait and animal painters. The hard pastels have less impact, but the softer pastels can be very richly applied with little effort.

Canson Mi-Teintes. Of the many products from Canson, Mi-Teintes is the one used for many years by pastel artists. It is very economical, comes in many colors, and is widely available. There are two sides to Canson Mi-Teintes. The side that the company

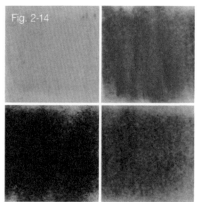

Fig. 2-13. Townsend paper "cream." Clock-wise: Polychromos, Rembrandt, Girault, Schmincke. Also used in Fig. 2-14 2-15 and 2-16.

Fig. 2-14. Velour paper.

Fig. 2-15. Canson Mi-Teintes paper, textured side.

considers to be the "right" side contains a manufactured texture. When the pastel is applied, it leaves a uniform pattern of paper showing through. Some like this affect; others prefer using the smoother side to achieve richer applications of pastel without the texture getting in the way. This paper does not hold as many layers as the surfaces previously mentioned. It cannot take wet underpaintings. I generally limit use of Canson to color studies, always using the smooth side. But there are well known pastel painters who use this surface exclusively.

IRREGULAR OR HIGHLY-TEXTURED SURFACES

In addition to painting on purchased surfaces, some pastel artists like to make their own. The chief advantage, aside from cost, is that you can create an irregular texture of underlying lines that enhances the dynamic feel of a painting. Homemade or pur-

chased grounds can be applied to a wide variety of substrates. When the ground is rolled on, the result can be similar to the homogeneous purchased surfaces discussed above. When brushed on, the tracks of brush strokes can lend a rhythmic texture to the surface that is revealed by pastel in the process of painting.

How does the substrate beneath the ground influence the look of a painting? The substrate determines its final texture. Gatorfoam is the smoothest of substrates. Museum board, smooth mat board, and printmaking papers (e.g., Rives BFK) provide softer and slightly more textured substrates. Textured mat board and watercolor paper are the most textured of all substrates. A heavy watercolor paper, such as Arches 300lb cold pressed, used as a substrate for the application of a ground, is both the softest and most textured surface that I have experienced.

The thickness of the ground and the type of brush used are also important in determining how

Fig. 2-16. Canson Mi-Teintes paper, smooth side.

deep the textured ridges of the ground will be. The deeper the grooves, the more the texture will show, but the more the surface will *eat* your pastels! In the past, I used a relatively thick application of ground; I now prefer a less textured surface that doesn't interfere with the painting, but still provides subtle lines. For an example of a highly textured surface, see Fig-

ure 4-8. See Appendix D for more information on preparing your own surfaces.

PREPARING PAPERS FOR USE

Unless using a hard board, such as Ampersand Pastelbord, paper surfaces need to be taped on to a backing board. Foam core is a good choice as it is easy to cut, lightweight, and provides a soft surface. Some artists like to use Gatorfoam, because it is both sturdy and lightweight. When the painting is finished, it can be left taped to the backing board for storage until framed.

Even when using a sturdy surface, I like to have it taped to a larger backing board so as to easily paint the bottom area. I roll four pieces of tape, place them on the corners of the surface's under side, then adhere the surface to the foam core board. If the board is 16" x 20" or larger, I also put tape over the corners to hold the surface in place.

Fig. 2-17. Mat board with ground. 8-ply mat board with two coats of liquid primer toned with liquid acrylic. NuPastel has been added on the left, Schmincke on the right, and Girault at the bottom.

Fig. 2-18. Gatorfoam with ground. NuPastel has been applied on the left, Girault in the middle, and Unison pastel on the right. The Gatorfoam is a harder surface and the lines of brushed-on ground are more apparent under the pastel.

Fig. 2-19. Arches 300lb cold-pressed watercolor paper with 2 coats of liquid primer toned with liquid acrylic. On the left is NuPastel, with Girault in the middle and Schmincke on the right. (Note: the purchased surface closest to this is St.-Armand Sabretooth.)

Hinge-taping paper to a backing board

While some papers have an uncoated border, making it easy to tape, others, such as Wallis, La Carte, or Pastelmat, do not. For this reason, *hinge-taping* might be preferable, because it allows you to paint to the edges, unhindered by tape.

Mounting paper

Mounting paper to a backing board involves a process of dry-mounting that is done prior to painting. This is essential for some surfaces in order to use them for wet underpaintings. Dry-mounting is also desirable when working on larger sheets of paper as it will keep them from buckling. It assures that the paper will remain in place, completely flat, and available for the application of pastel layers without wrinkling. It also makes it easier for framing.

There are three options for working on mounted paper: 1) purchase pre-mounted boards; 2) have a local frame shop dry mount the paper; or 3) mount it yourself. The last is the most economical, of course.

To mount paper, use matte medium or an archival glue. Some artists use spray glues. Be sure to coat the entire back of the sheet and then apply it to an archival surface of foam core or museum board. (If the painting will be framed with mats, cut the board at least 1" larger than the paper on all sides. If not using mats, cut the board to the same size.) Place glassine over the paper and rub it hard with your hands or use a roller. Be sure there aren't any bubbles under the surface. Place the dry-mounted item under a stack of books to dry overnight.

RECOMMENDED SURFACES FOR THE BEGINNER

In my classes, I recommend Wallis "Belgian gray" to beginners in pastel. It takes NuPastels or other hard pastels beautifully and for those without large collections of pastel, this is really important. Its mid-tone

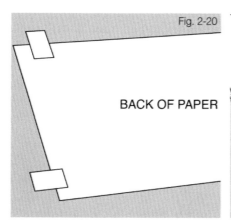

Fig. 2-20. To hinge-tape a surface to a board, begin by turning the paper over. Add a strip of tape to four corners so that half of the tape is on the paper and the sticky side is left exposed when the paper is turned right side up.

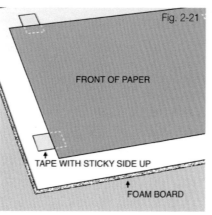

Fig. 2-21. Next, place the paper, right side up on a piece of foam core.

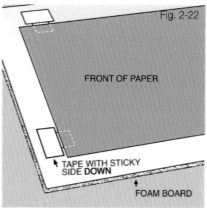

Fig. 2-22. Finally, place another piece of tape, sticky side down over each of the first pieces of tape which are sticky side up. Half will be on the tape, the other half will be on the backing board, securing the paper, and making it possible to paint to the edge.

neutral color allows darks to look dark and lights to look light and it is perfect for direct applications of pastel.

Aside from Wallis, Art Spectrum Colourfix is popular as it can be purchased in packages of varying colors. Pastelbord and Art Spectrum Supertooth are good surfaces for underpaintings as they do not need mounting. But many artists love the feel of Wallis and take the time to mount it first.

Pastel surfaces aren't inexpensive. Canson Mi-Teintes is one of the least expensive; Pastelmat is one of the more expensive. I recommend beginning small when starting in pastel to be able to get the sense of the medium and the possibilities of layering pastels, without having to cover huge areas of the surface. Another option is to make your own surface, as described above and in Appendix D. Regardless of size, I believe in using good quality surfaces. These enable the artist to achieve

the rich layers and applications of pastel strokes that make it such a beautiful painting medium.

HOW ARTISTS DECIDE ON A SURFACE

The paintings in Figures 2-23 to 2-26 demonstrate the end result of decisions made by contributors about their particular working surfaces. Some of these are pastel-specific surfaces, some are surfaces designed for other media.

My current favorites are Pastelbord, Pastelmat, and Wallis "Belgian gray," but I worked for years on Wallis museum grade white, Colourfix, and Colourfix liquid primer brushed on Gatorfoam. In the painting il-

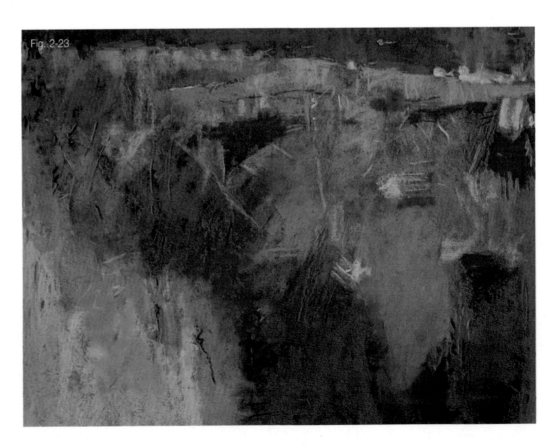

Fig. 2-23

lustrations in this book you will see a range of surfaces, all labeled as specifically as possible. While most of the contributors use pastel surfaces, artists Wakeham, Kimball, Wright, and Canfield use surfaces designed for other media.

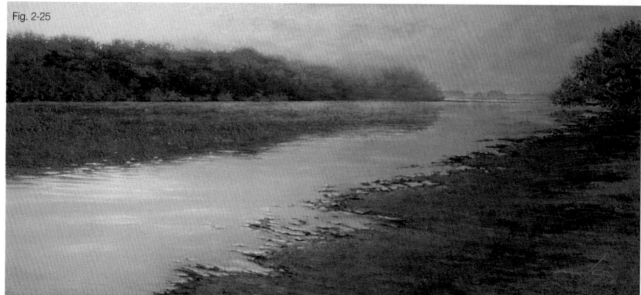

Fig. 2-23. *New Horizon*, by Deborah Stewart, 18" x 24" Wallis.

Stewart prefers a sanded surface, such as Wallis, for its strength and durability. She says "I know I can salvage an unsuccessful painting if my first effort does not turn out the way I want. Many times the second attempt turns out better than the first." As an abstract painter without specific subject matter, she needs this type of flexibility in the surface.

Fig. 2-24. *It's All About the Light*, by Robert Carsten, 19" x 24" La Carte.

Carsten uses La Carte for most of his paintings. He likes how it takes the pastel and accepts the addition of many pastel layers. Carsten uses direct application of pastel, without the use of an underpainting, and La Carte is a good choice for this type of application. He uses different colors; for this one choosing a warm mid-toned surface.

Fig. 2-25. *Threatening Remarks*, by Mike Kolasinksi, 12" x 24" Art Spectrum Colourfix liquid primer on archival foam core.

Kolaskinski prefers to make his own surface, using a roller to apply the ground to archival foam core. He describes his surface as similar to sandpaper in texture, allowing many layers of pigment to be held in place. He likes to tone the surface a mid-value reddish brown.

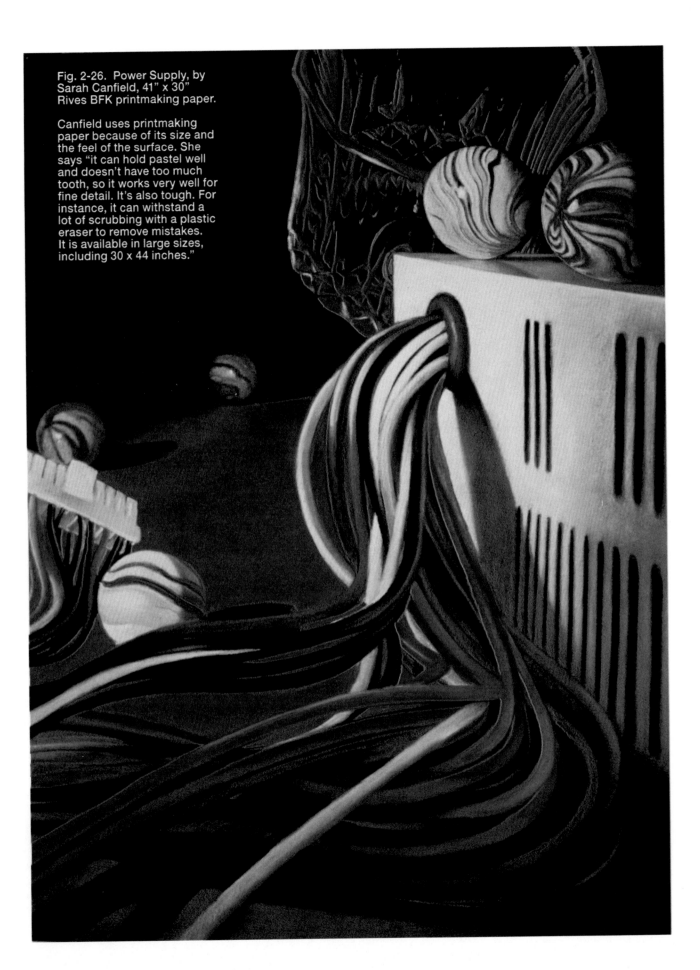

Fig. 2-26. Power Supply, by
Sarah Canfield, 41" x 30"
Rives BFK printmaking paper.

Canfield uses printmaking
paper because of its size and
the feel of the surface. She
says "it can hold pastel well
and doesn't have too much
tooth, so it works very well for
fine detail. It's also tough. For
instance, it can withstand a
lot of scrubbing with a plastic
eraser to remove mistakes.
It is available in large sizes,
including 30 x 44 inches."

SUMMARY

- The choice of pastel surface is a key decision in achieving your desired look.
- Consider the types of pastels available to you or that you most like to use when selecting surfaces. If using primarily hard pastels, consider using a soft surface.
- Dry mounting some surfaces is a good way to create a rigid surface on which to work
- Make sure to tape your surface to a largerbacking board, unless the surface is already large and rigid.
- Hand-made surfaces can create irregular texture.

EXERCISES

☐ Determine whether the paper you use most often feels *soft* or *hard*, *rough* or *smooth* when applying various types of pastel. Is it easier to use one type over another? Is it easy to add many layers?

☐ If possible, purchase the paper sampler from Dakota Pastels or a variety of surfaces and use the sheets to do small paintings. Determine which surfaces grab the pastel and which are most resistant. And, most importantly, which works best for you.

☐ Try making your own surface with a purchased ground.

☐ Examine paintings in *The Pastel Journal*, noting your favorite paintings and the surfaces that were used by the artists.

Chapter 03
STROKES AND LAYERING

T he most distinct aspect of your style is the way in which you apply pastel to a surface. When I began to use pastel, lacking access to a teacher, I just did what came naturally to me. Many artists do the same thing, and this is why pastel paintings can vary in such interesting ways. Your style in applying strokes of pastel determines whether underlying colors show through, how obvious the strokes are, and whether or not they are blended.

PASTEL STROKES

There are two basic ways of applying pastel: in linear, drawing-like strokes that use the ends of the pastel stick, and in painterly strokes that use the broader sides of the pastel. You can also use the edge of the pastel stick to create small, distinctive marks. These strokes may be applied directly to a surface or over an underpainting, as discussed in the next chapter.

Linear strokes

Linear strokes consist of lines—straight or curved—applied in one direction, criss-crossing or in random directions. Artists who prefer a linear approach often use harder pastels, keeping them whole to enable a better stroke. All linear strokes result in *broken color*, each with its own particular look, feel, and dynamic appeal.

The studies in Figures 3-2 through 3-8 illustrate the influence of different kinds of strokes on the development of a still life on Wallis "Belgian gray" paper.

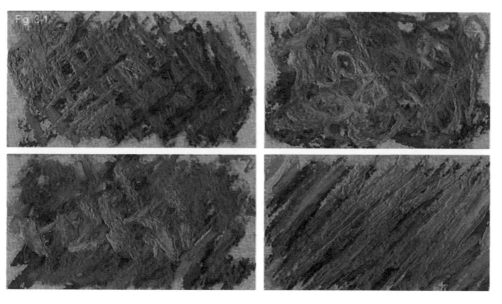

Fig. 3-1. Linear strokes, clockwise from left: cross hatching, scribbling, one-directional lines, small lines.

Fig. 3-2. <u>Cross hatching</u>. In this first study of two pears and a bowl, I applied cross hatching strokes to build up the colors. Straight lines are applied in different directions to build up a complex surface of energetic color. This type of stroke might also be applied over layers of scumbled color (see Figure 3-6 below), to combine both painterly and linear strokes. Hard or medium hard pastels are best for this technique.

Fig. 3-3. <u>Circular or scribbling strokes</u>. Note the swirling strokes of pastel in the background of this study. For comparison, also look carefully at the painting by Elroy Williams (Figure 5-4) who has applied the end of a full stick of hard pastel in a free-form way to build up color. This results in paintings that are fluid and dynamic.

Fig. 3-4. <u>Small individual strokes or pointillism.</u> In this study I used primarily short strokes. You can also place small dots of different colors next to one another to produce a vibration of color.

Fig. 3-5. <u>Linear strokes in one direction.</u> Here, I employed nothing but diagonal strokes and found it difficult in such a small picture. This effect seems to be kind of boring, but it could have potential in more limited use.

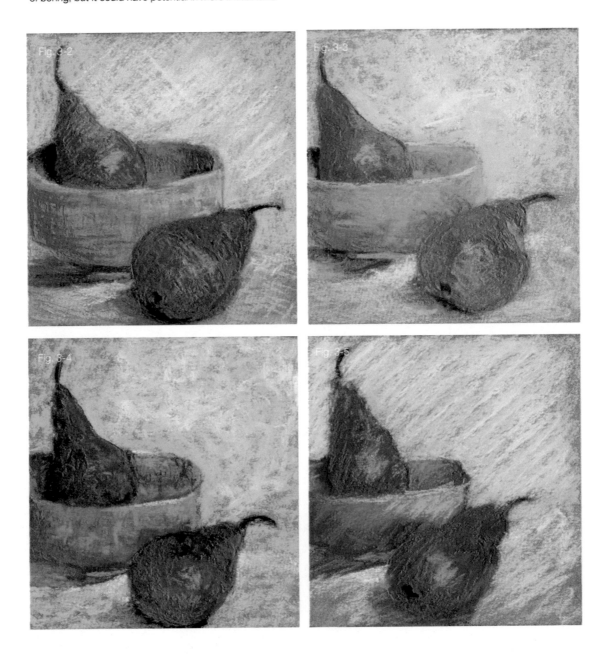

Painterly Strokes

Scumbling and block strokes may enhance the painterly affect of your work. For these strokes, artists are more likely to use the side of smaller, broken pieces of pastels.

You can use one or more types of stroke in your paintings. I use the sides of the pastels most often, particularly for the initial layers, and use the ends for achieving detail later on. However, forcing myself to use different strokes for these studies was both fun and educational. I highly recommend this exercise.

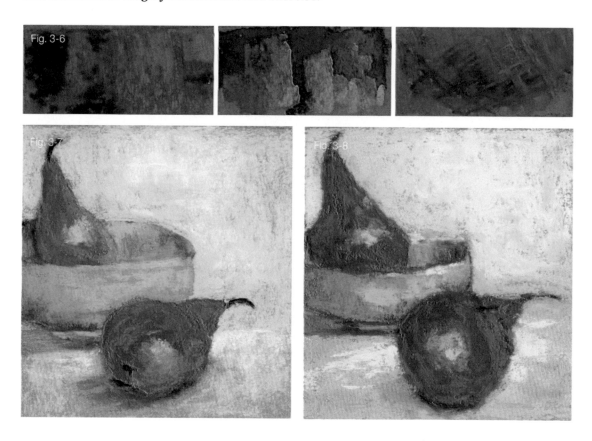

Fig. 3-6. Examples of painterly strokes, on the left are scumbled color and block strokes in the middle; at right is scumbled color with cross-hatching added on top.

Fig. 3-7. <u>Scumbling.</u> This is a technique used in all paint media to brush in light layers of color, over one another. In pastel, this is best done using the side of the stick. It is easier to scumble with hard pastels, but you can use this stroke with any type of pastel. The texture of the surface will determine how broken the color will be. Scumbling with hard pastels is a good way of applying initial masses.

In this study, soft pastels were introduced for the first time. I started with the sides of hard pastel, scumbling one over the other, then went to the soft pastels with the same approach. It is easiest to see the affect of the scumbling in the upper right corner of the background where there is less build up.

Fig. 3-8. <u>Painterly block strokes</u>. For this final study, I applied primarily soft pastels to form multi-directional block strokes. The broad end of a soft pastel was moved in varying directions to apply blocks of color. The size and softness of the pastel will determine the size of the strokes.

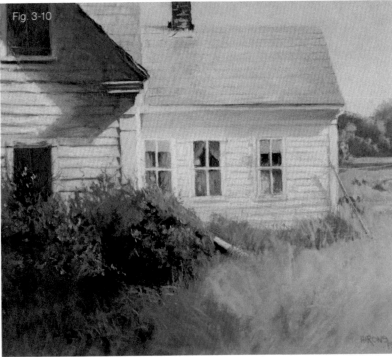

Fig. 3-9. The upper portion of this illustration shows soft pastel applied very lightly to Wallis "Belgian gray" paper, leaving room for many more layers. Below that I have applied more pressure to get a saturated stroke that will be harder to layer over. Overuse of heavy, saturated strokes will create cakey or muddy-looking paintings.

Fig. 3-10. *House on Deer Isle*, 16" x 20" Gatorfoam with ground.
Much of the color in this painting is layered (shadow), broken (house), and in small pieces (shrubs and sky). I applied more pressure and a very soft pastel to create the small strokes of yellow- orange flowers on the bushes.

Saturation of stroke

The pressure with which you apply the pastel will create either saturated or unsaturated color. If the pastel is applied lightly, no matter what the stroke, unsaturated or *broken* color is produced. If you apply a heavier stroke of solid pastel, saturated color occurs. Note that the more saturated the stroke, the darker the pastel appears.

The texture of the subject matter itself will help determine when more or less saturation is needed. The less texture of an object, the more saturated the color will appear. For example, a hard, shiny surface, such as a bowl or pitcher, will call for more saturated strokes of color than a more textured surface, such as woven fabric. But leave the saturated strokes for the end; do not begin with them. Landscapes rarely call for large areas of saturated color, rather smaller pieces of diverse color. Nevertheless, a saturated piece of blue in water or a solid block of brilliant green in meadow can create a beautiful point on which to rest the eye.

To blend or not to blend

Pastel is made of tiny crystals of pigment that catch the light and glisten. That's what makes it such a beautiful medium. But when pastels are blended too heavily with the hands or another tool, the crystals can be flattened and dulled. For this reason, I use very limited blending and advise students to do the same.

However, when sparingly done, blending pastel can create very smooth, lovely transitions of color.

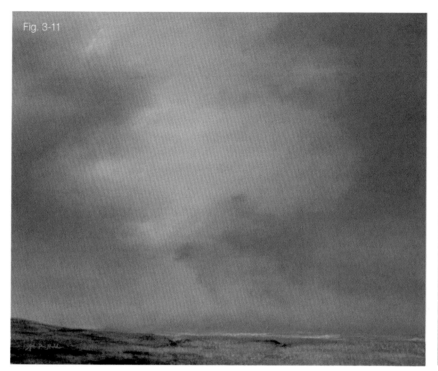

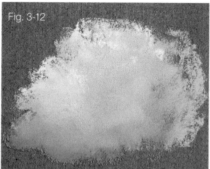

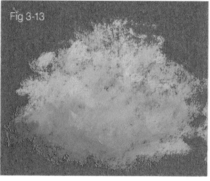

Fig. 3-11. *Hints of Spring #4*, by John Davis Held, 20" x 24" Townsend paper.

The artist uses his fingers, covered in artist's tape, to lightly blend pastel in his paintings of skies. Note the beautiful, soft transitions of color with hints of white cloud behind.

Figs. 3-12, 3-13. In these small illustrations, I used the same pastels on a piece of Wallis, blending with my fingers in Figure 3-12 and not blending in Figure 3-13. Either one could be effective for clouds. It depends on the amount of texture desired.

Such paintings often exhibit a tranquil mood that is very appealing. Paintings where the individual strokes of pastel are more visible may seem more energetic. Some artists blend to smooth skies or skin, because these have little texture. If you are trying to achieve a highly realistic look, you may want to blend the pastel. On the other hand, having a similar texture throughout the painting can be desirable and can be a case for not blending.

Tools for blending

When I blend pastel, I use my little finger to lightly soften edges in clouds or background hills, and to blur reflections in water. Tools designed for blending include rubber-tipped blenders and stumps. I have found that the latter tend to remove too much pastel.

Pipe insulation is an inexpensive alternative, available at hardware stores. Be careful using your fingers, as extensive blending on sanded paper can cause bleeding and an unintentionally-toned paper!

Exceptionally, blending can be used to cover up unwanted color when working on a toned surface. For example, if applying a light sky over a dark red paper,

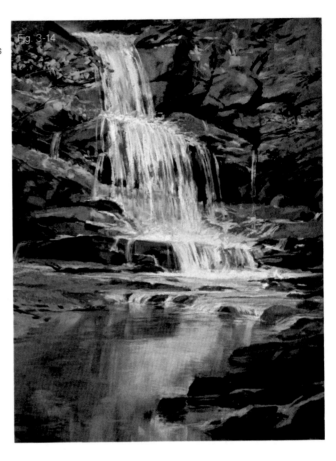

Fig. 3-14. *Falling Water*, by Robert Carsten, 24" x 18" La Carte. Carsten used PanPastels and a foam sponge to soften the reflections in this painting. Note how glassy the water appears.

a single layer of pastel can be applied and blended to cover up the original tone. Subsequent layers can be added without blending to produce a textured sky that does not have bits of red poking through. On the other hand, one of the reasons for working on a toned surface is to retain its influence throughout the picture, so consider letting it show in at least subtle ways, even in the sky.

Blending with pastels

My preference is to use pastels to blend selected areas of color. As each layer is applied, the pas-

tel gradually fills the paper, but individual pieces and strokes of color can still be detected where you want them. By layering strokes, the pastel becomes a blended area of multiple colors that the eye perceives as a mass. This creates complexity and vitality.

Additionally, you can burnish unblended areas of pastel with a hard pastel to create softer, more uniform passages of color. Start with a layer of soft pastel, brushed in lightly without covering the entire surface. Use a similar color of a harder pastel to bring together the areas of soft pastel, filling in the spaces. This is a way of blending without using your fingers.

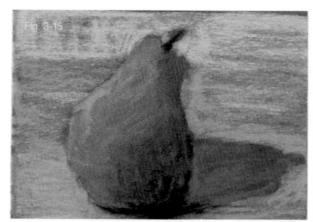

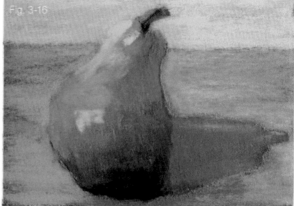

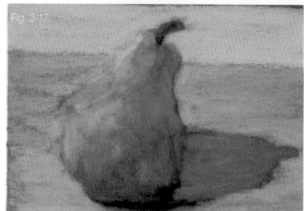

Fig. 3-15. Hard NuPastels and Polychromos have been used to lay in the basic shapes and colors of the pear, as well as the table and background.

Fig. 3-16. Intermediate Girault pastels have been used to lighten and develop more colors in the pear.

Fig. 3-17. Finally, a variety of soft pastels have been applied to further lighten and brighten the pear and add highlights.

Another way to achieve a more blended effect is to apply PanPastels with applicators or sponges.

LAYERING TECHNIQUES

There are two *best practices* that pertain to layering pastels: to graduate from hard to soft pastels, and to work from darker to lighter values. Both of these practices also have exceptions.

Hard to soft

To preserve tooth, many pastel artists begin their paintings by blocking in initial shapes and colors with hard or intermediate pastels. A question frequently asked by those new to the medium is when to transition to softer pastels. There is no simple answer. I most often switch when I feel that the initial applications are complete or when the needed colors are not available in the harder pastels. The surface used and other factors will also determine the initial pastels used and the point at which I turn to softer sticks. On a relatively hard surface, such as Pastelbord, I may begin with intermediate pastels and move to the soft, omitting hard pastels altogether. On pas-

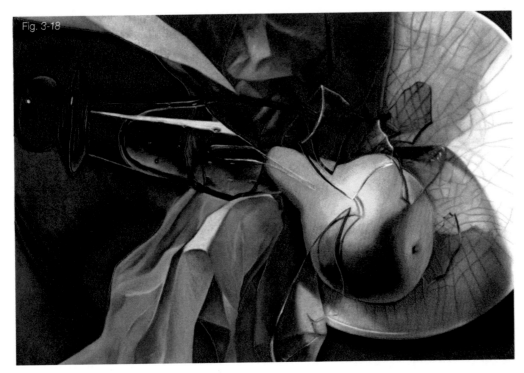

Fig. 3-18

Fig. 3-18. *Broken*, by Sarah Canfield, 30" x 44" Rives BFK printmaking paper.

Canfield uses soft pastels to begin laying in color, then burnishes with harder Rembrandts. This technique enables her to achieve the hard edges and smooth transitions in her exacting still life paintings.

Fig. 3-19. Here is a simple progression of dark to light. Note how beautifull the light pastel appears over the dark.

Fig. 3-20. Here greens that might be used to paint a tree gradually progress from dark to light.

Fig. 3-19

Fig. 3-20

tel-grabbing surfaces, such as Wallis, I prefer to begin with hard sticks.

EXCEPTION: when and how to use hard pastel over soft

While we normally work from hard to soft, there are times, such as when blending or defining a detail, when we may choose to apply hard pastel over soft. As mentioned earlier, a hard stick comes in handy to burnish applications of softer pastel. And you might find that the side of a hard pastel is convenient for adding the small branches of a tree over a soft pastel sky (see Figure 3-24). A pastel pencil may also do the trick, but it could be too hard.

Dark to Light

The second "best practice" of pastel is to work from dark to light. This guideline can be applied in different ways.

• You can start with a slightly darker value of the same color and layer the appropriate value over it, giving the resulting color more vitality.

• Based on a values study, you can begin with darker values of any color, over which lighter colors are applied. *A gradual transition from darker to lighter should be used.*

• Light pieces of color can be added directly over

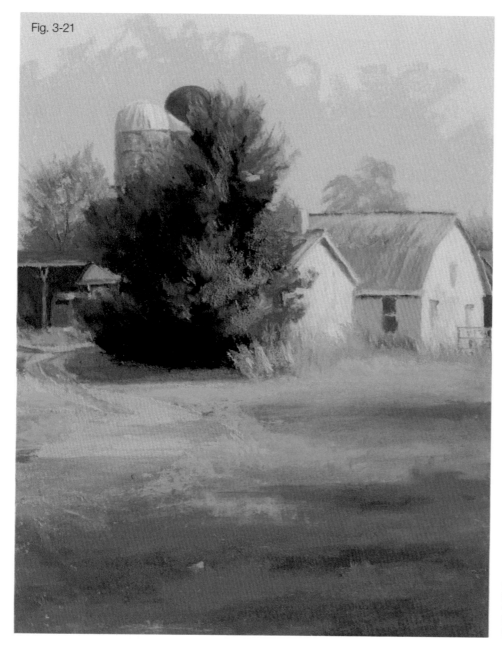

Fig. 3-21

Fig. 3-21. *Tuscarora Farm*, 12" x 16" Supertooth. Note the range of darker values of green used in the shaded side of the tree, which displays lighter greens on its sunny side to the right, but not too light.

dark to provide highlights. White highlights in a bowl, or sunlit blades of grass or flowers in front of the dark shadows of a bush are good examples. (See Figure 3-10.)

There is no question that placing dark over light can cause *mud*. For an example of this unfortunate outcome, see Figure 5-12.

TIPS: Working from dark to light

- Working from dark to light does not mean starting very dark in areas that will be very light! Start a little darker and work to lighter value.
- When working in dark areas, such as an evergreen tree or a large area of shadow, begin with a dark pastel and move very gradually to slightly lighter values. Be careful not to go too light too soon. You are aiming for subtle transitions from dark to light.

EXCEPTION: When and how to add dark pastel over light

There are times when we need to add darks in areas that are already painted with lighter pastel. If you are adding small pieces of dark, this can be easily accomplished. Use a soft pastel and a firm stroke to apply the small accents of color, bringing some of the lighter color back over it to make it recede. This is a useful way of adding dark accents under bushes and grasses.

If, however, you have determined that a broad area of color is too light, do not add dark over it. Brush it off and start over. Otherwise, the pastel will have a muddy look that is not satisfying to the eye.

PAINTING TREES AND SKY: where to start?

A problem frequently faced by the landscape painter is determining where to start in mixed areas of dark and light, such as trees against sky.

Figs. 3-22 and 3-23. Summer trees. In this small study, I painted the foliage of the tree as a mass, then added the sky holes. If there is more tree than sky, paint in the tree and add the sky holes afterwards, using a slightly darker shade of the sky color.

When painting winter trees, start by adding the heaviest branches of the trees. Then fill in the sky around them. Finally, add the smaller branches on top using hard pastels.

Fig. 3-24. *Crown Farm*, by Muriel Ebitz, 18" x 12" Wallis. This is an example of using both hard pastel over soft, and dark pastel over light. Ebitz is a master at adding small tree branches over sky. Note the various colors of the sky, applied with soft pastel prior to adding all but the largest of branches.

These are the major techniques for working in pastel. For more information on specific techniques, an excellent resource is Richard McKinley's Pastel Pointers blog (see Appendix B).

SUMMARY

- Pastel strokes are one of the most indicative aspects of an artist's style.
- Pastel is primarily about layering; the toothier the surface the more layers can be applied.
- In pastel painting, it is best to work from hard to soft and dark to light; however, you may make exceptions:
 ▸ Hard pastels can be used over soft to burnish and smooth the color.
 ▸ Dark pastels can be used over light for intricate details, such as tree branches.
- When moving from dark to light, do it gradually to provide nuance and to be sure you attain the final value desired.

EXERCISES

☐ Strokes: Using a piece of mid-toned paper, such as Canson Mi-Teintes, draw a number of 4" x 4" square boxes. Using hard, intermediate, or soft pastels, try using the different strokes discussed in the chapter, one approach in each box.

☐ Layering: Starting with a really dark pastel, find increasingly lighter pastels and layer one over the other. Try keeping the value differences as small as possible. Consider ways in which you might incorporate this technique into your favorite subject matter.

☐ Blending: make two boxes on your surface and add pastel to each. In the first, blend with your finger, in the other use only pastel sticks to blend. Which do you like best?

☐ Burnishing: Apply several soft pastel sticks then use one or more hard pastels to burnish them.

Chapter 04

TONING AND UNDERPAINTING

Many pastel artists use the techniques of toning and underpainting to create vibrant pastel paintings. Although it may be easier initially to work on a pre-toned surface, learning these techniques is important if you wish to realize the full potential of working in pastel.

DEFINITIONS

Toning: adding one or more colors to a white or very light surface to provide an overall tonal foundation for the painting.

Underpainting: applying one or more colors to the surface to define the major shapes and values of the subject matter, over which subsequent layers of pastel are applied.

Dry underpainting: pastel applications that are smeared into the surface without the use of a solvent, or sprayed with a workable fixative.

Wet underpainting: 1) pastel applications that are "melted" with the use of water or a solvent, or 2) a wet medium, such as watercolor, oil wash, or liquid acrylic, that is used to define the basic shapes and values of the composition.

TONING A SURFACE

Why tone a surface? With so many choices for purchasing toned surfaces, why go to the trouble of doing it yourself?

- Beginning with a white surface allows maximum flexibility. You can add any colors you want, based on the needs of a particular painting.
- When you tone a surface, the hue, value, and temperature of the surface are within your control. (Characteristics and choices of color will be addressed in Chapter 11.)
- You may not have the appropriately-colored paper available.
- By applying more than one color, self-toned surfaces can achieve a richer, more varied effect than a mono-toned paper.

How to use toning. A surface can be toned to suit a particular painting, or multiple surfaces can be prepared at one time. I often use multiple colors when I tone a surface. I like to use watercolor or liquid acrylic on white Pastelbord or Pastelmat. A number of colors, randomly added, can bleed into one another, creating a dynamic foundation for a painting. As I begin to apply the pastel, I try to leave some of the toned surface showing through, which gives added vibrancy to the painting. (Note: I do not call this is an underpainting, because the colors do not define specific shapes of the composition.)

Another use for toning is to cover previously used paper or boards. Some surfaces, such as Pas-

telbord, will tolerate washing and reuse. When your painting doesn't work, brush off as much pastel as possible outside, then rinse off the surface in the sink or hose it down. Once the surface has dried, you can tone it anew. Though toning won't completely cover the remains of the original painting, subsequent layers of pastel will.

TONED SURFACES

Figs. 4-1 and 4-2. Pastelbord toned with watercolor.

Fig. 4-3. White Pastelmat toned with watercolor.

Fig. 4-4. A previously painted Pastelbord retoned with watercolor.

Fig. 4-5. Pastelbord with yellow, turquoise, and red liquid acrylic applied to provide a multi-toned surface. I added the drawing over the toning.

Fig. 4-6. *Still Life with Two Oranges*, 11" x 14" Pastelbord. In this painting, the golden undertoned surface can be seen coming through in the upper portion of the painting and in the lower part as well. While I applied rich applications of pastel to the pottery and fruit, I applied very light strokes of color in the turquoise cloth and background.

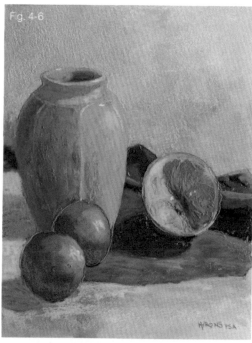

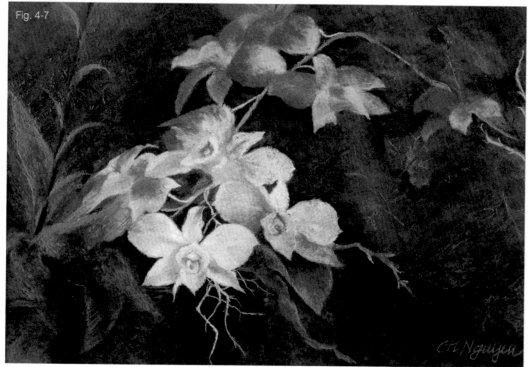

Fig. 4-7. *White Orchid and Blue Pots,* by Cam Ha Nguyen, 15.25" x 23" Gatorfoam with ground.

Nguyen let some of the original red-toned surface show through in her painting, providing mystery and vibration to the cooler colors of the background greens.

UNDERPAINTING

Both dry and wet underpaintings can help you to define the major shapes and values of the composition. Once the underpainting has been applied, the layering techniques described in the previous chapter are applicable.

Why use an underpainting?

• Whether wet or dry, the underpainting sets the stage for the painting.

• Applying a wet underpainting can provide a layer of color that takes up little or no tooth, allowing additional layers to be built up on the surface.

• A wet application sets the color into the surface, and once dry, will not mix with subsequent layers of pastel.

• An underpainting can create a bold, abstract foundation for the painting by simplifying the composition into large values-based masses.

• Using a little darker underpainting on a rough surface will provide a good foundation over which lighter pastel can be applied (the dark to light rule). The darker pieces showing through can create a broken color effect, depending on the texture of the surface.

• An underpainting can efficiently cover areas without using up a lot of pastel. A translucent watercolor underpainting, left partially uncovered can add brilliance to the painting.

• This is a good way of loosening up!

In summary using an underpainting may be helpful, **but you do not have to do one.** If the subject matter is complex and requires a lot of initial drawing, such as a portrait, an underpainting may risk losing the drawing. But if you are trying to loosen up or create bolder, more interesting beginnings, this is a great technique. Though useful for all subject matter, underpaintings are particularly helpful for landscapes, as you can freely build up masses of shape, value, and color that influence the success of the overall composition.

TYPES OF UNDERPAINTINGS

There are as many ways of doing an underpainting as there are reasons for using it. Underpainting techniques may range from simple to complex. Here are some methods I have seen well-known pastel artists use and which I have also found to be successful. Each method is demonstrated in Figures 4-10 through 4-13 using the reference photos in Figures 4-8 and 4-9.

Single pastel stick. The simplest type of underpainting is created using one hard stick, preferably dark, to lay in the basic shapes of the composition. The side of the stick is applied with different degrees of pressure to produce lighter or darker areas. For a wet underpainting, use an inexpensive acrylic bristle brush and water or a solvent to *melt* the pastel into

the paper. This type of underpainting can be useful when you want to cover only a portion of a light or mid-toned surface. I sometimes refer to this as a "partial block-in."

Values-based block-in using one color per value shape. This more complex type of underpainting blocks in basic shapes of the composition based on how dark or light they are. You may want to define one color to be used for each of four values (dark, mid-dark, mid-light, light), or you may use differing colors, depending on the composition. The primary criterion is that within each value shape, one pastel is used in order to keep the color pure.

Values-based block-in using multiple colors per value shape. In this case, colors are chosen by value, but you may use more than one color of the same value to fill each shape. Warm and cool colors can be mixed to produce more complex colors. This will result in a richer, but perhaps muddier underpainting (but this can be OK!).

Loose color wash. While hard pastels are generally used for the first three approaches, painting media, such as watercolor, gouache, oil, or acrylic, washes, or liquid acrylic, are more likely to be used in this wet approach to underpainting. The major shapes are indicated lightly with a pencil and the wet media is, then brushed over it, filling in and creating a rich undersurface. The choices of colors and values will be selected based on the compositional plan for the painting, but the color can be loosely defined in these wet washes.

You can mix the above approaches, or try others. I suggest experimentation with various techniques for underpaintings, keeping in mind the type of subject matter you like to paint and how you respond to the underpainting in your application of pastel.

Fig. 4-8. Photo reference. I chose this scene from Northern California as a basis for the four types of underpaintings illustrated in Figures 4-10 through 4-13. The underpainting examples are each 9" x 12" on Art Spectrum Supertooth.

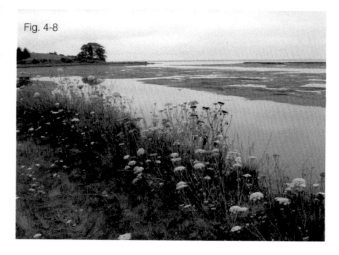

Fig. 4-8

Fig. 4-9

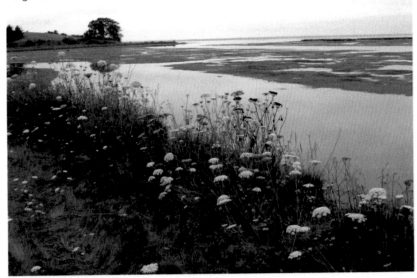

Fig. 4-9. A black and white version of the photo helped me to see the scene's values and to determine what I wanted to change. I added a second tree and made the first more prominent and darker than in the photo.

Fig. 4-10. Single pastel stick. Since this technique is best done on a toned surface, I added color with liquid acrylic. A dark violet NuPastel was used to lay in the shapes of the land, leaving the sky and water uncovered. I varied the pressure of the pastel to approximate the values.

Fig. 4-12. Multiple colors per value shape. For each shape, I added two or three colors. For example, I began the sky with a light, dull orange, and added yellow on top. For the foreground grasses, I used a variety of violets and reddish earth tones, reserving greens for the subsequent applications of pastel.

Fig. 4-11. One color per value shape. I limited the dark to the two trees in the background and reassessed the reflections in the water, having made up the second tree to the right. I then applied a single color to each of the major value shapes.

Fig. 4-13. Watercolor wash. I began working vertically, then laid the paper flat when giving it a second coat to attain the dark blue greens. Note the glow of the sky in this version.

SURFACES FOR TONING AND UNDERPAINTINGS

It is generally best to work on a white surface or one with a very light tone, such as UART. The first type of underpainting (one color for all shapes) can be applied very nicely to mid-toned surfaces. The pastel defines the major shapes of objects, while the toned surface provides the color for the negative space. In other cases, where the value and temperature of the pastels used is important, the tone of a paper can interfere. For this reason, I recommend white or very light surfaces for all but the first type of underpainting.

Not all pastel papers can be used for wet applications. Some are heavy enough to take the application of water or solvents without buckling, while others are best mounted. Table 4-1 provides guidance for some of the commonly-used brands.

As you will recall, the rougher the surface, the more you will be able to let the underpainting or toned surface show through. The color of the underpainting will lie in the crevices, while the pastel can be applied on the ridges of the surface. This is a great way to provide more complex and engaging surfaces. See Figure 4-14.)

MEDIA FOR TONING AND UNDERPAINTING

Hard pastel

Hard pastel is applied to the paper, based on the desired values and colors. For a dry underpainting, use hands, paper towels or cloths to smear the pastel into the paper. Or apply the pastel in whatever way you wish and apply a workable fixative to keep the colors from mixing with subsequent layers. For an example of this technique, see Figure 11-11.

For a wet underpainting, water or solvent applied with brush is used to *melt* the pastel. The solvent may be denatured or isopropyl alcohol or mineral spirits. The mineral spirits (or Turpenoid) work best, but you have to deal with disposal due to its toxicity. I use alcohol; in the classroom my students generally use water. For examples, see Figures 4-10, 4-11, and 4-12.

Use inexpensive acrylic bristle brushes. Do not use watercolor brushes! But also, do not use a really cheap brush that will leave a lot of hair on the surface. If hairs are left, wait for the color to dry and lightly brush your hand over the surface to remove the unwanted bristles.

Watercolor or gouache

Watercolor can be applied beautifully to pastel surfaces and can provide lovely passages of translucent color that might be left uncovered. The chal-

Table 4-1

Surfaces can be used for underpainting without mounting	Surfaces need mounting or mounting is advised	Surfaces cannot be used at all for underpainting
• Art Spectrum Supertooth • Ampersand Pastelbord • Richeson surfaces on Gatorfoam or masonite • Pastelmat • Canson Touch boards • Hand-made surfaces on Gatorfoam, mat board, or heavy watercolor papers	• Wallis white (both grades) • Art Spectrum Colourfix[1] • Richeson paper • Townsend paper • Canson Touch paper	• La Carte • Canson Mi-Teintes

1 If water is used, the paper may buckle; alcohol can generally be used on unmounted paper.

Fig. 4-14. *Beach Trees* 18" x 24" Gatorfoam with ground.

This painting was done on a very rough board. Note how the dark underpainting shows through in the foreground, giving an added dimension to the layers of red orange on top. An underpainting is a big help on rough surfaces as it would be difficult to fill in the white surface with pastel strokes alone.

Fig. 4-15. *Spring Song,* 16" x

Fig. 4-14

lenge to watercolor is that it fades and it's hard to keep the values right in the underpainting. In order to get rich darks, use very little water and apply multiple applications to build the desired color and value. I use watercolor in differing ways. Sometimes I use it for the entire underpainting. Other times I use it for the sky and areas where I do not want to apply a lot of pastel. (See Figure 4-15.)

Gouache underpaintings can be richer than watercolor. But due to the opaqueness of gouache, translucency will be lost.

Oil or acrylic washes

When oil or acrylic paints are used as an underpainting, they must be highly diluted so as not to fill up the tooth of the paper. If too thick, the oil medium will not dry for a long time. I have not used acrylic paint, but I do use liquid acrylic, thinned with water. Occasionally, I have used too much, making the surface slick and not accepting of the pastel. When properly applied, this medium can provide a rich, bright underpainting.

Figures 4-16 through 4-18 provide three incomplete and quick studies done for my class to show how pastel would look when added over underpaintings using these different media. The surface is Art Spectrum "super tooth."

TIPS ON CREATING SUCCESSFUL UNDERPAINTINGS

The type of underpainting and medium used to do the underpainting can vary from painting to painting, or you might choose to always use the same ap-

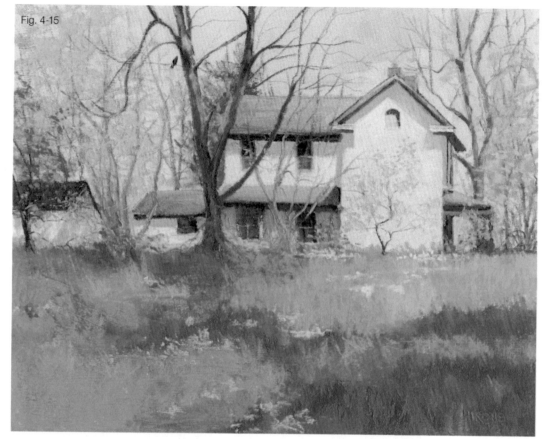

Fig. 4-15

20" Gatorfoam with ground. I started with a water color underpainting and liked the way the blue of the sky came out. I decided not to paint over it with pastel.
Fig. 4-16. Hard and soft pastel added to a

Fig. 4-16

Fig. 4-17

Fig. 4-18

hard pastel underpainting. The rich darks in the background and shadows work nicely for the subsequent applications of pastel.

Fig. 4-17. Soft pastel added over watercolor

underpainting. Notice how light the background is and how the darker pastel doesn't work as well over it. I should have used a lighter pastel to bridge between the light underpainting and the desired darkness. However, I am able to leave the watercolor in the lower left foreground without using any pastel at all.
Fig. 4-18. In this third example, I used liquid

acrylic, using a rich blue against which the bright red orange and yellow greens really stand out.

proach. A mixed approach of styles and media can also be employed within a painting. There are no rules for doing underpaintings, Remember: the underpainting is there to help. But here are some tips to consider.

- When doing a values-based block-in, it is important to **avoid hard edges**. Brush carefully so that one color transitions into another. A dark, hard edged underpainting may be hard to cover with pastel.

- When using pastel for the underpainting, **use only hard or medium hard pastel sticks**, such as Nu-Pastel or Rembrandt. Do not use Girault with alcohol as it is very granular and produces streaks, not blocks of color.

- **How much color** to add is often the question of the beginner. You want to produce a rich underpainting that has enough color to assist in the final painting. Weak, thin applications of color that produce very light underpaintings are generally not very useful, unless the entire painting will be very light. On the other hand, you want to avoid adding too much pastel, which might fill in the tooth and look cakey. If unsure, start with a lighter approach; you can always add more.

- If using an oil or acrylic wash, be sure to **add enough solvent** so that there is no solid paint being applied to the surface. If it is oil, it won't dry and applications of pastel will create a gummy mess! But again, be sure that there is enough color to be useful.

- Since watercolor fades, I often **add more watercolor** to the underpainting, once the first application has dried.

No one medium is perfect. If you want to main-tain the appropriate values in an underpainting, hard pastel is best, as you can choose the right value to begin with. The hard pastels can produce rich, dark underpaintings that are great for the dark passages of the painting. However, the lighter pastels, because they contain so much white, can look very chalky and dull once melted. So I might use watercolor for the sky or areas I do not want to apply a lot of pastel to, and hard pastel in the darker areas. In still life, I am more likely to use liquid acrylic or a dry underpainting of pastel to give more excitement to the picture. It's OK to mix and match.

A further consideration is the importance of the initial amount of drawing. Pastel underpaintings cover your drawing, while watercolor underpaintings allow the drawing to show through. This can be critical if you've spent a lot of time on the initial drawing.

Think also about where you will be painting. My choice of which medium to use often relates to where I'm doing the painting. When painting outside, it is easiest to use hard pastel or watercolor. In the studio, I might use the liquid acrylic or oil wash. Acrylic paints dry quickly and unused paint needs to be quickly washed off the working pan, unless using disposable plates. There's also a limit as to how much you want to carry outside. Using hard pastels and a small bottle of alcohol can be the easiest and most lightweight approach for *plein air* painting.

Once you have chosen a style of underpainting and the medium to be used, there is the all important question of what colors to use. For that, see Chapter 11.

SUMMARY

- Toning a surface provides maximum flexibility to the artist.
- Be sure that the surface can take wet applications without buckling.
- Underpaintings provide a broad, abstract beginning to a painting; they can be wet or dry.
- Wet underpaintings provide underlying color without losing the tooth of the surface.
- There are many ways in which to create underpaintings.
- There are various media that can be used to create underpaintings.

EXERCISES

☐ Choose a simple subject, such as a piece of fruit, and put it on a colored napkin. On white pastel paper that will take water, draw four boxes, about 4" x 6." Draw the subject in each.

a. First do an underpainting using one pastel stick and a solvent. Use more pressure where there are darks and less pressure where there are lighter areas.

b. Next, draw the subject and break it into shapes of value (see Chapter 7). For each value choose a single color and apply that color wherever that value appears. Use only one stick per shape. Then use a brush and solvent, being sure to keep the edges of the shapes loose.

c. In the third box, draw the shapes again by value, but this time mix warm and cool colors within each area and melt with a brush. The result should look quite different from the second exercise.

d. Finally, try using a wet medium, such as watercolor, to lay in color more loosely, based on the composition.

Now, paint with pastel over each of the four underpaintings. Can you determine whether one or two seem to work better than the others?

☐ Purchase several types of white surfaces, such as Wallis, Colourfix, Supertooth, or Pastelbord.

Do a small underpainting of your choice on each, then add hard and soft pastels to determine the feel and texture of the surface

Which surface worked best? Might the different surfaces be better for different uses? Consider your preferred stroke and application of pastel, as well as the type of pastels preferred, when considering which surfaces might work best.

☐ Using a single surface, such as white Colourfix, do three small underpaintings using hard pastel melted with: 1) water, 2) alcohol, and 3) mineral spirits or, Turpenoid. Which worked best?

☐ Try toning a surface using one or more colors of a wet medium.

☐ Do a dry underpainting on a white or neutral surface, such as Wallis "Belgian gray." Spray with workable fixative.

Chapter 05

PUTTING IT TOGETHER TO DEFINE A *LOOK*

By knowing how various types of pastels work on certain surfaces, as well as the variety of techniques that can be employed, the pastel artist can define his or her own look. If you do not already know how you want your paintings to look, I recommend a period of experimentation.

n this chapter, I define some of the *looks* that can be achieved in pastel paintings. Where possible, I discuss types of materials and techniques that I think enable the look. While the accomplished artist can probably achieve a desired look using almost any of the materials, I offer suggestions on materials that make it easier.

THE VIGNETTE

A vignette is a drawing or painting, generally done on a toned surface, where some portion of the surface is left untouched. If 80% or more of the surface is untouched, it is a drawing; if 80% or more is covered with pastel, it is considered to be a painting.

Vignettes are particularly popular for portraiture. Using a toned paper, the artist creates the portrait, being careful not to smudge pastel on the areas of paper to be retained unpainted. The figure often gradually disappears into the tone of the paper.

Artists who create portrait vignettes often prefer less textured surfaces, such as the smooth side of Canson Mi-Teintes. When a soft, beautiful look is desired for a commissioned portrait, artists generally do not want the surface texture getting in the way.

The primary technique is direct application of pastel over a light graphite or charcoal drawing. Any kind of stroke may be used. In order to keep the sur-

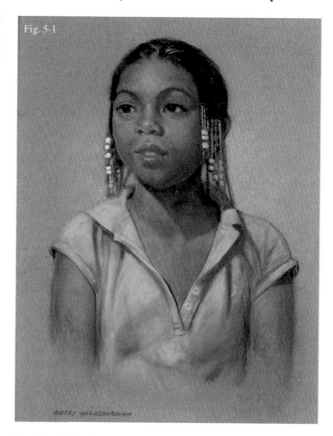

Fig. 5-1. *Sitting Pretty*, by Betsy Goldsborough, 17" x 14" Canson Mi-Teintes.
This is a typical vignette with the body fading into the surface below and no pastel around the figure. The light, neutral surface allows the darks of the hair, warm skin tones, and vibrant turquoise blouse to really sing. Note the pieces of turquoise in the hair and beads. Goldsborough began with a charcoal drawing that was sprayed with workable fixative. She then worked from hard to soft pastels, building up the layers of color.

Fig. 5-2. *Leaf study,* by Susan Due Pearcy, 10" x 14" Colourfix. This vignette is a *pastel drawing* as more than 80% of the surface has been left unpainted.

Fig. 5-3. *Still Life with Garlic and Cherries,* 11" x 10.5" Wallis "Belgian gray."

I sometimes like to leave part of the surface uncovered. Here, I suggested background color but didn't complete it. I'm not sure whether this qualifies as a vignette, but I like the unfinished look. For another example, see Fig. 11-14.

Fig. 5-4. *The Distraction,* by Elroy Williams, 12" x 16" Canson Mi-Teintes

Williams uses a circular, free-form stroke to begin his painting, building gradually with many colors of hard NuPastels to final layers of softer Great Americans. His lines are very evident throughout the painting.

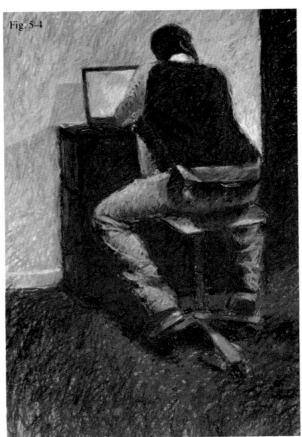

face areas clean and unsmudged, be sure to position the work straight up or with the easel tilting forward.

A variety of pastels may be used, but the artist generally begins with hard pastels and is careful not to move too quickly to soft. Medium hard pastels, such as Rembrandt, are often popular for portraits. Surfaces such as Canson Mi-Teintes, Colourfix, Pastelmat, and La Carte are all conducive to vignettes.

THE LINEAR LOOK

The linear look derives from the build up of linear strokes, either straight or curved, applied in many layers of broken color. Strokes such as cross-hatching and scribbling, as described in Chapter 3, may be employed. The gradual build-up of many strokes results in a richly embroidered texture of colors and lines. At least some of the strokes remain visible and these give vitality and a dynamic quality to the painting.

Most types of surfaces can be used for this approach, but the very highly textured or the really soft *pastel grabbers* are probably not the best. Colourfix, La Carte, Pastelmat, Pastelbord, and Canson are good choices. Since many lines will be added, hard pastels are the best place to start, slowly building to softer pastel (if used).

A toned surface is probably best to provide back-

Fig. 5-5

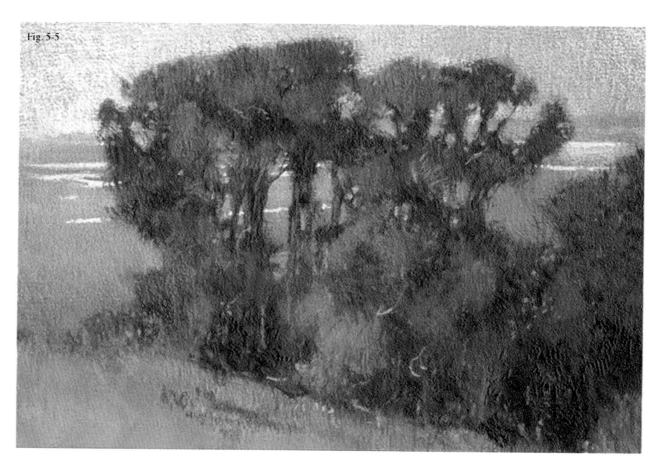

Fig. 5-5. *Eucalyptus*, by Duane Wakeham, 19" x 29" Arches 300lb cold-pressed watercolor paper with ground.

Wakeham is one of the premiere painters of the textured look. It is most evident in the sky and distant marsh, but can also be seen throughout the painting. The texture comes from the watercolor paper, to which he brushes on a mixture of gesso, water, and pumice. He finds that the irregular texture works well with his technique and likes the way the gesso provides a sturdy board-like support. He tones the board in a mid-value range; in this case burnt sienna. Wakeham next applies an underpainting of the basic shapes using a single color of hard pastel in any one shape. This is melted with denatured alcohol. Over that, he applies hard pastels, moving to Rembrandts when a greater variety of values and chroma are needed. Soft pastels are added only at the end.

ground color for the direct application of pastel. Linear strokes can also be placed over scumbled color or underpaintings. The primary feature is that the lines are visible in the finished painting.

THE TEXTURED LOOK

This look is created primarily by the surface rather than the stroke. The rougher the surface, the more broken is the color, and the more the surface or underlying colors will show through. This can cause a shimmering look and can be very effective if achieved uniformly throughout the painting. The artist may use a toned surface or do an underpaint-

ing. The more textured the surface, the easier it is to accomplish this look. Surfaces such as Colourfix, Richeson sanded papers, watercolor papers coated with ground, and hand-made brushed-on surfaces en-

Fig. 5-6. *A Truer World #13,* by John Davis Held, 16" x 19" Townsend paper.
John Held creates paintings of skies from his imagination, using lightly textured paper created by Diane Townsend. This allows him to carefully blend the color with his fingers without stifling the beauty of the pastel. Note the gradual transition of color in the sky and the soft edges. There is little evidence of strokes in these paintings, but the contrasts are very eye-catching.

Fig. 5-7. *Changing Channels,* by Michael Kolasinski, 12" x 24" Colourfix Liquid Primer rolled on archival foam board.
Kolasinski works on a surface toned with mid-value reddish brown to provide contrast. He starts with Richeson hard sticks or NuPastels, then moves to a mix of soft pastels, including Ludwig, Unison, Sennelier and Schmincke. He blends only with his pastels, applying rich applications of pastel strokes to produce a very painterly look. He says, "if I want an area to recede or to appear flat, I'll sometimes push the pastel into the surface with my finger to create this effect. However, I prefer to let the light bounce off the pigment particles, providing the glow I'm after." He does not use fixative, fearing that it will flatten the pastel.

Fig. 5-6

able this look. Heavy watercolor paper with ground is the roughest, yet softest, surface of this type that I have experimented with.

Recommendations for this approach:
• Stick to the hard pastels for as long as possible, moving gradually to the intermediates. Soft pastels will fill in the tooth quickly and may not be used at all or only for accents.
• No brushing off! Plan your composition and values ahead of time. Brushing off will kill the background color and the area will look dull in comparison.
• No finger blending. The point of this look is to have color showing through, so blending is definitely out!

• One must work from dark to light; dark applied over light in these surfaces becomes muddy and dull.

THE BLENDED LOOK

One of the attractions to pastel for many artists is its ability to be blended, creating soft transitions between colors. This is particularly appealing for skies and skin tones. The signature feature of this style is the lack of evident strokes in a large part of the painting. The artist may blend with the hands, blending tools, or with other pastels, as discussed in Chapter 3. Sanded papers, such as Wallis and UART or other less textured surfaces, such as Townsend and Can-

son papers, are best for blending. Pastel also blends beautifully on La Carte, but not as well on Pastelmat, which is more resistant.

While the artist may begin with harder pastels, it is generally the soft pastels that are used to create the blended areas.

Artists may combine blended with unblended color. But the overall effect is one of seamless color transition.

THE OIL PAINT LOOK

This is probably the most common look to be found in pastel today. I describe this style as one in which the surface is richly developed with broad strokes of color, with some of the strokes apparent to the viewer (as opposed to the blended look). While a little of the background might show through in places of less build-up, other areas are more thickly defined. When framed without mats and with museum glass, these paintings look very similar to those created with oils.

Sanded papers like Wallis and UART are popular, but almost any surface will work except the most highly textured or those with little tooth. It depends on how much layering one wishes to do or whether one prefers to add bold strokes of color. If more layering is desired, Colourfix and Pastelbord are good choices. Wallis, UART, La Carte, or Pastelmat enable

Fig. 5-8. *Winter Cornfield,* by Joyce Lister, 14" x 19" Colourfix.

Lister's paintings frequently exhibit a high degree of energy from the strength of her strokes.
For this painting she chose dark brown Art Spectrum Colourfix for its toothiness. She also felt that the color would provide a good underlying value for the rolling hill of corn rows zigzagging back in space with an alternating dark/light pattern of snow and earth. She used only soft pastels for this piece.

Lister says of herself "I am not the kind of person who always uses the same materials and/or employs the same techniques. I like to try new products and enjoy using many different sanded surfaces and brands of pastel. I find that there is no one particular surface or type of pastel or procedure that I use all the time. I like to experiment, and yet, I believe my paintings have a consistent look and feel."

bolder strokes. Underpaintings are frequently employed, but are not essential.

Hard or medium hard pastels are often employed to begin the painting, but the beauty of this look comes from the soft pastels. Buttery pastels, such as Schmincke, Great American, and Terry Ludwig are vital to achieving such an impact. But intermediate pastels, such as Girault, can play an important role in transitions.

THE BOLD STROKE LOOK

This is a variation on the *oil paint look* where the strokes are more prominent, giving the painting a dynamic quality. The entire surface is normally covered in a painterly way. The materials and techniques are similar to those that create the oil paint look, but the strokes are more pronounced. Highly textured surfaces (such as Arches water color paper) might not be the best for this technique, however, hand-prepared, brushed-on surfaces are frequently employed. Soft pastels are a must.

Fig. 5-9

Fig. 5-9. *Bowl with Lemons*, 11" x 14" Gatorfoam with ground.

I applied two coats of clear Colourfix liquid primer to Gatorfoam. I next toned the surface with varying colors of liquid acrylic, paying attention to where the darks and lights would be. In the painting, Soft pastels were used richly to build up the bowl and lemons, but more loosely over the the acrylic in the negative spaces, allowing much of the acrylic to show through. The yellow ocher at the top of the painting is all acrylic.

THE MIXED MEDIA LOOK

This look involves the use of media, such as watercolor, in addition to pastel. The most well known proponent of this style is Richard McKinley. His beautiful watercolor or oil wash underpaintings and delicate applications of pastel have been enchanting artists and collectors for years. These are not *mixed media paintings*, they are pastel paintings (the 80% rule works here as well). But by taking advantage of the translucency of watercolor and the opaqueness and brilliance of pastel, the artist can produce a painting with variety of surface and texture.

A challenge with a watercolor underpainting is the tendency to cover it all up. The primary problem is that watercolor fades and unless you produce a really rich underpainting, the overlay of pastel will not work. It may look too dark and opaque (see Figure 4-17). I find that using Girault pastels, a favorite of McKinley, is one of the secrets to successfully using watercolor with pastel. The grainier Giraults come in lovely, soft grayed colors that can be used as a *bridge* between the underpainting and the softer pastels. Another solution is to use pastels that are close in value to the watercolor in areas where there is a transition from watercolor to pastel. In the center of interest and areas that will be richly covered with pastel, darker, softer sticks can be used. For examples that use watercolor underpaintings, see Figures 6-4, 11-13, 11-14, and 13-9.

Fig. 5-10. Wimpy pastel. Hard pastel lightly applied on textured side of Canson Mi-Teintes.

Fig. 5-10

The surface is also important. For some time, I added watercolor underpaintings to a handmade board. Over time I realized that the surface was too hard to fully accept the watercolor. Surfaces such as white Wallis, Pastelbord, Supertooth, or Pastelmat are much better for this approach, as they absorb the watermedia better and can support the creation of a rich underpainting.

I often also like to tone the surface with liquid acrylic mixed with water for a still life.

These are just some of the many looks that can be achieved in pastel. In addition, some of them can be combined in one painting. However, it is often best to keep a similar look throughout. Using a high degree of texture in one area and significant blending in another can give the appearance of two different paintings. If a particular look is to succeed, it must be maintained throughout the painting, to the best of your ability.

THREE LOOKS TO AVOID

Now that I have described a number of desirable looks, I want to discuss ways of avoiding some of the *not-so-good* looks that can become pitfalls of working in pastel.

Wimpy pastel. Wimpy pastel paintings consist of thin applications of relatively hard pastels, often

Fig. 5-11. Cakey pastel. The heavy applications kill the beauty of the pastel.

Fig. 5-12. Muddy pastel. Layers of soft pastel applied, darker over lighter. Note how muddy the blues look on the right.

applied to the textured side of a paper like Canson Mi-Teintes. Much of the paper shows throughout the picture, rather than in carefully defined areas. There is little variety in the richness of texture or stroke—it is weak and blah! I have always felt that such paintings give a bad name to pastel, as they simply do not display the beauty of the medium.

Not all lightly applied pastel is wimpy. Many artists are able to use soft applications to create a uniformly beautiful effect. When you see one of these paintings, you know that this is the look the artist was aiming to achieve.

To avoid creating a wimpy look, try using different papers and pastels, as well as different degrees of saturation when applying the pastel. Or, if using Canson, turn the paper over and use the smooth side. Often paintings that exhibit a wimpy pastel look are due to a lack of experience with the wealth of materials and techniques currently available.

Cakey pastel. This is the opposite of wimpy pastel. In this case, soft pastels have been used with too heavy a hand, making the surface appear dull and cakey. Some might refer to it as "chalky."

Avoiding a cakey look involves two things: 1) understanding the relative softness of surfaces and how they interact with varying hardnesses of pastel; and 2) learning to apply soft pastels with a light touch. For example, when using soft pastels on a sanded surface you can barely touch the pastel to the surface to apply a layer of color. If layering of multiple colors is

desired, one can repeatedly add more pastel as long as the touch is very light. Only in the final layers, where more saturated color is desired, should one push the pastel into the surface.

Muddy pastel. The term 'mud' is often used by pastel artists in relation to dull color. I use it most often to refer to the look of pastel when dark colors are applied over light. In pastel, one can work from dark to lighter colors beautifully. But when a large area has been painted too lightly and a darker-valued pastel is applied on top, the color appears muddy and dull.

Getting the values right at the beginning is the answer to this problem. If a large area of pastel has been applied and is too light, it is best to brush it off in order to add a darker color.

Muddy pastel can also result from repeated brushing off of the pastel, which can leave the surface dull and lifeless. This often occurs when the artist has little idea of what colors to apply and repeatedly brushes off one color, replacing it with another. If unsure about a color to use, try a very small piece of the color, rather than laying in a lot of it and brushing it off (see Chapter 10 on testing colors). Any unwanted small pieces of color can be easily covered by subsequent strokes of pastel. An even better approach is to do color studies, also discussed in Chapter 10.

SUMMARY

- By using a variety of pastels, surfaces, strokes, and techniques, artists can create an infinite number of looks.
- Your look is generally something that comes from within; but knowing about materials and techniques makes it easier to succeed.
- Avoid creating wimpy, cakey or muddy looking paintings by understanding your materials and how to use them.

EXERCISES

☐ Choose the looks that appeal most to you. Using small sheets of paper or board, try to emulate this look to see if it satisfies you.

☐ Using your favorite surfaces and pastels, work in a free manner to develop the style that best suits you. Keep good notes for reference. Decide what it is that comes naturally to you.

☐ If you want to experiment more, purchase the paper sampler from Dakota Pastels. Do small paintings on each surface, using different pastels and techniques, as appropriate, to determine which surface works best for you.

☐ Look through issues of the *Pastel Journal*, identifying paintings you particularly like. Try to identify the specific look of these paintings and learn more about the materials and techniques used to create them. Try integrating some of the approaches into your own work.

PART TWO

Painting Essentials And Styles

Part two covers three fundamental aspects of painting: composition, values, and edges. Also included are ways of further developing one's style through types of compositions, degrees of value differences, and variety of edges that are employed.

When I was beginning to paint, I remember starting a painting in the lower right corner of the canvas and immediately starting with the detail. The painting was obviously a failure! How one begins a painting is the most important part of the painting process. And, while pastel is forgiving, making too many changes as the painting proceeds will result in loss of tooth and muddy-looking paintings. Thus, determining the composition and values, as well as

making decisions regarding edges, are basic steps that need to be made up front.

While these determinations are important aspects of painting in any medium, I focus on how working in the medium of pastel might influence your approach to decision-making. For instance, in Chapter 6 on composition, I explore various styles of composition and how these can be achieved using different pastel techniques. Getting the values right is always critical; but there are also decisions you can make regarding the style of the painting and values, as discussed in Chapter 7. In Chapter 8, I explain a variety of styles for edges and the importance of materials in accomplishing a desired outcome.

Chapter 06 COMPOSITION

The composition is comprised of the various shapes and lines that form a painting.

A strong composition is the basis for all successful paintings. No amount of great technique or color will save a painting with a weak composition. As the focus of this book is on finding a personal style, the discussion on composition here must be limited. For more information, I highly recommend: *Mastering Composition* by Ian Roberts, and *Design and Composition of Paintings* by Margot Schulke (see Appendix B).

THE CENTER OF INTEREST

What is the picture about? When considering a subject for a painting, such as a beach in Hawaii, there are a number of questions to ask before you begin. What can I do to make this an interesting painting? Why have I chosen this particular view of the beach? What is it in the picture that I want the viewer to see--is it the light hitting the crest of a wave, a bright red umbrella, or the side of a beach house in the dunes? These are all potential *centers of interest* for a painting. Note that the center of interest does not need to be a particular object, but can be an area of the painting or a portion of an object. Note that when buildings, people, or animals are added to paintings, they often automatically become the center of interest, whether intended or not. If you really can't find any area to emphasize in a representational painting, it might be best to choose another subject.

Why is it important? Determining the center of interest is key to planning the entire composition. Knowing where you want the viewer's eye to go allows the painter to manipulate the shapes and lines in the composition to lead the eye to that area. Once determined, the center of interest can be enhanced. Can you see ways to *"push'* the light in the area to make it more dramatic? Can the color be intensified to give it more interest? Likewise, other areas of the picture can be altered so as not to detract.

What is the best location for the center of interest? One of the *rules* of composition is to avoid placing the center of interest in the middle of the page. One way to accomplish this is to imagine or lightly draw lines that divide your picture plane into thirds vertically and horizontally. A painting is more appealing if the center of interest is located in one of the areas where the lines intersect.

Must I have a center of interest? Not all paintings have a center of interest. Abstract paintings often rely more on a flow of connecting color shapes of different values and intensity to lead the eye on a journey through out the art work. The center of interest is more commonly used in representational paintings. I find that the style of painting determines the relative importance of the center of interest. If you have a composition with intriguing shapes and a good flow of value and color throughout, a strong center of interest is not as essential.

Fig. 6-1. *Tidal Marsh,* by Joyce Lister, 18" x 24" Gatorfoam and ground.

Lister says: "I am most concerned with composition—the arrangement and pattern of dark, light and middle values on the picture plane and the visual path in and around the painting. I usually do not think about the center of interest until the painting is near completion." In this painting, the sharp lines and value contrasts of the meandering waterway and linearity of the docks, and fences lead the eye to the light colored boat houses against the dark foliage.

Fig. 6-2. *Elkhorn Slough,* by Duane Wakeham, 19" x 29" 300lb Arches cold-pressed watercolor paper with ground.

Wakeham is known for his strong compositions. He says: "All of us probably have our own criteria for what makes a successful painting. For me, perhaps the most important consideration is a strong underlying abstract structure both in terms of division of space and placement of shapes, as well as in distribution of color. That structure, which is composition, exists separately from subject matter and technique, and neither choice of interesting subject matter nor beauty of technique is sufficient without well-developed composition."

Fig. 6-3. *Photo reference for Elkhorn Slough.*

Note the significant changes in composition, as well as color, from the source photo. Wakeham used the photograph to generate an idea that was developed into a composition of much greater strength.

COMPOSITIONAL STYLES

I define two basic compositional styles for representational paintings based on how I compose my own paintings and my perception of composition in paintings by others:

- The center of interest painting
- The big shape painting

Center of interest paintings

The oil paintings of Richard Schmid (www.richardschmid.com) most clearly demonstrate what I mean by *center of interest painting*. Whether painting a portrait or a still life, Schmid focuses attention on the face or other primary area of interest by using masterful strokes of color to develop sharp edges, and renders the rest of the painting with less detail in broad strokes of paint. In some cases, his canvas is not completely covered. This style leaves no question about what is most important. Pastel artists who often use this approach include Albert Handell and Richard McKinley.

Using underpaintings of watercolor or oil wash can be important to accomplishing such paintings. The center of interest is painted with saturated strokes of pastel, leaving the thinner applications to fade out over the underpainting toward the edges of the picture.

BIG SHAPE PAINTINGS

While the center of interest is still important in big shape paintings, their success relies on the quality and connections of the shapes and values that flow throughout the picture. More often, the entire surface will be covered with pastel.

Fig. 6-4. *Ice, Phone* 10" x 20" Wallis museum grade white.

This is an example of a center of interest painting. I found the perfect subject matter: two adjacent and colorful derelict trucks with a third one near by. Using a watercolor wash to begin the painting, I was able to focus on the pair of trucks to the left as the center of interest, painting them in detail with rich applications of pastel. Notice how the truck to the far right of the painting is only suggested, as if a ghost.

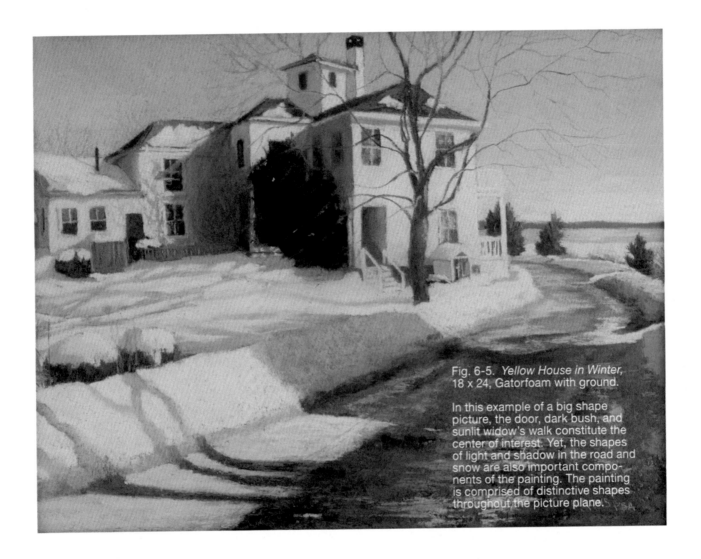

Fig. 6-5. *Yellow House in Winter,* 18 x 24, Gatorfoam with ground.

In this example of a big shape picture, the door, dark bush, and sunlit widow's walk constitute the center of interest. Yet, the shapes of light and shadow in the road and snow are also important components of the painting. The painting is comprised of distinctive shapes throughout the picture plane.

Deciding on which style to use is an important consideration at the beginning of the painting process. For me, the commitment to a style determines the surface to be used and the techniques to be employed, particularly when using an underpainting.

Figures 6-6 and 6-7 show still life paintings based on the same set up. Figure 6-6 is a *big shape* painting, while Figure 6-7 is a *center of interest* painting. While very different, both are successful interpretations. Note also the difference in orientation (horizontal vs. vertical).

COLOR AND COMPOSITION

Regardless of the style of a composition, color is one of its key components. You can use pieces of the same color to lead the eye through the picture. An area of saturated color can be placed in the center of interest, with smaller amounts of this color added in other parts of the painting to lead the eye to the center.

Color can also be used to unify the picture, either by letting a background color show through or by add-

Fig. 6-8

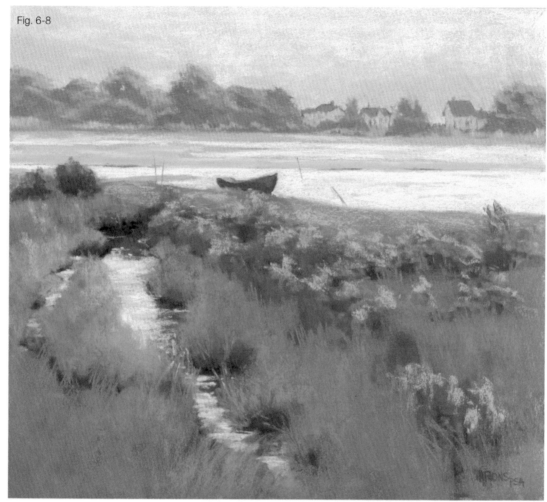

Fig. 6-8. Red Dory, 16" x 20" Pastelbord.

The light yellows and soft red violets are the unifying factors in this painting. The yellow in the foreground water leads the eye to the area of horizontal yellow water and the dory, which is the center of interest. The sky is also painted with yellows and the rooftops are all the same subtle red violet, tying them to the red violets in the foreground bushes and boat.

ing strokes of the same color throughout consistently in the picture. It is important not to isolate a color by using it in a single place. Even a very small hint of the color elsewhere will balance the painting. However, be careful not to put bright colors near the edge, where they will lead the eye out of the

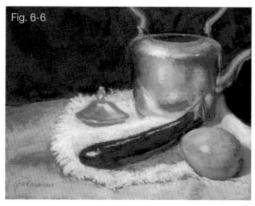

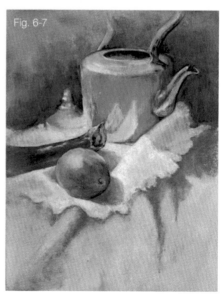

Fig. 6-6. Still Life with Eggplant, by Grace Newcomer, 9.25" x 11.75" Colourfix.

Fig. 6-7. Still Life with Eggplant, by Sharon Butrymowicz, 14" x 11" Pastelbord.

picture plane.

An important role for color in very busy compositions is to give the eye a place to rest. The painter Eduard Vuillard, a late 19th century French member of the Nabis, created paintings of people in interiors filled with patterned cloth, wall paper, and household objects. In many of these paintings, he employs a piece of saturated, unpatterned color to break up the detail and give the eye a resting spot.

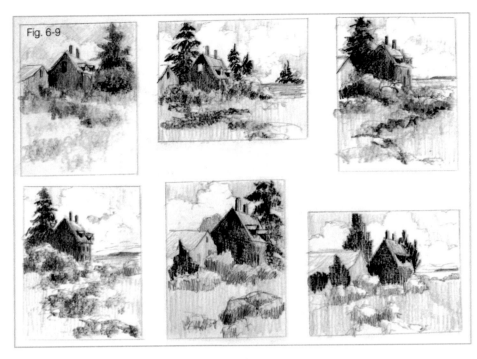

Fig. 6-9. Compositional studies of the Olson House. I completed a number of studies on this subject, trying out different placements of the tall tree, as well as vertical and horizontal arrangements. This is the home in Maine of Christina Olson, painted many times by Andrew Wyeth.

COMPOSITIONAL STUDIES

Compositional studies are small drawings that help the artist to quickly determine whether a composition is strong or in need of change. They can be done with a variety of drawing media.

Compositional studies help to determine:

- Size and shape of the composition.
- Orientation: vertical or horizontal.
- Placement of the center of interest.
- Type of composition (center of interest or big shape).
- Ways of simplifying and strengthening the composition by omitting unneeded objects, changing shapes, or emphasizing important lines.
- The surfaces, pastels, and techniques to be employed in the painting.

When doing one or more studies, it is important that the sketches be proportional to your painting surface. You might begin with a pre-determined size when working on boards or mounted surfaces. Or you can draw the composition first, cropping later with lines to form a box of any size. (The latter method may result in non-standard sizes that might influence your framing.) See Figures 6-16 and 6-17 for instructions.

I often find it difficult to fit buildings into pre-set small boxes. There is a tendency to make the buildings too large and they quickly fill in the box of the study. Later, when I lay in the composition on the larger pastel surface, there is more room available and I have to adjust the composition. For this reason, I sometimes prefer to draw the composition first, cropping with lines once complete, as in Figure 6-15.

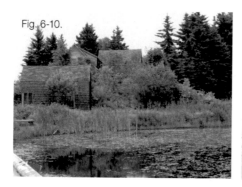

Fig. 6-10.

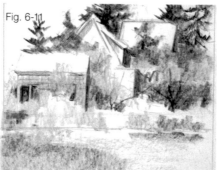

Fig. 6-11.

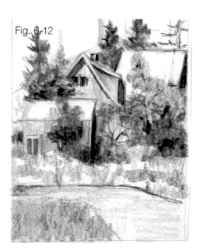

Fig. 6-12

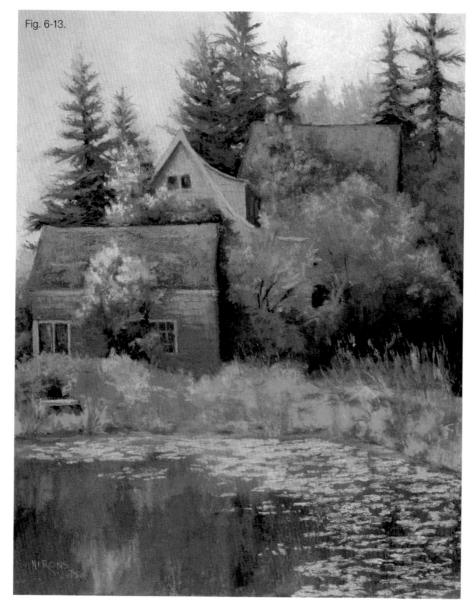

Fig. 6-13.

Fig. 6-10. *Source photo for Owls Head Reflections.*

On first glance, the composition in the photo isn't very exciting. Yet the grouping of buildings with the dark trees and the reflections in the pond interested me, as well as the scene's textures and colors. I began with a horizontal study, next exploring a vertical composition. I opted for the vertical, once I realized that my interests were in the dark, pointed fir trees, the peaked central roof, and the reflections in the pond, all being vertical lines. In the painting, I extended the trees and emphasized the roof's curvature.

Fig. 6-11. Horizontal study.

Fig. 6-12. Vertical study.

Fig. 6-13. *Owl's Head Reflections,* 20" x 16" Gatorfoam with ground.

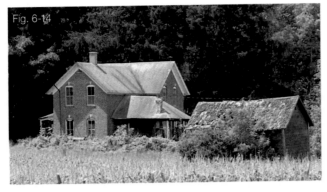

Fig. 6-14.

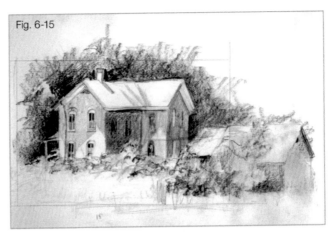

Fig. 6-15

Fig. 6-14. *Source photo for House by the River.*

Fig. 6-15. *Compositional sketch for House by the River.* I drew the house and barn as I saw them in the photo, but omitted the first story roof on the house and made the buildings straighter (less likely to collapse!). I then added lines to crop the picture. I decided not to include the entire barn, because I wanted to emphasize the house. However, I liked the fact that the barn was in the foreground, adding depth to the composition. For the completed painting, see Figure 11-18.

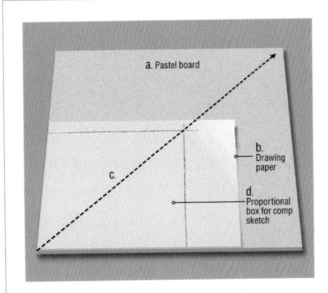

Fig. 6-16. Beginning with pre-determined sized board

a. Lay board on flat surface.

b. Place a sheet of drawing paper in the lower left corner that is smaller than the board.

c. Position a straight edge from the lower left corner of the drawing paper to the upper right corner of the board. Draw a line across the drawing paper.

d. Make a box of any size by adding vertical and horizontal lines that are connected to the diagonal line on the drawing paper. The box will be proportional.

Fig. 6-17. Beginning with a compositional sketch

a. Once lines have been drawn around the composition, cut the sketch and place on a sheet of pastel paper in the lower left corner (b.)

c. Position the straight edge so that it intersects the lower left and upper right corners of the sketch. Draw the line onto the pastel surface to any point.

d. Connect with vertical and horizontal lines to create a proportional box that will contain the painting.

SUMMARY

- Strong compositions are the key to successful paintings.
- Determining the location of the center of interest and its importance to your composition is a first step in deciding how to proceed with the painting.
- Two styles of composition are: Center of Interest and Big Shape Paintings.
- Compositional sketches can be used to make many of the important decisions regarding the painting, such as the orientation of the picture plane and what elements will be omitted to simplify the composition, as well as the surface to be used.
- Color placement is also an important aspect of composition.

EXERCISES

Working from life

☐ Use a viewfinder to observe your subject (a still life, landscape, etc.). Try cropping it in different ways. Do vertical and horizontal studies.

☐ Using a subject of your choice, draw the entire composition. Use mat corners or pieces of white paper to experimentally crop it in different ways to identify the most dynamic composition.

Working from photographs

☐ Simplify the subject by doing multiple drawings of it, each time omitting unnecessary details and focusing on the basic shapes. Do this until you are happy with the composition.

☐ Do different compositional studies from one photo, cropping them in different ways.

☐ Piece together two or more photos to create a strong composition that integrates them all.

Working from memory

☐ When outside, look carefully at a scene and memorize the basic shapes and flow between light and dark areas. Do a drawing of the scene from memory. Do not worry about the loss of detail.

Working from others' paintings

☐ Choose one or more artists whose work you admire. Do compositional studies based on their paintings, establishing the basic shapes and lines in their compositions.

☐ When looking at the work of artists you admire, determine whether the compositions focus on the center of interest or the quality and flow of shapes.

Developing your style

☐ Consider the compositions you most often like to paint. Would you consider them to be center of interest or big shape paintings?

☐ Paint a center of interest painting where certain areas of the picture are left less defined to determine whether this fits your style. Next, do a big shape painting. Which of these styles feel more comfortable to you?

Chapter 07

VALUE MASSING AND INITIAL LAY-IN

The term *value* refers to the degree of lightness or darkness of a color, as defined by a 10-point gray scale. Establishing proper values is critical to developing strong compositions in all media. It is particularly important in pastel because of the need to work from dark to light and to avoid too much brushing down of color. Thus, paying careful attention to values at the beginning of the painting process is critical to creating successful paintings.

alue masses are shapes of the same value. These shapes can comprise parts of different objects and negative space, and they can be made up of different colors. Seeing objects for their similar values throughout the composition is the main consideration in the value massing process. For example, in a still life, a shadowed area of a bowl and its adjoining background might be considered as one value mass.

SEEING IN TERMS OF VALUE

In order to see compositions in terms of value masses, the following approaches are helpful:

• Turning color into shades of gray
• Reducing the many values we see to four groups — dark, mid-dark, mid-light, and light
• Seeing value shapes instead of discrete objects and colors

Turning color into shades of gray

A convenient way to reduce colors to grays is to use a tool such as the 3-in-one Picture Perfect View Finder (Figure 7-1). This handy tool allows you to view a subject through a red filter that turns colored objects into different shades of gray values, thereby reveal-

ing value masses. Note that this tool's clear windows have been divided into horizontal and vertical thirds with intersecting diagonal lines indicating appropriate places for the center of interest. I use this for all of my plein air and still life paintings. It allows me to quickly see shapes of dark, light, and mid ranges, as well as to identify and place the center of interest.

If lacking a viewfinder, an alternative technique is to squint at the subject. This helps to eliminate details and blur colors into shapes. Another way of seeing values is to identify the darkest shape and compare it to other relatively dark shapes in the subject

Fig. 7-1. Picture-Perfect 3-in-1 View Finder.

area. Do the same thing with the lightest shape.

When working from a photo, it is helpful to turn it into black and white, either with the computer or a copier. Remember that in many photographs, dark shadowed areas will be too dark and flat, and the lights will probably be too white. However, a black and white photo can help you see value patterns in complicated areas such as foliage or shadows on a figure. It can be an excellent aid in recognizing a subject's potential for value massing.

Reducing values to dark, mid-dark, mid-light, light

The eye is very sensitive to values. The gray scale (Figure 7–2) allows you to identify 10 values ranging on a gradient from black (0) to white (10). When doing a values study, it is best to use no more than four values, with a possible fifth value being the white of the paper. Use whatever viewing tools are available to reduce the subject matter to value shapes. Define the shapes in terms of light, mid-light, mid-dark, and dark. Reserve the darkest darks and lightest lights for accents and highlights. For landscapes, unless doing night scenes, it is best to keep large dark masses to value 3 or higher.

Note: because pastel artists work from darker to lighter values, beginning with a slightly darker

Fig. 7-2. The gray scale, along with marks made by four gray shades of Tombow pens. Tombow pen color 95 is the rough equivalent of value 9 (light); 75 is the equivalent of value 7 (mid-light); 65 equates to value 5 (mid-dark); and 45 equates to value 3 (dark).

value—either in an underpainting or in the initial applications of pastel—can be a useful approach. Do not begin the lighter passages of the painting too light, or there will be no place to go!

Seeing in terms of value shapes instead of discreet objects and colors

Identifying value masses creates an abstract underpinning for a composition. By defining value shapes that connect parts of adjoining objects, the resulting shapes become stronger and more abstract.

Color can be a distraction in seeing values correctly. If an object is bright red and another is a dull green, it may be hard to see that, while one is brighter

Fig. 7-3

Fig. 7-4

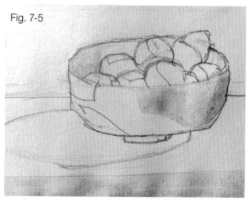

Fig. 7-5

Fig. 7-6

Fig. 7-3. Color photo of a bowl with mineola oranges.

Fig. 7-4. Black and white photo. The black and white version allows you to see that the shadowed areas of the bright colored oranges are close to the value of the inner side of the grayed blue-violet bowl. Also note how the left outer edge of the bowl disappears into the shadow cast on the table.

Fig. 7-5. Compositional study. I began with the basic shapes of the bowl, table, cast shadow, and oranges within the bowl. Next I indicated lines for the shapes of the light and shadow on the bowl and oranges.

Fig. 7-6. Values study. I assigned appropriate values and filled in the shapes, choosing to make the shadow darker so as to lose the lower edge of the bowl. I used the white of the paper to indicate the brightly lit areas of the oranges.

in color than the other, the values are actually the same.

Seeing value shapes allows the artist to control edges, a technique used in creating *painterly* pictures. When adjacent objects are the same value, their edges will not be sharp. When the shapes differ in value, their edges become more pronounced. These "lost and found edges" can create very dynamic pictures within which light areas emerge from dark.

VALUES STUDIES

A values study is a *small* version of the painting that defines the value masses. Such a study can be a continuation of the chosen compositional study (as in Figure 7-6), or it can be done separately. As with the compositional study, the values study should be in rough proportion to the painting's dimensions. It is useful to keep values studies small so as to be able to quickly and easily fill in the shapes with the appropriate values.

Tools for doing values studies

- Use white drawing paper and one of the following:
- Graphite pencils in a variety from 2H to 4B or softer.
- Prismacolor markers in cool gray, using 10, 30, 50, 70.
- Tombow pens in various shades of gray, such as 95, 75, 65, 45.
- Four values of gray hard pastel.

Fig. 7-7. Vertical and horizontal studies for a landscape of road and trees. Graphite pencils were used to block in the value masses in the study at left; tombow pens were used in the study at right.

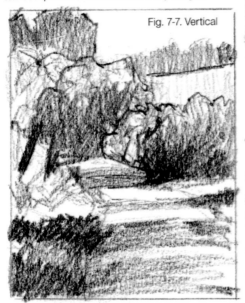

Fig. 7-7. Vertical

Fig. 7-7. Horizontal

- Vine charcoal.

Using graphite pencils for values studies can be a natural extension of the compositional study. However, it takes longer to build up the right value with graphite. Using markers or Tombow pens can be a lot faster and more definitive. But be sure to work from light to dark—once a dark mark is made, there is no going back! Using gray hard pastels can be more flexible, as they can be brushed off and changed if not correct. While I have included vine charcoal in the list and in the illustration, I find it less useful for

Fig. 7-8

Fig. 7-8. Tools for doing values studies. Tombow pens in four shades of gray, graphite pencils, a kneaded eraser and sharpener, soft vine charcoal.

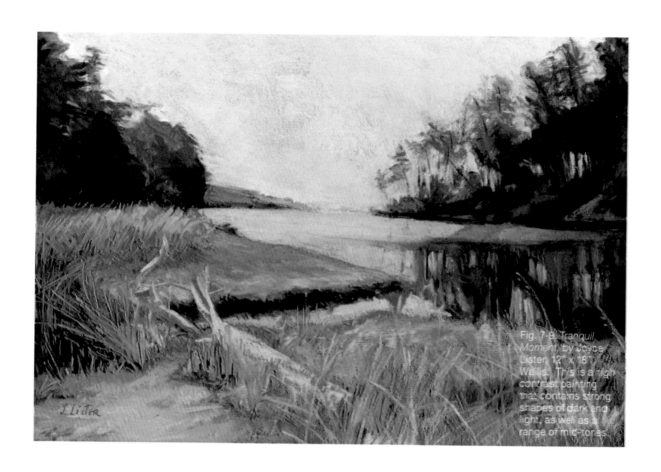

Fig. 7-8. *Tranquil Moment*, by Joyce Lister, 12" × 18", Wallis. This is a high contrast painting that contains strong shapes of dark and light, as well as a range of mid-tones.

values studies, preferring to use it for lay-in of the composition.

VALUES AND STYLE:
HIGH CONTRAST VS. TONALISM

The high contrast painting depends on strong darks and lights, along with a range of mid-values to create drama and interest.

Tonalism is a style that became popular in the 19th century. Artists such as Camille Corot, Bruce Crane, James McNeil Whistler, and John Twachtman created paintings with close value ranges and little contrast. Twachtman's snow scenes are very light, while Whistler's nocturnes are primarily on the darker side. Corot and Crane painted in mid-tones. Because these paintings use less contrasting value, they have a quiet, peaceful, sometimes somber appearance. The color is often more grayed, as opposed to the purer, brighter colors of the Impressionists.

Most paintings one sees today contain contrasting values that range from the very dark to the very light. I refer to these paintings as *high contrast paintings*. However, a number of painters prefer the quieter moods of *tonalist* paintings.

Contributors to this book who identify themselves as tonalists are Lee Kimball and Duane Wakeham. High contrast is the style I most often use, yet I

Fig. 7-10. *Woodland,* by Sharon Butrymowicz, 9" x 12" Wallis "Belgian gray." Note the midrange values in this quiet painting, where even the lights are not as light as they might be and the darks are limited to small accents.

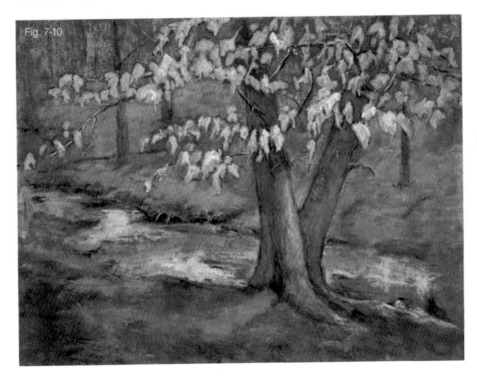

Fig. 7-11. Initial lay-in for *Still Life with Garlic and Cherries.* 2-H graphite pencil on Wallis Belgian gray. Direct application of pastel was used for this still life and the initial pencil drawing was kept to simple lines. This is the simplest type of lay-in. (The finished painting appears in Figure 5-3.)

find the subtle beauty of tonalist paintings to be very appealing. They often capture a sense of mystery and shimmering light that can be quite beautiful. Because pastel lends itself to both styles, it provides intriguing opportunities for the artist.

LAYING-IN THE COMPOSITION AND VALUE MASSES

Once the composition and value masses have been determined through small studies, the next step is to lay-in the composition, and perhaps the value masses on the desired surface. There are many ways to do this. Consider the following:

- Whether you intend to work on a toned surface or over an underpainting
- How much detail is required to represent the subject
- Your style of working in pastel (e.g., loose or more controlled)

Graphite pencils, hard pastels, pastel pencils, and vine charcoal are all useful drawing tools for suggesting major shapes and value masses. I generally prefer a 2H pencil or a piece of soft vine charcoal for the initial drawing. The graphite is best when the lines are critical, such as paintings with houses. When working on a

Figs. 7-12 and 7-13. The initial lay-in for this still life was done with a single dark blue hard pastel stick on white Pastelbord. Alcohol was used to melt the pastel and create value masses. The darks and lights were achieved through the varying degrees of pressure used when applying the pastel. This could also be considered a partial block-in underpainting. I added an additional underpainting over this lay-in.

Fig. 7-12

Fig. 7-13

darkly toned surface, a hard pastel or pastel pencil of a lighter color can be useful in order to see the lines. But try not to do too much erasing, as it will muddy the paper surface.

When working on a toned surface, artists are more likely to begin with a linear approach, drawing simple lines to indicate the major shapes of the composition. How detailed the lines become is determined by the complexity of the subject. This works well for landscape. If the subject includes a group of buildings with complicated perspective, or a face or figure for which the drawing is critical, the lines will be more carefully and intricately applied.

When painting a landscape with large areas of clouds, trees, or other objects, I often like to mass the shapes in initially with charcoal. A brush and water are used to wash the charcoal into the surface. At this point, the masses and shapes are evalutated to determine the success of the composition. If I am not happy with the results, it is easy to wash out the charcoal. Water-soluble or regular graphite can also be used in this way. If trying this approach, be aware that really heavy applications of charcoal or graphite can muddy the picture. Also, if you choose to leave parts of the painting less covered, as in a center of interest painting, do not apply charcoal in these areas.

Fig. 7-14

Fig. 7-14. Initial lay-in for *Sunrise from Crescent Beach.* Charcoal was used to lay in the clouds, houses and land masses, then washed into the board with water. An underpainting was added on top of the initial charcoal layer. (The finished painting appears on page 6.)

TIP: In order not to lose the initial drawing, work on a toned surface and add pastel directly to the initial drawing, without the use of an underpainting. Or, if an underpainting is desired, use watercolor and not hard pastel to allow the lines to show through.

SUMMARY

- Value massing creates abstract underpinnings for paintings.
- Establishing correct values at the beginning of the painting process is critical.
- There are tools that enable you to see value masses when working from life.
- Values studies are an important tool for establishing values.
- High Contrast and Tonalist paintings are two styles that leverage value differences.
- Laying-in the initial composition can be done in many ways and with different types of media.

EXERCISES

Value Massing

☐ Working from life (e.g., a still life), do compositional studies, choosing the ones you like best. Within the basic outlines of the objects, indicate lines for the different value shapes. Then, fill them in with varying shades of gray, using whatever tools are available. Be sure to fill in the background and connect similar-valued shapes.

☐ Working from a color photo, do a values study to determine the shapes of the major masses in the photo. If possible, change the photo to black and white and see how close your study resembles the black and white photo.

☐ Examine paintings you admire to determine whether they are high contrast or more tonalist. Examine how other artists have made use of value shapes.

☐ Do two values studies for the same subject: the first with highly contrasting values, the second with values that are closer together in the values scale.

Initial Lay-in

☐ Try different ways of adding your composition to the surface by drawing, blocking with charcoal, adding water to a block-in, or using the side of a hard pastel.

☐ Considering the type of subject matter you enjoy painting, determine if one method of laying- in the composition is preferable over another, or if a mix of approaches suites you best.

Chapter 08 EDGES

I used to think of edges as something to be attended to at the end of the painting process, smudging a bit here and there to soften edges that are too hard. But the more I look at paintings I really admire, the more I realize what an integral part of the painting process edges are, and how important it is to think about them early on. The way in which edges are approached is also an important aspect of your style. Thus, while edges are discussed in other chapters, I believe the topic warrants a chapter of its own.

LOST AND FOUND EDGES
AND VALUE MASSING

A principal tool of the painter is the use of *lost and found edges*. This means that some edges are hard and crisp, while others disappear into the neighboring value shapes. As discussed in Chapter 7, finding and losing edges has everything to do with values. If two objects or shapes have the same value and abut one another, the edge will be *soft* or *lost* —perhaps barely discernable. Where a dark piece of color abuts a very light piece of color, the edge will be much sharper and eye-catching. Thus, when you want to create a strong center of interest, values and edges are critical.

During the initial planning stages for a painting, when doing values studies, think about where edges can be lost or found. If there is a strong center of interest, make sure there are sharp edges of contrasting value in that area of the painting. For areas of less importance, find ways to *lose* the edges, by using similar values.

Lost and found edges are also critical to creating the illusion of *atmospheric perspective*, with distant mountains or trees having soft, blurry edges, and foreground objects having more sharply-defined forms. See Figure 8-3

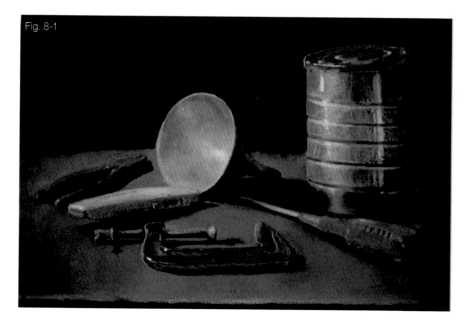

Fig. 8-1

Fig. 8-1. *Screw Can*, by Michael McGurk, 12" x 18" Wallis.

In this still life, McGurk uses a dark background to lose edges, such as the right side of the can and the back of the workbench, while making other edges very sharp with contrasts of value and color. The dark, black background is a common technique of the still life artist to provide contrast of value and edges.

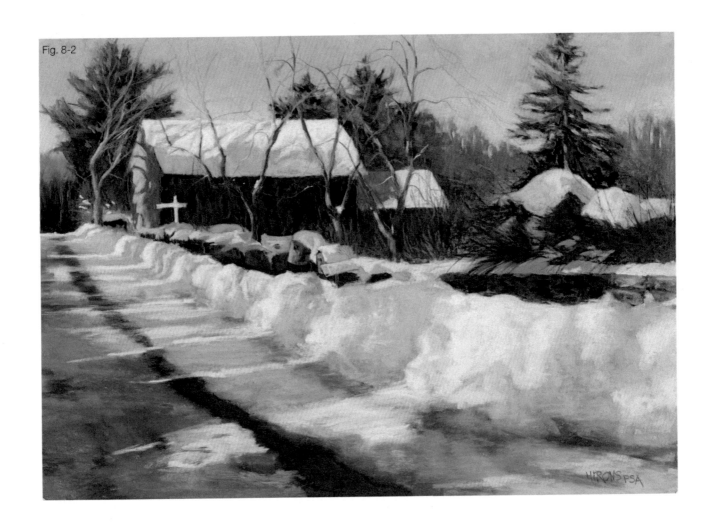

Fig. 8-2

EDGE AS AN ASPECT OF STYLE

Aside from *lost and found edges*, the overall quality of edges in a painting is an integral part of an artist's technique and signature style. The paintings of Sarah Canfield (see Figures 2-26, 3-18, and 12-4) use sharp, well-defined edges to create a very realistic look. Duane Wakeham's paintings, on the other hand, have very soft edges resulting from the build-up of many layers of pastel on a highly textured surface.

Thus, in defining your style, consider how to make use of edges. If you want to be very realistic, lost and found edges will be important. If you want to be a little looser and more impressionistic, less-defined edges throughout might be preferable.

MATERIALS AND TECHNIQUES

Surfaces. The smoother the surface, the sharper the edges can be; the rougher the surface, the harder it is to achieve fine lines and crisp edges. If you are painting a portrait and want it to be very realistic, a finely sanded surface, such as Wallis or UART, is a good choice. La Carte and Pastelmat are other surfac-

Fig. 8-3

Fig. 8-2. *Back Road Sun and Snow,*
11.5" x 19" Pastelmat.

Note the strong edges on the white post
against the dark barn in the center of
interest, and the soft edges of the shad-
ows in the snow bank. The distant trees
on the right also have very soft edges as
they meet the sky, while the edges of the
stone wall appearing above the snow are
much sharper and more defined due to
the value differences.

Fig. 8-3. *Lane North,* by Lisa Shepperd,
18" x 18" Colourfix.

Note how blurred the background trees
appear in comparison to the large tree
and foreground corn stalks.

es that allow for beautiful detail and fine edges.

An irregular surface texture can create a degree of excitement in paintings. For landscape paintings, working on a surface with a brushed-on ground can create unexpected pieces of texture. The coarser the surface, the more difficult it becomes to achieve hard edges. This can be a real plus!

In *The Pastel Book,* Bill Creevy explains ways of creating surfaces that will produce a more dynamic look, including the use of matte medium. I experimented with this once and found it difficult, but fun. Using a purchased or prepared ground on heavy mat

or illustration board can also create rough surfaces that will produce uneven edges (see Appendix D).

Hardness of pastel and strokes. It is much easier to achieve fine lines and sharp edges with the harder pastels. These can also be used to fill in and finish off an edge when softer pastels were used initially. The softer the pastel, the looser the edge will be, even on a surface that enables sharp edges, such as Pastelmat.

The stroke can also define the type of edges produced. If you carefully define the edge with a hard pastel, it will be crisp. However, by using cross-hatched,

Fig. 8-4. *Twilight Marsh,* by
Duane Wakeham, 19" x 29"
300lb arches cold-pressed wa-
tercolor paper with ground.

In this painting the edges are
soft and values are muted
throughout the picture.

Fig. 8-5. *Off Season,* 9" x 24"
Wallis "Belgian gray."

Off Season was painted on Wal-
lis using hard pastels to define
the houses and telephone poles.
The surface and pastels enabled
me to achieve crisp lines and
minute detail. For the sky and
sand, where I wanted softer
transitions of color, I used soft
pastels.

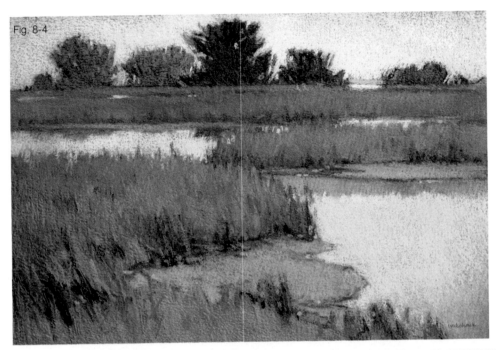

Fig. 8-4

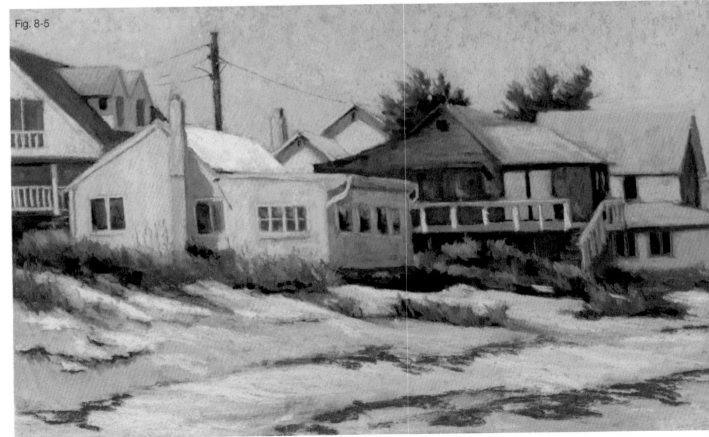

Fig. 8-5

Fig. 8-6. *A New Day,* 18" x 24" Gatorfoam with ground.

This painting was done on a fairly rough surface. The textured lines are evident in the sky, buildings, and truck. I was able to achieve a certain amount of detail, but the surface also allowed me to layer colors over one another in the various structures. Note how abstractly the trees are painted.

scribbled, or short strokes of color, as described in Chapter 3, you can produce edges that are broken and more dynamic. Starting out with loose edges can be a good approach. You can always sharpen them later; keeping edges soft to begin with can maintain vitality in the painting.

Lay-in. If you want your work to be more painterly and to avoid too many hard edges, try avoiding line in the initial lay-in. Instead, use the broad side of one or more small pieces of hard pastel to create blocks of color. Keep the subject matter simple to begin with, such as a still life with limited objects or a pure landscape. Brush the pastel with a solvent to create painterly shapes of value. You can correct the drawing of shapes as you proceed. To read more, I recommend Bob Rohm's *The Painterly Approach* (see Appendix B). See Figures 7-12 and 7-13 for an example.

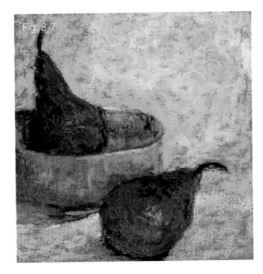

Fig. 8-7

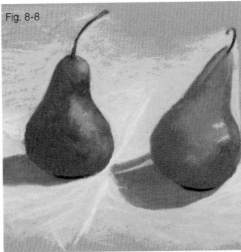

Fig. 8-8

Fig. 8-7. The multiple short strokes of hard pastel produce very loose edges. The surface is Wallis.

Fig. 8-8. In this second illustration, I used very meticulous strokes, still with hard pastels, producing crisp edges. The surface is La Carte.

WAYS TO SOFTEN EDGES

If you have created edges that are harder than you desire, there are a variety of ways to soften them. The easiest is to use your little finger, rubbing or dabbing lightly along the edge. But do not over-do it. Rubber-tip blenders or other blending tools can also be useful. Another way to soften edges is to use a hard pastel to *feather* the edge with a short vertical or diagonal stroke.

Fig. 8-9. Detail from *Wash Day, Monhegan* 16" x 20" Pastelbord.

Figure 8-9 is a detail from a painting in which I added lobster buoys to the lower left corner. I wanted them to appear loose and not too distracting. I painted them with red and a light yellow, then pulled the grass up over them using hard pastel to completely soften the edges and dull the bright reds.

Figure 8-9

SUMMARY

- Think about edges at the beginning of the painting process: where will they be sharp (found), and where will they be blurred (lost).
- Lost and found edges are key to defining a center of interest.
- Edge manipulation is an important component of creating painterly work.
- When doing landscapes with aerial perspective, be sure to keep the edges soft on distant objects.
- Loose edges throughout a picture can be an aspect of one's style accomplished using textured surfaces or linear strokes.
- There are many ways to loosen edges.

EXERCISES

☐ Examine a number of paintings to determine each artist's preferences for edges: precise edges, loose edges, or a mix.

☐ Try different surfaces to see how they affect the painting of edges.

☐ Use different strokes to achieve tight and loose edges.

☐ Try out other ways of loosening edges, such as with your finger or with a pastel stick.

PART THREE

Color Choices

The third aspect that defines an artist's style involves color. Many artists are attracted to pastel because of the vibrant colors of the pastel sticks and the beauty of pastel paintings. But one must learn to control and use color wisely in order to fully achieve this beauty.

This involves a sound understanding of the basics of color theory and how it applies to the medium of pastel, as described in Chapter 9. Creating harmonious color by selecting limited color palettes and doing color studies is the subject of Chapter 10.

The remaining chapters deal with the creation of paintings and color usage within them. Once the palette for the painting is chosen, the artist chooses the color of a toned surface or the colors to be used in an underpainting (Chapter 11).

As I noted in the preface, we have choices. One of these choices is how realistic or expressive we want the color to be in our paintings. Based on my experience of painting and teaching, I define three approaches to color in Chapter 12 that could be used exclusively or in conjunction with one another. These are *observed* color—reproducing what we see, *interpreted* color—pushing the color to be more vibrant, and *intuitive* color—color that comes from within or other sources.

Chapter 13 describes three stages of developing the painting once the surface color has been chosen or an underpainting has been applied. These include color choices for the initial layers of pastel, development of the desired color, and finishing touches and critical analysis. Three demonstrations illustrate the various applications of pastel and approaches to color. In summarizing the decisions made for each painting, I bring together many of the ideas and instructions given in this book. And finally, I include several examples of problem solving that entail both simple and extreme measures.

Chapter 09

COLOR THEORY BASICS

Using pastel does not require the artist to mix paint. Because of this, the pastel painter's knowledge of the theory and characteristics of color can be wanting. In this chapter, I discuss four color characteristics, and how they relate to the medium of pastel.

COLOR CHARACTERISTICS

There are three *properties* of color:

Hue: the basic family to which a color belongs, such as red, green, or blue. There are twelve hues on the Triadic Color Wheel, which include primary, secondary, and tertiary colors.

Value: the lightness or darkness of a color, as compared to the gray scale of ten values (10 = white; 0=black).

Chroma: (also referred to as *intensity* or *saturation*): the pureness vs. the dullness of a color.

In addition, there is a fourth important characteristic of color:

Temperature: the warmth or coolness of a color.

Hue, value, and chroma are *properties* because they are constant, while temperature is relative. What this means is that for any given stick of pastel, the hue, value, and chroma can be determined unequivocally. But how the temperature of that color will read in a painting can only be determined by seeing it in relation to the surrounding colors.

Fig. 9-1. Pastel stick with gray scale. This pastel stick is blue in hue, value 4 on the value scale, and high in chroma (or pure in color). However, its temperature can only be determined in relation to the other sticks of color that will be used adjacent to it. While blue is intrinsically a cool color, it is possible that there might be another blue used in the painting that is cooler, making this color appear a little warmer.

COLOR WHEELS

Triadic Color Wheel. All color comes from the light spectrum. The various color wheels that have been devised are an attempt to portray where each hue appears in the spectrum. There are a number of color wheels; the Triadic Color Wheel is the most familiar and widely available.

Fig. 9-2. The Triadic Color Wheel.

One of the primary purposes of this wheel is to help artists in mixing colors. The twelve hues are arranged in a circle, with the color at the edge being the purest or highest in chroma.

For each color, there is a tint (color + white), a tone (color + gray), and a shade (color + black). These are useful for painters who will mix pure color with white, black, or gray to make these tints, tones, and shades. With pastel, the colors have already been mixed within each stick. This is why we need a collection of pastels that includes the darks, lights, and the pure and more grayed colors within each hue.

Fig. 9-3. The Analogous Color Wheel.

The Triadic Color Wheel is based on three primary colors: red, yellow, and blue. There are three secondary colors: green, orange, and violet, each of which is a combination of the two primaries on each side of them. The six tertiary colors: yellow orange, yellow green, blue violet, blue green, red violet, and red orange, are combinations of a primary and a secondary color. For example, blue green is a combination of blue (primary) and green (secondary).

Analagous Color Wheel. The Analogous Color Wheel is based on the work of Albert Munsell (1958-1918), who developed a system to explain color to his students. Today the Munsell color system is widely used in industry, particularly in the manufacture of inks used in color printers. In this color wheel, the color orange, a secondary color on the triadic Color wheel, is omitted[1], leaving five primary colors: yellow,

1 You will find an indication for orange (O) on the color wheel but it is not factored into the placement of complements.

red, violet, blue, and green.

The premise of this tool is that color harmony can be created by using a dominant color and the colors near to it on the color wheel (i.e., analogous colors), along with small amounts of its complement (the opposite color on the wheel). The wheel also provides for *discords*, two colors that are equidistant from the complement. Thus, in using the Analogous Color Wheel, we can produce paintings with harmony, a little contrast, and a few surprises!

An example of a color palette using the Analogous Color Wheel would be the following:

Dominant color = blue green

Analogous colors = green, blue

Complement = red

Discords = yellow and red violet

Note: Unless specifically stated, the discussions on the various aspects of color theory are based on the Tri-

adic Color Wheel. However, there will be further exploration of the Munsell system.

HUE

Hue, the first property of color, defines the basic color family to which a color belongs (e.g., red, blue, violet). Determining the hue is the first step in understanding the color we see in our subject matter and in selecting the appropriate pastels.

The color families are represented by the 12 primary, secondary, and tertiary colors of the Triadic Color Wheel. When we look at a color, we first classify its hue, such as red, yellow green, or blue violet. We next see it in terms of its darkness or lightness (value), and finally, we examine its brightness or dullness (chroma). Thus, we might define a color as being a medium dark bright red or a light grayed green. It is best to refrain from using industry terms such as cherry red, cerise, tomato red, plum, and so forth.

The twelve hues of the color wheel are *chromatic color.* Black, white, and the grays made from black and white, are *achromatic color.* While black and white are very useful for those who need to mix oils or acrylic paints, they are less likely to be used by pastel artists. Pure grays also, while contained in some sets of pastel, are less likely to be used than grayed colors, as discussed under chroma.

Brown is a combination of the three primary colors: red, yellow, and blue. The degree to which each of these colors is present will determine the exact shade of brown, ranging from ochers and siennas, to rusts and umbers. When white is added to these browns, they become light *neutrals,* such as beige or tan.

The primary importance of hue is in determining color palettes and in reproducing colors as they are observed.

VALUE

The second property of color is value: the lightness or darkness of a color, based on the 10-point value scale (Figure 7-1). **Value is the most important property of color** for the following reasons:

- Having the right value is more important than having the correct hue to make a painting work.
- Value is key to defining the center of interest and strong compositions.
- In layering pastels, we work from darker to lighter values.
- In order to mix pastel sticks to form mixed complements or analogous blends, we rely on finding sticks of the same value.

Value is more important than hue

The primary importance of value is hard for the new artist to grasp. We get caught up in looking at color and trying to reproduce it without paying enough attention to its darkness/lightness. It is often the case that the artist does not have the exact color in the value that is needed. In such cases, find a color with the right value, even if the hue is not correct. Understanding this principle enables freedom of color choices, as long as the values are correct. Matisse illustrated this point well when he painted a green stripe of the right value down the nose in his wife's portrait!

Fig. 9-4. Photo reference. A bright red euonymus bush on a rainy day. The value of the bush is about 4-5 on the values scale. Another factor in this photo is that the bush is very high in chroma, while everything around it is grayed.

Fig. 9-5. Right hue/wrong value. In this 4" x 6" study, I chose the correct hue (a red that is similar to that in the photo); however, the red has been lightened with a lot of white. (Do not confuse *brightness* with *lightness*.) Its value does not read well with the values of the surrounding building, wall, and vegetation.

Value and pastel

Pastels are premixed with either white or black to create a range of values within each particular hue. Ideally, the pastel artist would have a range of five values for each of the 12 colors on the Triadic Color Wheel. In addition, a range of values for grayed colors is also desirable. If you purchase a complete set of pastels, you will have such a range. However, if a selective set is purchased, such as a 72-stick portrait set, the number of values for each color will be limited. These sets can be supplemented with dark and light sets.

While you can't make new pastel colors, you can mix sticks to produce grayed colors or mixed analogous colors, *as long as the values are the same.* It also helps to mix pastels that are of the same relative hardness/softness.

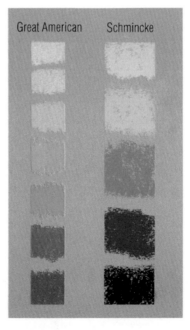

Great American Schmincke

Fig. 9-7. Value ranges from light to dark of Great American "Paris" and Schmincke "ultramarine deep."

Determining the value of pastels

While it is sometimes possible to "eyeball" the value of a pastel, the surest way to know its value is to place a swatch of color on a sheet of white or neutral paper. You can then compare this to the values scale.

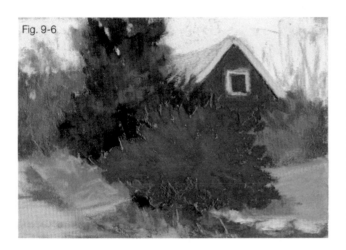

Fig. 9-6. Wrong hue/right value. In this second study, I chose a bright reddish orange that is similar in value to the source photo. Note how much better it fits into the surrounding landscape. It is more believable, even though the hue is not the same as that found in the photo.

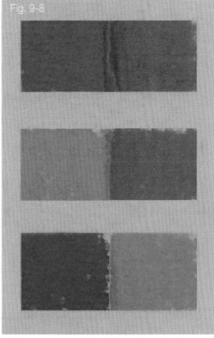

Fig. 9-8. In this illustration, I have paired a mid-dark blue with a mid-dark orange at the top that appear to be close in value. In the middle row, I used the same orange but a lighter blue; in the bottom row, I used the same blue (as top) and a lighter orange. Note the harder edges in the middle and bottom rows.

Fig. 9-9. Three analogous colors of pink, orange, and yellow with a mixture at the bottom.

In order to determine whether two pastel sticks are the same value, place a swatch of one on white or neutral paper, then place a swatch of the other right next to it so that the edges abut. If there is a sharp edge, the values are not the same. If there is little edge, the value is the same or close enough. Squinting at the edge is sometimes helpful.

Once you have found pastels of the same value, you can mix complements to produce grayed colors, or analogous colors to create more nuanced color. Each will be discussed further in this chapter.

CHROMA
(also called Intensity or Saturation)

Chroma, the third property of color, refers to the pureness as compared to the dullness of a hue.

For the pastel artist whose colors are premixed, chroma can be a confusing topic.

Chroma is best understood if you think of mixing paints. When you squeeze yellow oil paint from a tube, the color is pure and of the highest chroma. Once white is added to lighten it, or black is added to

darken it, the chroma is reduced. If the complement, violet, is added, it will produce a grayed and lower chroma color as well. Gray paint (mixed black and white) can also be added to gray a color and lessen its chroma. Because chroma is lessened both when a color is lightened or darkened, as well as when it is grayed, this can be a confusing concept.

Value and chroma

An added complication is that each of the twelve hues in their purest chroma are different in value. A pure chroma yellow is light in value, while red and green of the purest chroma are at a mid-range value, and blue and violet are purest at the dark end of the scale. Since value is key to mixing pastels, it is hard to make mixes out of violets and yellows. The violets have to be whitened to be at the same value as the yellow, as seen in Figure 9-15.

Understanding value and chroma of color is also an issue in seeing and interpreting color correctly. When the artist sees a color that is perceived as very bright, the tendency is to use a stick that has been whitened. However, the addition of white to any color cools it, as well as lightening it. Thus, the key is to find a color that is high in chroma and the right value as well.

Chroma and pastel

Pastels come in a wide range of chroma, from the pure saturated sticks to the very grayed where

Fig. 9-10. Gray scale with high chromas of the 12 hues on the Triadic Color Wheel.

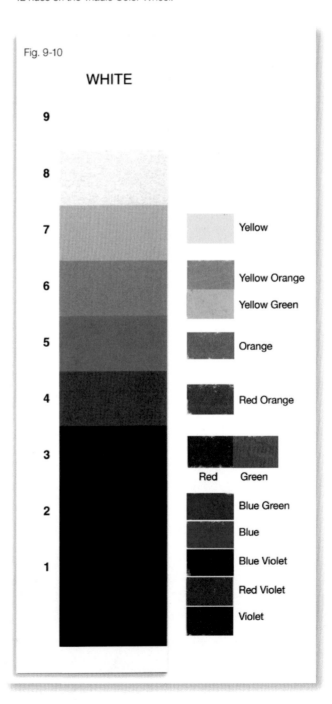

Figs. 9-11 and 9-12. In Figure 9-11, the colors are higher in chroma. Figure 9-12 shows a selection of grayed colors.

Fig. 9-13. Light grayed pastels.

the underlying hue is barely discernable. The high chroma colors are often used in florals, still life, and other colorful subject matter. If you are a landscape painter, the grayed sticks of varying values are particularly useful. They are necessary to paint clouds, rocks, distant mountains, and stands of bare trees. No matter the subject, the amount of grayed or pure color used is a matter of style. Grayed colors can provide contrast that enables the high chroma colors to sing. Too much high chroma color can appear garish and unpleasant to the eye.

It can be difficult to determine the pureness of color in pastels. Schmincke is one of the best brands for labeling their pastels. Each stick is identified with a 3-digit number and a letter. Those with D indicate pure color; B equals color plus black; H is color plus white; and M and O have more white. Unison pas-

tels are named by color, such as blue violet or blue green, as well as with a number indicating the degree of darkness/lightness. Great Americans also have a numeric system. Ludwig uses no labeling at all, but offers wonderful grayed colors, nonetheless.

Gray versus *grayed color*

It is important to distinguish between pure gray and grayed color. Pure gray is a combination of black and white, neither of which has any color. *Grayed color* pastel sticks contain some degree of underlying hue that has been mixed with gray or with its complement, such as a grayed red or grayed violet.

Some pastel sets, such as NuPastels, include pure gray sticks. I discourage students from using these in their paintings, but they can be useful for value studies.

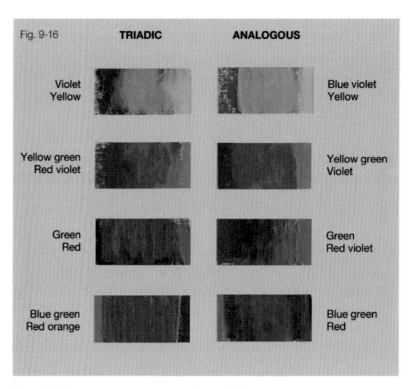

Fig. 9-14. Mixed red and green complements.

Fig. 9-15. Mixed violet and yellow complements.

Fig. 9-16. Mixed complements based on Triadic (left) and Analogous (right) Color Wheels

Mixing complements to create grayed colors

By mixing opposing colors on the Triadic Color Wheel, you can achieve blends of *grayed color*. Mixes of reds and greens, blues and oranges, or violets and yellows, as well as opposing tertiary colors, will each create a different form of grayed color that can add beauty and variety to paintings. For example, if painting a shadow cast by a dark blue bowl on a brown table, the artist might mix dark blue with a dark orangey brown to create a grayed shadow area. The use of several colors will add more interest and vitality to the shadow and will help it relate to the bowl. Using these mixed complements is also important when using a limited palette.

Where colors appear on the Triadic Color Wheel determines their complement. And thus, red and green, when mixed, make a grayed color. However, on the Analogous Color Wheel, the complement of green is red violet. I did the exercise in Figure 9-16 to see how different the color mixes would be when using the different complements defined by the two color wheels. Keep these added possibilities in mind.

Using grayed color pastel sticks versus mixed complements

The pastel artist has the opportunity to use grayed color in two different ways: 1) by using premixed grayed pastel sticks, or 2) by mixing your own grayed color using complements of the same hardness and value. Unlike grayed pastel sticks that have

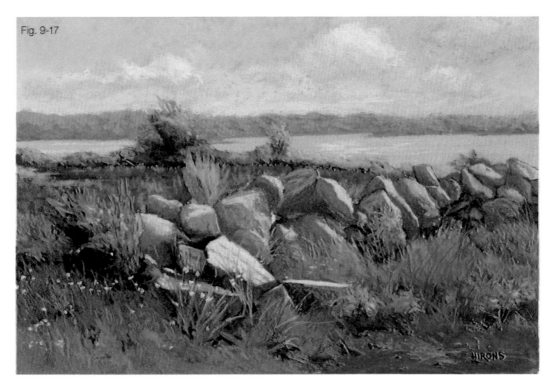

Fig. 9-17. **New England Stone**, 12" x 18" Wallis. The rocks in the painting were painted with a variety of warm and cool grayed pastel sticks.

one base hue, grayed colors created from mixed complements retain characteristics of both colors from which they are created. These combinations can provide beautiful passages of soft, nuanced color in your paintings.

I use both grayed sticks and mixed complements. While there is no right or wrong approach, here is my guidance:

Grayed pastel sticks are effective for areas in which multiple strokes of differing grayed colors in different values will be used, such as rocks, clouds, or trees (see Figure 9-17.)

Mixed gray complements work well for larger areas that are of the same value, such as the shadowed side of a house or a cast shadow in a still life (see Figure 10-3.)

Use mixed grays if your collection of pastels does not include pre-mixed grayed colors.

TEMPERATURE

Temperature is the warmth or coolness of a hue. While temperature is not technically considered to be a *property* of color, it is very important in our paintings. Furthermore, there is a dual nature to temperature.

Intrinsic temperature

• Temperature is *intrinsic* to the underlying hue: violets, blues, and greens are cool, while reds, oranges, and yellows are warm. (Note that yellow

green and red violet have both warm and cool components.)

- Furthermore, within each primary and secondary hue, there are tertiary hues that represent the warm and cool versions of that hue, such as blue green and yellow green.

Relative temperature

- In paintings, the temperature of a particular pastel stick is *relative* to the colors that are used around it. Thus, a blue green will appear warm in one place but cool in another.

Determining the temperature of pastels

If you choose to arrange your pastel box by hue, you will no doubt also arrange by intrinsic temperature. In my pastel box, the cool violets, blues and greens are on the left, while the warmer yellows, oranges and reds are on the right (see Figure 1-8.). This arrangement is pretty straightforward.

More difficult is determining whether a particular pastel stick is warm or cool. Students often ask, "Is this a warm green or a cool green?" The answer is found when you place the stick against the area of the painting in which it is to be used. Relatively speaking, it will be warmer, cooler, or close to the same temperature as its surrounding colors.

USING COLOR THEORY TO ENHANCE YOUR PAINTINGS

Dominance

Defining a dominant **hue** is the first step in developing a color palette. A dominant color is used throughout the painting and sets the stage for other colors that

Figs. 9-18 and 9-19. In these examples, the same blue green is paired with a warm yellow green in the first example, and a cool blue violet in the second. Note how the blue green appears cooler in the first, warmer in the second.

will work well with it. In Lisa Sheppard's painting, *Good While it Lasted* (Figure 9-20), the dominant color is a cool green. Notice that it not only appears in the land masses, but has also been used for the roof of the barn.

A dominant **value** is desirable, but may be hard to determine, particularly when there is strong contrast of values in the picture. The dominant value will affect the overall mood of the painting, especially if it is dark or very light. In Figure 9-20, the dominant value is in the mid-range, and it is complemented by only small pieces of dark and light.

A dominant **temperature** also sets the mood. Note how cool the colors are in Figure 9-20, giving the sense of a cold early morning with frost on the fields.

Fig. 9-20

Fig. 9-20. *Good While it Lasted*, by Lisa Shepperd, 13" x 18" Colourfix "storm blue."

Sheppard uses cool greens, red violet, and blues for the primary shapes and smaller amounts of warm orange and yellow for accents.

Dominant **chroma** can also impact a painting's mood. If filled with bright colors, the painting appears to be vibrant and alive. In contrast, a painting that contains more subdued grayed colors conveys a quiet mood, such as that of a foggy or snowy day. In Figure 9-20, the dominant chroma is grayed. Even the warmer orange in the water is not bright enough to be considered high chroma.

Determining the dominance of these characteristics is important to planning your painting. It can influence your choice of colors for a surface or an underpainting, your color palette, and which pastels you will layer while painting.

Contrast

One of the primary uses of value, temperature, and chroma is to develop contrast in a painting. **Value** contrast, in particular, is critical in creating strong compositions and reproducing accurately what we see. One need not use a lot of dark, so long as there is some contrast. In Figure 9-20, note how important the small pieces of dark are in the upper right, where the stream turns to the left next to a small tree. Contrasts in both value and temperature help lead the eye through the picture.

Fig. 9-21. *Evening, Marten's Farm*, by Lee Kimball, 32" x 32" gray mat board.

This painting has it all! While the value differences are not great, the bottom is definitely darker than the sky above. The contrasts of temperature are both subtle and strong, rising from the warm red-oranges of the fields to the violets, oranges, and yellows of the clouds (or dust?), to the cool blue of the evening sky. The chroma of the sky is muted by the various colors layered on top of each other, while the color in the fields is more saturated. The subtle blending of colors in the sky, as well as the warm and cool colors of the field are all about nuance.

Fig. 9-21

Contrast of **temperature** is perhaps the most important feature of Sheppard's painting. Placement of orange against cooler greens and violets draws the viewer immediately into the picture and through the composition. Strong contrast of temperature can also be seen in the work of Mike Kolasinski (Figure 5-7). His use of warm and cool colors is a great strength of his paintings.

Chromatic contrast is also a highly influential factor. Small amounts of high chroma color, when surrounded by grayer colors, contribute to the vibrancy of a painting. Bright colors will not really sing if there are too many other colors of high chroma surrounding them.

Nuance

While contrast creates the impact, nuance provides the beauty. Nuance involves subtle gradations of value, temperature, and chroma skillfully placed as transitions in passages of color. In areas that are dark, apply slightly lighter colors, gradually building to lighter values. In distant mountains, find pastels that are similar in value but slightly different in temperature to provide the subtle sense of shadow and light. Be selective with your use of high chroma colors by providing subtle washes of grayed color that build gradually to smaller areas of high chroma.

Subtle contrast can be created in large areas of the *same value* where colors *differ in temperature*. The

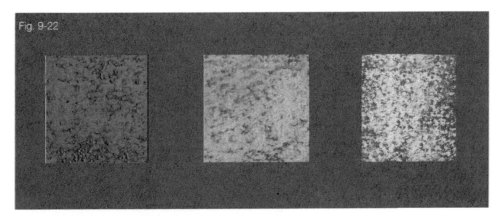

Fig. 9-22

Fig. 9-22. If you want a light pink, choose the lightest red that is available in your collection and mix white over it. This process will work if the beginning color is fairly light; it is not effective for dark colors.

Fig. 9-23. If a darker color is needed, mix two dark pastels of opposing temperatures (e.g., red and green). The resulting color will be darker than the original colors. A mixture of blue green and a red of the same value creates a darker and more grayed color.

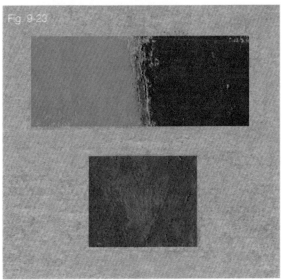

Fig. 9-23

background of a still life or portrait, a large field, sky or a roof, or the leg of a model are all candidates for this attention. By using mixes of analogous colors in such areas, you can provide subtle changes in color temperature that will break up the expanse and create depth and beauty. In large expanses of sky, I often mix warm and cool blues, blue greens, and light violets. By keeping the value the same, the area will read appropriately; by varying the temperature, it will be more eye catching and engaging.

Developing nuance in your paintings takes patience, time, and a good selection of pastels. Combining subtly nuanced color with areas of higher contrast is one secret to creating successful paintings.

MAKING ACCOMMODATIONS

No matter how many pastels you own, there will always be a situation when you do not have the exact color. The artist with a limited collection must find ways to accommodate. By understanding the properties of color (hue, value, and chroma) and the relative nature of temperature, you can create substitutions.

Changing the value

While the value of pastel sticks cannot be changed, there are a few tricks that can be employed if the right darks or lights are not available. (See Figures 9-22 and 9-23.

Changing the temperature

When the exact color isn't available, the problem is often one of temperature. Begin by finding the closest color possible in the correct value. Next ask whether the desired color is warmer or cooler than the stick in your hand. This process is illustrated in Figures 9-24 through 9-27.

Fig. 9-24. Magenta pot. The color of the pot is a cool reddish magenta. It has highlights of warmer and cooler colors, as well as a sheen on its surface.

Fig. 9-25. For the purposes of this exercise, I limited my pastels to Polychromos hard pastels, using warm and cool reds and four values of blues. Since I was trying to simulate a limited collection of pastel, I stayed away from the magentas at first. I began by identifying areas of darker and lighter, warmer and cooler color and used various blues, warm reds, and pink to establish the first layer of color.

Fig. 9-26. I next started to refine the color, still using the same pastels, except for the addition of warm yellow and brown for the base of the pot. I mixed blue and pink to make the cast shadow and used this combination also on the sides of the pot where there was a sheen. My goal was to mix warm reds and blues to make the cooler magenta of the pot, but I couldn't help adding some cooler reds at this stage.

Fig. 9-27. In the final version, I have refined the color further, added highlights, and introduced more reds into the blues. The overall effect is of a cool red vase. While not perfect, the resulting colors are probably more intriguing than what I might have painted with the exact colors.

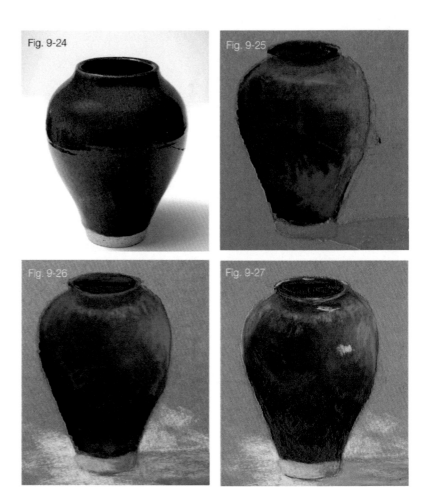

Changing the chroma

I have already noted how we can mix complements to create grayed color. What about adding gray to a color? If your collection is limited, this is an option.

While there are many accommodations that can be made, you cannot create a bright, high chroma color from a duller color. Sorry!

Fig. 9-28. Adjusting chroma with gray: In the top two rows of this illustration, I added a gray of the same value over an orange and an aqua. The gray definitely dulls the color. By letting some of the original hue show through, the overall outcome is more colorful.

Compare the orange and aqua with gray on top and the mixture of orange and aqua at the bottom. The resulting color is more complex than the grayed colors above.

SUMMARY

- The three properties of color are hue, value, and chroma.
- A fourth important characteristic of color is temperature, which is relative to what is around it in a painting.
- Understanding these characteristics is elemental to using color effectively.
- Pastels are premixed to contain various degrees of value and chroma.
- Pastels of the same value can be mixed to create grayed colors or interesting analogous colors.
- Dominance, contrast and nuance are used to establish the mood of a painting.
- Some accommodations can be made if your collection of pastels is really limited.

EXERCISES

☐ Mix complements and analogous colors (this is an exercise I give to all new students).

Using a complete set of hard pastels, find complements that are the same value. Place a swatch of each on the left and right sides of a column, then mix the two in the middle. Continue with as many combinations as are possible.

Repeat this exercise using colors that are next to each other on the color wheel. Again, be sure that the values are the same or similar.

Keep these studies for reference.

☐ Test the use of grayed pastels against mixed complements in various areas of a painting to see which approach you prefer and in which situations they are best.

☐ Organize your pastels. If you have multiple sets and individual sticks, purchase a travel box of some sort and decide how to organize it. Decide where to put the grayed colors. Two ways to organize your pastels are:

1) First by hue, then by value, using the color wheel to move in a progression of warm to cool hues. (To view how I apply this system to my own box, see Figure 1-8.)

2) First by value, then by hue and temperature, starting with the very lights at the left, and working from warm at the top to cool at the bottom. Depending on the number of rows in your box, define 4, 6, or more differences in value. This system can help those who are value-challenged. I had my pastels organized in this manner for some time, but found it difficult to put used pastels back in the right place, and it was also hard to accommodate the many greens this way.

Chapter 10

PALETTES AND COLOR STUDIES

Once you have a sound understanding of color theory using pastels, the next step will be to use this knowledge to create harmonious color in your paintings.

As with musical harmony, in which combinations of notes form chords that are pleasing to the ear, so too can the right combinations of color chords create *color harmony* that will delight the eye. Artists who construct their subject matter, as in setting up a still life, can use their knowledge of color harmony to select the colors of the objects to be used in advance of painting. The landscape painter, however, paints from what Mother Nature has provided. (Some artists believe that she has given them all that they need, while others feel she could use a little help!)

Using a *limited color palette*—a selection of two to four colors to be featured throughout a painting—is one way to achieve *color harmony*. An important tool for deciding on the specific colors to include in the palette is the *color study*.

ACHIEVING COLOR HARMONY WITH A LIMITED PALETTE

When you limit the number of hues that will be used in a painting, you define a *limited palette*. This term can have different connotations for oil painters, as discussed at the end of this section. While not all artists use a palette limited to just two to four colors, it is still important to understand how various color combinations can work in paintings in order to achieve balance.

Limited color palettes include color combinations given on the Triadic Color Wheel, such as complementary, analogous, triads, split comple-

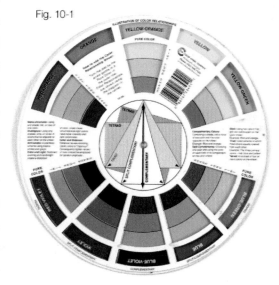

Fig. 10-1

ments, and so forth. The Analogous Color Wheel also suggests color combinations that produce harmonious paintings.

The benefits of selecting a limited palette include:

- Establishing the mood of the painting and the experience you wish to convey to the viewer.
- Determining a dominant color temperature of the painting.
- Setting parameters that can aid in the selection of a toned surface or in the colors in an underpainting.
- Simplifying and facilitating the selection of pastel sticks for specific areas of the painting, such as shadows, sky, vegetation in a landscape, or objects in a still life.
- Preventing random colors from becoming isolated in the painting.

Fig. 10-1. Verso of the Triadic Color Wheel showing color palette combinations.

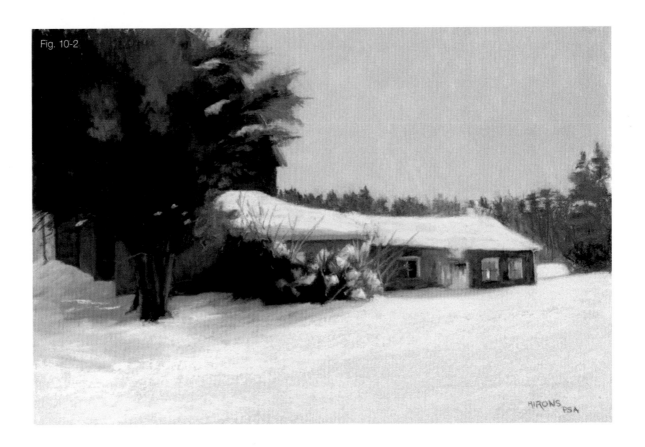

Fig. 10-2

- Providing the viewer with a sense of harmony, regardless of whether the colors are quiet, exciting, or reflective of the actual subject matter.

There are a number of color combinations found on the triadic color wheel which I group in the following categories:

- single hue (monochromatic)
- opposing hues (complements, near complements, split complements, double complements)
- nearby hues (analogous)
- equidistant hues (triads)

On both the Triadic and Analogous Color Wheels, the starting point is the selection of a single dominant hue. From there, hues nearby or opposing are added. When painting a summer landscape, the dominant color will most often be green (at least here on the East Coast of North America). When painting a winter landscape, the dominant color is more likely to be violet or blue. By starting with a dominant color, you can decide whether you want to use a palette with hues that are monochromatic, complementary, analogous, or from a wider range of colors.

Single hue (monochromatic). A monochromatic color scheme consists of one hue in its various value and chroma ranges. When limited to one color, both warm and cool temperatures of the color will be

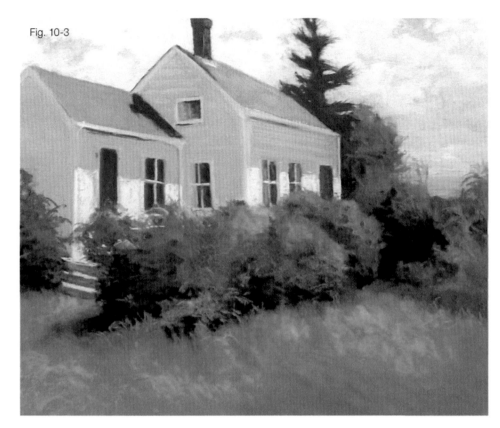

Fig. 10-3

Fig. 10-2. *Snow Light,* 13" x 19" Supertooth.

In this painting I used cool reds with warm and cool greens in a broad range of values. By limiting the palette and using the same hues in the sky and snow that are found in the trees and buildings, the picture is unified and harmonious.

Fig. 10-3. *Rosa Rugosa,* 16" x 20" Pastelbord.

This painting is based on a dominant color of warm yellow greens, with lesser amounts of the complement, red violet. The shadowed sides of the house are a grayed blend of light cool greens and cool reds. There is also dark red violet in the trees and bushes. And the roses are a brighter version of the color in the roof.

A little blue was added to the sky and distant water. You do not have to restrict yourself completely to the two complementary colors, but they should be the most prominently-used colors in the painting.

needed to provide contrast. This scheme is rather constraining and less used than the others, though it can be an effective option for some paintings.

Opposing hues (complements). If you wish to produce vibrant, exciting color, as well as lovely grayed blends, use complementary colors that are found opposite each other on the color wheel. By choosing a dominant color and using lesser amounts of its complement, as well as combining the two colors to make grayed colors, you can produce beautifully harmonious paintings. To keep the color balanced, do not use high chroma sticks of the complement; instead opt for slightly grayer, lighter, or darker sticks.

Complements based on the Triadic Color Wheel include:

Green and red

Orange and blue

Violet and yellow

Yellow green and red violet

Blue green and red orange

Yellow orange and blue violet

Another option is to use *near complements* by selecting a dominant color and an opposing color that is not the complement: green and orange, violet and orange, blue and yellow orange, and so forth. (Note: this category is my addition; it isn't given on the color

Figures 10-4 and 10-5 illustrate use of analogous palettes.

Fig. 10-4. *Hay Rolls*, by Michael McGurk, 16" x 20" Wallis.

The dominant temperature is warm, composed of yellow greens, green, and yellow ochers, with cooler blue greens in the distance.

Fig. 10-5. *Autumn Glory*, 16" x 20" Gatorfoam with ground.

In this autumn scene, the dominant color is red orange, with cooler reds and red violets from one side of the wheel, and warmer oranges and yellow oranges from the other side. Together, they combine to provide a very warm palette. My choice of yellow for the sky and water adds to the overall warmth.

wheel. I often use a palette consisting of either green or violet mixed with warm earth tones (i.e., orange).

Split complements combine three colors: a dominant color and both colors to either side of its complement, such as: blue violet with yellow and orange. *Double complements* (called *tetrads* on the color wheel) consist of two sets of complementary colors, such as blue/orange and violet/yellow.

Using *opposing, complementary hues* provides both warm and cool color. And because opposing temperatures tend to vibrate when placed next to one another, they can be exciting. This is why many pastel artists opt to use the complement as an underpainting or toned surface, allowing little pieces of it to show through (see Figure 4-7).

When referring to the color wheel, remember that the full range of color values and chroma may be used, not just the pure color at the outer edge of the wheel. You can find beautiful paintings based on complementary color, in which just the barest hint of a hue can be seen in the light and grayed passages. Nevertheless, the fact that the artist has restricted color usage to a limited number of colors makes the painting more harmonious.

Analogous hues. The analogous color scheme (according to the Triadic Color Wheel) also starts with a dominant color and includes the colors to either side of it. Up to five colors can be used. This results in paintings that have a strong dominant temperature of warm or cool. As noted above, the cool palette of blues and greens is a very popular landscape palette. Warm pinks, oranges, and yellows are more likely to be used in floral paintings or fall landscapes. For the winter landscape, the palette might make use of

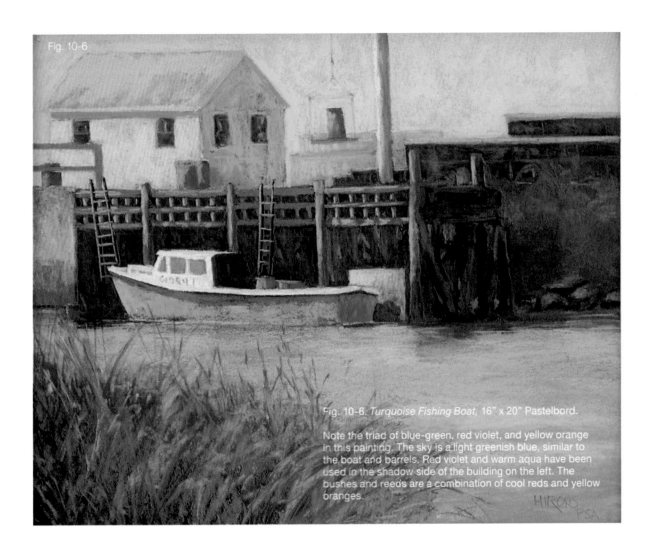

Fig. 10-6. *Turquoise Fishing Boat,* 16" x 20" Pastelbord.

Note the triad of blue-green, red violet, and yellow orange in this painting. The sky is a light greenish blue, similar to the boat and barrels. Red violet and warm aqua have been used in the shadow side of the building on the left. The bushes and reeds are a combination of cool reds and yellow oranges.

a dominant red violet with reds in the bare bushes and berries, and blue violets in the sky and shadows. When there is snow, very cool versions of blue violet and a little yellow may be present.

Equidistant Hues (Triads). Triads include three equidistant colors on the color wheel, such as the three primaries (red, yellow, blue), the three secondaries (orange, green, violet), or three tertiaries: (red violet, yellow orange, blue green; or red orange, blue violet, yellow green). The benefit of triads is that they enable the use of more color and contrast. I frequently use an orange/green/violet palette for landscapes.

Color palettes based on the Analogous color wheel

Some artists prefer the Analogous Color Wheel as a basis for their color palettes. Interestingly, by choosing a dominant color and using a range of colors on either side of it, as well as the complement and the equidistant discords, the Analogous Color Wheel combines all of the benefits of the categories from the Triadic Color Wheel discussed earlier! (see Figure 10-7.)

Fig. 10-7. *Gracie,* 12" x 12" Pastelbord.

This picture contains analogous colors of oranges, pinks, and cool red magentas. The complement is blue green, which is present in the soft grayed greens in the pillow and couch, as well as on the cat. One of the discords is blue violet, which was used in the dark shadows and in a very light hue in the background, mixed with orange.

Fig. 10-7

Limited palettes from the pastel artist's perspective

For the oil painter, a *limited palette* implies the use of, perhaps, a limited number of tubes of paint. These might include the paints in three primary colors, or an earth tone and several other colors, with the addition of white and black. The pastel painter, on the other hand, chooses from a wide variety of pastel sticks in order to establish a palette. Within one color, there are multiple sticks arranged in our boxes for varying values and chroma. It is easy to mix in differing temperatures, as well, even though these may constitute a different hue on the color wheel.

It is the tertiary colors that are almost always used in my color palettes. For one thing, it is very difficult to determine which sticks are the primary or secondary colors of blue, violet, green, and so forth. They all appear to be either warm or cool variations of the base color. And while my typical landscape palette is the triad green-orange-violet, I tend to use a range of temperatures within each of these colors. Is this a triad or am I using six or even nine colors?

I have found that in trying to follow a complementary scheme, it is difficult not being able to use differing temperatures of a color. Thus, I think one should first think of the needs of the painting. Use the colors that work, trying not to introduce other colors that aren't needed, to keep to a relatively limited palette. Do not worry too much about terminology. Your admirers will care more about the harmony and contrast created in the painting than whether it is a split complement, double complement, or triad!

USING A FULL PALETTE

Not everyone chooses to use a limited palette. A number of the contributors to this book, including Robert Carsten, use a wider range or full spectrum of color to create vibrant paintings.

This is one more decision that can define your

Fig. 10-8. *River Through the Forest*, by Robert Carsten 18" x 24" La Carte.

While many bright colors are used for the fall leaves in the background, the dominant colors are blue and yellow green, which have been used throughout the picture. Note also that the bright oranges and pinks of the leaves are also included, in more muted versions, in the rocks and water. Using many colors works when there is careful attention given to balance and placement of the colors.

Fig. 10-9. Color study for a landscape painting from top to bottom.

style. My own preference is to use a limited palette for most, but not all, paintings. Each painting is a unique creation that requires consideration of what will work best. Envision what you want the end result to be, seeing it in your mind or exploring in studies. Consider the possibilities and remain open to changes as the painting progresses.

COLOR STUDIES

Color studies of your subject will help you to determine:

- the color palette,
- which specific pastel sticks to use,
- the underlying colors that are needed to "*stage*" your painting.

If you are certain of the color palette based on a still life set up or a good color photo, you may still want to do a color study to determine which pastels will work best. If you are unsure about the overall palette, or color schemes for specific sections of the painting, color studies are particularly useful.

Making decisions about the palette up front does not mean that changes can't be made as the painting progresses, but the fewer the changes, the less likely the painting will become muddy and overworked.

Types of color studies

Color swatches. The easiest and simplest type of study is to apply color swatches of pastel on a sheet of paper that is the same or similar in value and temperature to the painting surface. Sometimes I choose

Fig. 10-10.

Figs.10-11

Figs.10-12

Figs.10-13

Fig. 10-10. Black and white reference photo for *Pond Reflections*. The color in the original photograph was all green with white sky and water. I liked the shapes, values, and possibilities of the composition. By converting the color photo to black and white, I could freely develop colors in the composition.

Figs.10-11, 10-12, 10-13. *Pond reflections* color studies. I did three color studies, choosing a split complement of blue violet with yellow and orange for the first. In the second, I used complementary reds and greens. In the third, I chose another split complement of red orange with blue green and blue violet.

I decided to build my palette based on the first study, and made a few changes as the painting progressed.

Fig. 10-14. *Pond Reflections* 12" x 12" Pastelbord.

As an outcome of the color studies, the palette for the painting included light blue violet for the sky and water, accented with yellow. I added yellow greens to indicate the light in the trees and shrubbery. The background trees are a combination of the colors used in the foreground, but in much lighter values.

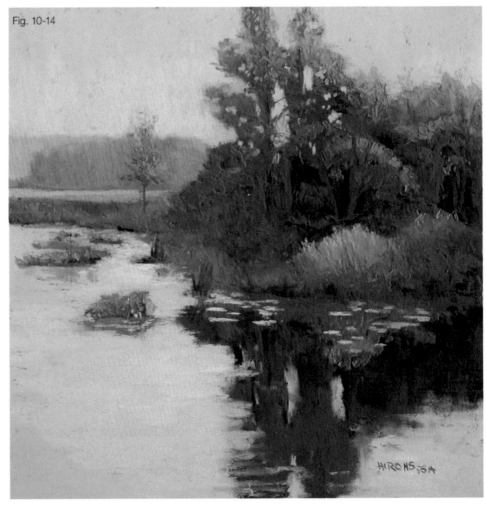

Fig. 10-14

a slice of the picture from top to bottom, marking colors for the sky, trees, mid ground, foreground as in Figure 10-9.

Doing multiple studies. If you plan to develop the painting on a toned surface, select a similarly toned piece of Canson (use its smooth side) or other inexpensive paper. Mark off three to four boxes in proportion to the painting's final size just as you

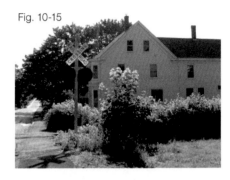

Fig. 10-15

Fig. 10-15. Reference photo for *House by the Tracks.* The sky is white, the road is gray, and there is little color in the house. But I remembered seeing it as a blue violet.

Fig. 10-16. Color Study for *House by the Tracks*, 4" x 6" Gatorfoam with ground

In this study, I used an orange underpainting for the sky with pink pastel on top. I also tried out various blue violets and blue greens for the side of the house.

Fig. 10-17. *House by the Tracks*, 16" x 20" Gatorfoam with ground.

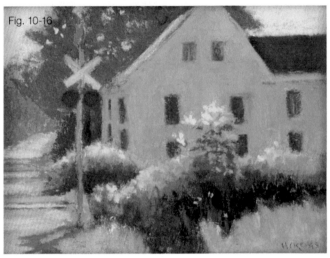

Fig. 10-16

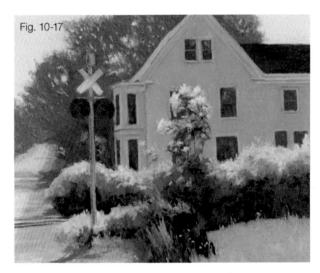

Fig. 10-17

would do for compositional values studies in Chapter 6. Quickly denote the major shapes in the picture, omitting any detail or highlights. Choose various color combinations to decide what you like. In doing this, think first about what colors the darks and lights will be.

In Figures 10-11 through 10-13 present a sequence of color studies for a 12" x 12" landscape painting to be created on gray Pastelbord. The studies are composed in 4" x 4" boxes on a blue gray sheet of Canson of the same value as the Pastelbord.

When developing a painting that will be created

over an underpainting applied to a white surface, it is desirable to do the color studies on a similar surface. I often use 4" x 6" pieces of inexpensive Gatorfoam coated with a ground. The intended underpainting is applied to this surface, and then the pastel colors for the color study. Because this process can be time consuming, I tend to do only one study rather than multiples. However, I feel free to brush off the color if I do not like it and then I try new colors. Note that in these studies, I am testing colors for the palette in relation to the initial underpainting color. Studies developed in this manner can be more detailed than the

Fig. 10-18. Studies for *Eel Pond Reflections.* In these studies, I tried out various value and color combinations for the sky, vegetation, and water. The final painting's palette is loosely based on the bottom left study.

Fig. 10-19. *Eel Pond Reflections*, 12" x 18" Wallis.

Fig. 10-20 and 10-21. Two studies for *Daybreak, Stonington*. (For the source photo and finished painting see Figures 12-18 and 12-19.) I began with the 6" x 8" study on the left, which is closer to the light conditions in the photo. I decided I wanted to try out an early morning picture and changed the values and the color for the second study on the right.

Fig. 10-20

Fig. 10-21

smaller, quicker studies and color swatches. I have framed and sold some of them.

In summary, the following guidelines are helpful in developing color studies:

- Use the same or similar *color* surface as the painting surface.
- Use less expensive surfaces, if desired, such as Canson Mi-Teintes.
- Keep studies small and undetailed, if possible.
- Do them only when you need to and do only as many as are necessary.
- Keep the pastels used for each study separate so that the desired combination can be used for the painting.

TESTING COLORS ONCE THE PAINTING IS IN PROGRESS

If a color palette is determined through the use of color studies, the pastels used for the studies will

Fig. 10-22. Color studies for Olson House. For compositional studies, see Figure 6-9.

form the basis for the painting. However, as the painting progresses, additional colors may be needed. Too much trial and error on the painting will result in muddy color that will not be pleasing. Some artists leave part of the paper free as a strip for testing colors. This can be useful, particularly for determining how a color will look on the particular tone of paper.

The primary purpose of testing a color is to determine whether the value, temperature, and chroma are right for the specific area where it will be applied. Once the surface has been covered with initial and subsequent layers of color, testing new colors against the test strip will not be useful. In this situation, some options are:

• Apply some of the colors from the areas of concern on the test strip and test the new color on top of them.

• Place a small dot of color in the painting to see how it works.

• Hold the pastel up to the area to see whether it seems appropriate.

The second approach is my chosen method for testing color. I use the third approach when helping others decide on colors to be used. The value, temperature, and chroma of a pastel can best be assessed by seeing it in its surroundings, not in isolation. Small pieces of color added to the painting will more accurately determine whether or not it will work. If the color is not desired, the spot of unwanted color can be lightly brushed off or covered by subsequent layers of pastel. Inevitably, as the build up of pastel in the painting becomes more complex, duplicating the color on a test strip becomes impossible.

SUMMARY

- Defining a limited palette is one way of creating harmonious paintings.
- Artists may choose to use color combinations that are close together, opposite one another, or equidistant from each other on the Triadic Color Wheel.
- The Analogous Color Wheel defines color palettes that combine the various possibilities of the Triadic Color Wheel.
- For each painting, consider its color needs and whether a limited color palette is appropriate. If so, what colors will fit the palette?
- Doing color studies is a quick way to determine color possibilities.
- As the painting progresses, it is important to test new colors against the colors already used in the painting.

EXERCISES

☐ When painting from life, use the edge of your paper, other paper, or a sketchbook to develop quick color studies.

☐ Using a black and white photo of a landscape or other subject, develop multiple color studies to determine a limited color palette.

☐ Use the Triadic Color Wheel to examine possible color palettes for quick color studies to determine which combinations are most appropriate.

☐ Determine the color palettes used in paintings by some of your favorite artists.

☐ Collect samples of paintings with pleasing palettes. From time-to-time, assess what your current tastes are and play with those color schemes.

Chapter 11

SURFACES AND UNDERPAINTINGS

Once the color palette is selected, you can make choices for the underlying color of your painting. The options include a purchased or hand-toned surface or an underpainting (dry or wet.)

The amount of underlying color retained in a painting will be determined by your choice of texture and style. In some cases it will be entirely covered, but will provide appropriate value and temperature ranges for the application of pastel. In other cases, the underlying color will shine through as an integral part of the painting. The types of surfaces and techniques that can be employed have been discussed in Chapter 4. In this chapter, the focus is on the choice of color.

This is not a science; there are no rules or *correct* ways of selecting initial color. I think it is best to start with some form of color rather than white, be it a toned surface or an underpainting[1]. The color can provide contrast or compatibility with the chosen color palette. The main thing is that it should help you achieve the look and color balance that is desired. Once you gain experience, choice of underlying colors will become more intuitive.

COLOR CHOICES
FOR A TONED SURFACE

The choice of colors for the initial and subsequent layers of pastel will depend on your approach to

1 Having said this, note that several of the contributors to the book work directly on white. As I said, there are no rules!

color, as described in the next three chapters. Choosing the color of a toned surface (whether purchased or self-prepared) is most often based on value and temperature.

VALUE OF THE SURFACE COLOR

Mid-toned surfaces. By far the easiest surfaces to use are those in the mid-range of values. On these surfaces, darks look dark and lights look light. They provide maximum flexibility and little annoyance. Wallis "Belgian gray" is a good example. La Carte, Pastelbord, Colourfix, and Pastelmat also come in lovely mid-range tones.

Lightly-toned surfaces. Light surfaces can work very nicely for vignettes with figures or portraits (see Figure 5-1). Small areas of dark can easily be applied without difficulty. In a landscape, however, where there may be larger areas of darker value, the light surface can be a problem if you do not want it showing through. The more textured the paper, the more this will be a problem. For instance, I find it easier to cover the surface of UART, a cream-colored gritty surface, than light yellow Colourfix. One solution is to do a partial underpainting using a dark hard pastel stick and a solvent.

Fig. 11-1. *Long Shadows*, by Lisa Sheppard, 18" x 26" Colourfix.

Sheppard used a deep ultramarine paper for this painting. The toned paper provided the painting with "instant colorful shadow areas and gave continuity throughout the picture." A little of the color can even be seen coming through in the sky.

Darkly-toned surfaces. If the painting is to be dark or in the mid-range of values, choosing a dark surface can prove useful. Such surfaces are helpful with night scenes or can provide beautiful contrast in a still life. However, be aware that it can be difficult to determine values correctly on a dark surface and the painting may come out darker than you had intended. Some artists use dark surfaces to provide texture by letting the color show uniformly throughout the picture.

Black surfaces. Working on black can be exciting. Since it is the darkest possible surface and totally lacking in color, pastels applied to it appear true to their hue. As with other darkly-toned surfaces, the right values can be difficult to determine. However, a colorful still life can be beautifully rendered on black.

White surfaces. As noted, I do not like to work directly on white, based on several unsuccessful experiences. On white, even the lightest of colors will look darker than they would on a toned surface, making it difficult to properly assess their value. Thus, I always tone or use an underpainting when working on a white surface.

Note: if you want to allow some of the original surface color to show through uniformly in your paintings as part of your style, I generally think that darker color surfaces work better than light ones.

TEMPERATURE OF THE SURFACE COLOR

With value, artists often choose a surface tone that is similar or darker than the overall value of the painting. With temperature, they are more likely to

Fig. 11-2

Fig. 11-2. *Bar Jewels,* by Carol Greenwald, 18" x 26" Colourfix.

Carol Greenwald has experimented with the use of toned surfaces that are very similar to the primary background color to be used in the painting. The dark burgundy color of the paper can be seen on the right side.

choose an opposing temperature —warm tones under cool paintings and cool tones under warm paintings.

Neutral tones. Just as with the mid-range values, the neutral tones of brown and gray can be useful surface colors. Brown is warm and gray is cool, but both are more neutral than other colors. I find a warm brown to be effective under cooler landscapes, and a gray, such as Colourfix "elephant," to work well under a warmer and more colorful still life.

Warm colors. Warm colors include various values of red, sienna, peach, orange, and yellow. Since many landscapes are predominantly cool, painters often begin on a warm surface.

Cool colors. Cool colors include the violets, blues, and cool greens. Green is a wonderful tone for figurative paintings that will include warm skin tones. Cool colors, such as Colourfix "aubergine," a grayed violet, can work very nicely under a still life that is predominantly warm in temperature or under a vibrant fall landscape.

While this discussion has focused on contrast, you can choose a surface color that is very similar to the predominant color in the painting, especially if you want to apply less pastel.

The color of the paper can also help define the composition, as shown by Sheppard (Figure 11-1) and Lister (Figure 5-8). By using a surface color that will be an important part of the composition, you can use lighter or darker colors around it to quickly develop the composition.

COLOR CHOICES FOR UNDERPAINTINGS

Choosing colors for an underpainting is more complex than choosing a single color sheet of paper, because multiple colors are most often used.

In Chapter 6, I defined two approaches to composition: the center of interest painting and the big shape painting. In Chapter 4, I discussed three types of underpaintings based on value shapes and one based on looser washes of color. Because the style of composition can make a difference to the color choices for the underpainting, I recommend:

• A values-based block-in for big shape paintings

• Loose washes of color for center of interest paintings

Although you can do either type of underpainting, or a mix of the two, I think it is easier in the beginning to approach underpaintings as recommended.

COLOR CHOICES FOR A VALUES-BASED BLOCK-IN

Once the composition and value shapes have been established in studies, the more difficult task is deciding what colors to use in the initial masses. The choices may be based on a chosen color palette or they may be more arbitrary. The basic decision is which of the following you want to use:

Opposing colors
Complementary color
Warm under cool/cool under warm
Analogous colors
Warm under warm/cool under cool

Arbitrary colors
Monochromatic
Four-color block-in
Same colors
Local color

Opposing colors

Complementary color. This scheme is often selected for an underpainting when the color palette will consist of a complementary color palette (including near or split complements). In such cases, the opposite color in its appropriate value is chosen for the underpainting, over which the pastel is added. By letting some of the underpainting show through, you can add an optical vibration to your paintings. This scheme is best applied as a wet underpainting. If using a dry underpainting, be sure to spray the initial color with a workable fixative, to keep the colors from mixing into a gray.

Warm under cool and cool under warm. This is a variation on complementary color that allows for the selection of any opposing temperature colors, not just the complements. This scheme can be used for any type of color palette. Subject-wise, it works well when there are large areas of warm and cool in the painting. Having opposing colors underneath provides more complexity and vibration to what could become flat, boring spaces. I often use this approach for buildings, applying cool color under the sunlit areas, and warm under the shadows, layering the appropriate temperatures of pastel on top.

Analogous colors or warm under warm/cool under cool. In this scheme, use colors that are in the same temperature range, but not the local (actual)

Fig. 11-3. *Complementary color*—underpainting. I began by blocking in the appropriate values in oranges, browns, and blues, using the opposite colors from what I saw.

Fig. 11-4. *Complementary color*—completed study. I added the local colors of blue and orange, letting the under-color show through in some places.

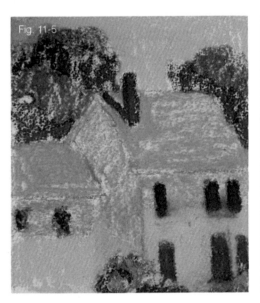

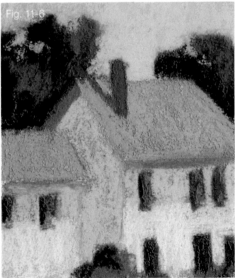

Fig. 11-5. *Warm under cool/ cool under warm* –underpainting. For this study, I made up a white house that is both in shadow and sun. Since I have used hard pastels, note that they are darker than the eventual values of the painting, which is often desirable. Orange was used for the shadowed planes and aqua for the sunlit areas. I also plan to have warm color on the roof and chimney, so I have used a cool blue under both.

Fig. 11-6. *Warm under cool/ cool under warm*—completed study. In the finished study, you can see the orange coming through the cool violet and some of the aqua showing through the light yellows.

color. This scheme is very useful for complicated areas of foliage. For the cooler, shadowed areas, use the appropriate values of violet or blue; in the warm, sunlit areas, use the appropriate values of orange, yellow, or earth tones. Place the appropriate values and temperatures of the green on top. Starting with the broader shapes of cool and warm allows you to assess the success of the composition as the painting progresses.

I think this approach is best used for complicated paintings where one needs to clearly identify the sunlit and shadowed areas. A still life with a lot of chair legs, folds of cloth, or palm fronds might be another example of this usage.

Fig. 11-7. *Analogous colors—* underpainting. For this study, I have made up a simple landscape of tree, bushes and grass with strong light coming from the left. Two values of violet were used for the shadowed areas, and two values of warm rust/orange for the sunlit areas. I warmed the sky with a light orange. (This illustration shows the study before alcohol was applied.)

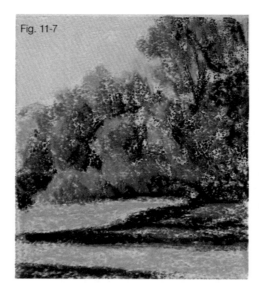

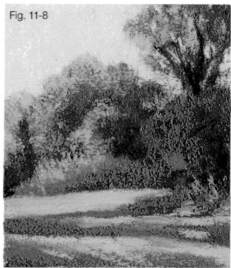

Fig. 11-8. *Analogous colors—* completed study. In the finished study, I used several values of warm and cool greens, allowing some of the undercolor to show through.

Fig. 11-9. *Monochromatic color—*underpainting. For this study, I placed three pears, one green Anjou and two brownish red Boscs on a yellow cloth, creating an all-warm composition. I chose a cool blue green in four different values as an underpainting for contrast.

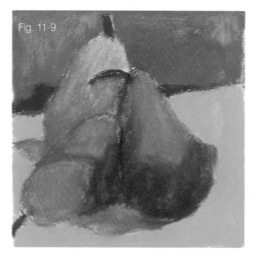

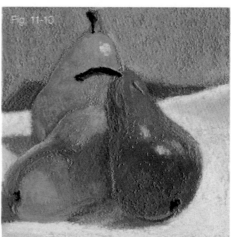

Fig. 11-10. *Monochromatic color—*completed study. Notice that there are small bits of the blue green showing through. I have also added some bluish green over the warm Bosc pear at right.

Arbitrary color

Monochromatic. If one has a monochromatic color palette, a complementary monochromatic underpainting (i.e., four values of one color) works nicely. However, this type of underpainting can be used for any color scheme. It is a way of simplifying the color selection process and can be useful when working outside with limited time for decision-making.

I illustrate the next category with a painting, rather than the informal studies shown above.

Four-color block-in. This scheme was introduced to me by Doug Dawson and I use it in my classes as well as in my own work. A values study is particularly important for this type of underpainting. Select four pastel sticks of different colors, each representing one of the four values used in the values

Fig. 11-11. *Four color block-in*—underpainting. In this example, the darkest value is a dark blue violet, the mid-dark is the magenta, the mid light is the warm sienna, and light is aqua. The sienna and magenta are close in value, but by choosing different temperatures, I still have a degree of contrast.

Fig. 11-12. *Plums, Pears, Cherries, 8.25" x 9"* Wallis "Belgian gray."

study. In every place a value is light, mid-light, mid-dark, or dark, use the appropriate pastel color stick, regardless of the object's local color.

This type of underpainting joins shapes of value to produce an underlying abstract composition that lends strength to the final painting. The challenges are in seeing objects in terms of value shapes and in choosing the four colors. Because the four colors are used in each shape where their value occurs, regardless of the local color, it actually does not matter what colors are chosen, so long as the value is right. Thus, you can really choose any colors you like!

Same or local color. I cover this possibility last because, on the whole, I find it to be a boring option.

Placing the color underneath that will go on top can defeat the purpose of having an underpainting. There are times, however, when it can be useful. If you are painting a complicated subject, such as a blooming cherry tree against a blue sky, you can apply a wet underpainting of blue for the sky and use the pastel to block in the tree over it. This will simplify the process of creating many skyholes.

COLOR CHOICES FOR LOOSE-WASH UNDERPAINTINGS

This type of underpainting works particularly well in a center of interest painting. In the center of interest and areas that will receive more pastel, con-

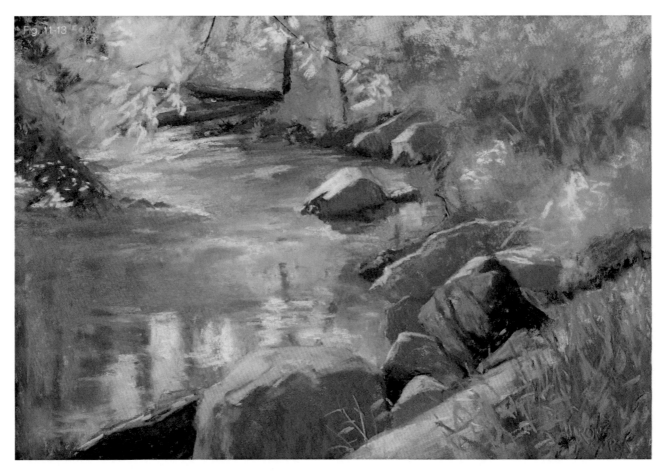

Fig. 11-13. *Froggy Hollow Reflections*, 12" x 18" Wallis.

I started this picture with a watercolor underpainting on the entire surface, using warm tones in the background where there is complex foliage. Next, I used similar tones of Girault pastels to lightly brush in some color, but left a lot of the watercolor untouched. Lastly, I placed richer applications of color in the rocks, leaves, and water reflections.

sider using a contrasting color that will give depth and interest to the layers of pastel. In the areas that are of less interest, use the local color to alleviate the need to cover it up later on. The washes in this area, however, must be rich and dark enough to work with the opaque layers of pastel given adjacent to it in the painting.

For examples of a loose-wash underpainting, see Figures 4-11 and 13-9.

DOING COLOR STUDIES TO DETERMINE COLORS FOR UNDERPAINTINGS

Because there are so many color options for underpaintings, trying out possibilities in one or more color studies can be a good idea.

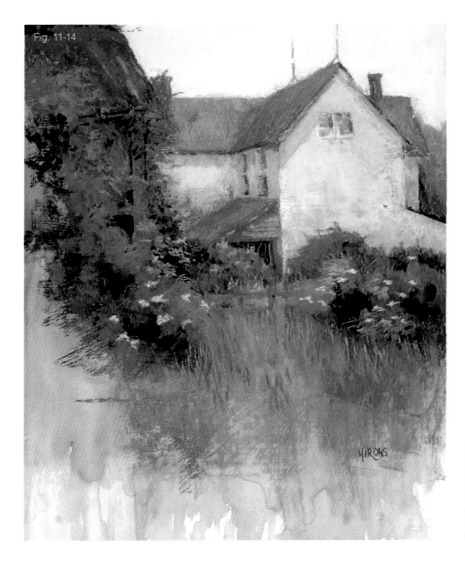

Fig. 11-14. *The Horse Farm*, 20" x 16" Gatorfoam with ground.
In this plein air painting, I left a lot of the watercolor underpainting showing at the bottom as well as some of the white of the surface. Note that the applications of pastel are very light as they approach the uncovered area.

Fig. 11-15. Color study for *Plums, Pears, Cherries* (Figure 11-11). An easy way to begin is with simple color swatches. In this study, four arbitrary colors of differing value have been used for a four-color block-in.

Fig. 11-16. Complementary colors. In this study, I included four values each of complementary colors to use for the underpainting of a picture using this color scheme. The four reds would be placed under areas of green and vice versa.

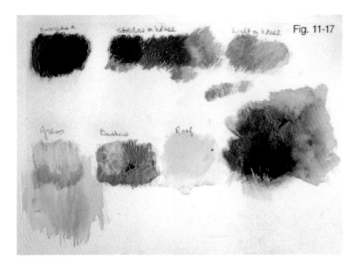

Fig. 11-17. This illustration shows various color studies for *House by the River*. I did a complementary underpainting and used both hard pastel, melted with water, and a watercolor wash for the underpainting (a mixed approach). My study consists of swatches of the hard pastel or watercolor with pastel on top. This study is developed on the same kind of paper on which the painting was done.

Fig. 11-18. *House by the River*, 11.5" x 19" Supertooth.

In the finished painting, the entire bottom left of the painting is watercolor, which also shows through in some of the background trees. The house was underpainted with hard pastels complementary to the local color. I used a cool green under the darker red and a warm yellow green under the warm red. (For the source photo and compositional study, see Figures 6-14 and 6-15.)

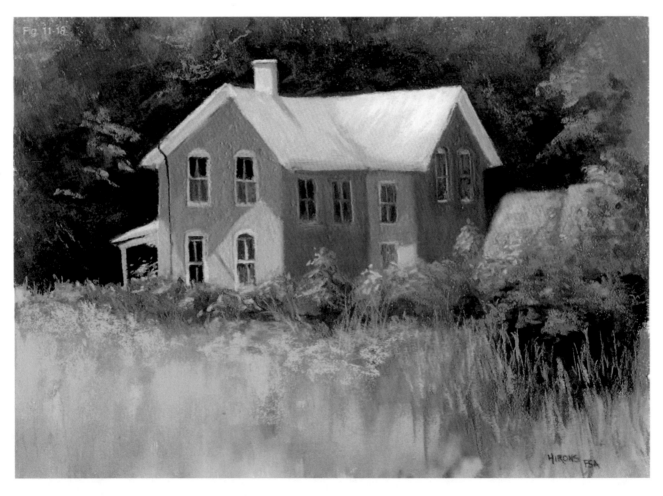

SUMMARY

- Choose the color of a surface based on the dominant value and temperature of the painting.
- Decide whether you want contrasting color or a color that will blend in with much of the background.
- To provide maximum flexibility, use white papers that can be toned to the desired color.
- Underpaintings are there to help! Choose colors that will provide useful contrast or areas of local color that will require little pastel to cover.
- Do simple color studies for underpaintings if you are unsure what colors to use.

EXERCISES

Choosing the color of a toned surface:

☐ Purchase three different colors of Canson: one warm, one cool, one neutral. Choose a simple still life with a dominant temperature. Do a small painting on each tone of paper and determine which was most successful.

☐ Try working on very dark or black paper to determine whether you like the effect.

Choosing colors for underpaintings:

☐ Set up a simple still life. Using a sheet of white pastel paper that can accept a solvent, draw the composition in four boxes and do the following underpaintings: 1) monochromatic color (choosing whatever color you like); 2) complementary color; 3) analogous; 4) warm under cool/cool under warm. Which do you like best?

☐ Try out various color combinations for a four-color, values-based block-in.

☐ Choosing your favorite subject matter, do various types of underpaintings to determine the approach that is most effective.

☐ Experiment with color studies for underpaintings using color swatches.

Chapter 12 THREE APPROACHES TO COLOR

How we see and represent color in our paintings is a signature aspect of our style. We do not all approach it in the same way. Some artists prefer to paint from life, observing and reproducing colors as seen. Others begin with color but are more likely to push it or play with harmonious color palettes. Still others chose to develop their own color, drawing on various sources of inspiration. I use all three of these approaches at different times, and I'm sure many artists do as well.

My goals in presenting this chapter are to make it clear that these options are open to you, to provide situations in which they might be used, and to discuss what this usage entails. How you use color is up to you. It might be the same for all paintings, or it might vary from painting to painting. What is vital is that you understand your approach at the beginning of the painting process.

OBSERVED COLOR

Observed color is *reproducing the color as seen.* It is where most of us begin and for many it is a life-time endeavor. One of the benefits of this approach is that you have clear goals and you know whether or not you have achieved them.

Observed color might be applied in the following situations:

- When the color is the primary reason for choosing the subject to paint (e.g., a still life, floral, or sunset).
- When doing a commissioned portrait and aspiring to capture the tones of skin, eyes, and hair as carefully as possible to satisfy the client.

- When painting the landscape *en plein air* to capture atmospheric effects and the colors in shadowed areas. Some do this exclusively; others use this approach so as to be able to more accurately work from photos in the studio.
- When honing one's skills. Observing and reproducing color, like drawing, is a critical skill for an artist and can be very satisfying.

Observed color can be applied selectively to certain parts of the painting while colors in other areas are chosen according to a different approach, as in Figure 12-1.

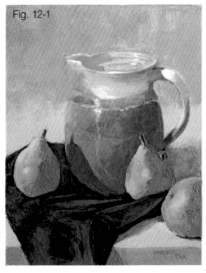

Fig. 12-1

Fig. 12-1. *Red Pitcher with Pears,* 14" x 11" Pastelbord.

In this still life, I used an observed color approach for the pitcher, pears and cloth. For the background, I used an intuitive approach, choosing colors that are consistant with the color palette.

Skills for achieving observed color

Using an observed color approach involves a number of skills that I discuss briefly. Each could be the subject of an entire book.

Put aside preconceived ideas about the color of an object. Forget about trees being brown and skies being blue. Look at what you are painting and analyze the color honestly and thoughtfully. If you are painting a landscape in early morning, the sky is more likely to have a yellowish tinge. And, while yes, the trees do look brown, do you also see some dark green being reflected by the leaves above or perhaps some dark violet in a shadowed area? Might there be some ocher where the light is hitting the bark?

It is easier to see color when painting still life, but it is still too easy to see an object as all one color. A white plate is not going to be white in all places. There may be cast shadows or reflected color from adjoining objects. It might not be white at all!

Thus, the first step is learning to trust what your eyes see rather what your brain is telling you.

See the color of an object in stages. Resist the temptation for immediate gratification! Do not start with the brightest spot of color or a highlight. Instead build to this and add it at the end.

Whether you are beginning with the local underlying color or an underpainting made up of differing colors, the development of observed color is a step-by-step process. Establish the underlying hue of an

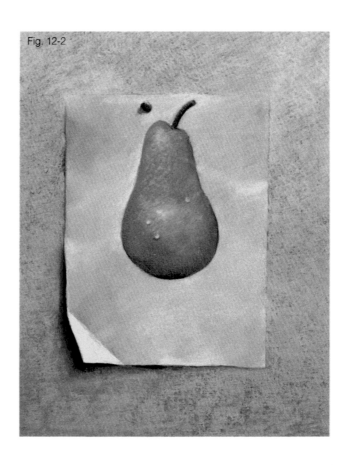

Fig. 12-2

object and the basic value shapes that you see. Observe how the light hits various areas of the object and determine its impact on the local color. Is the lit area lighter, brighter, warmer, cooler, or even a different color? Finally, examine the subject for special highlights, sheen, or reflected colors. By learning to see in stages, it is easier to reproduce color accurately.

Understand how various types of light can affect the color. This is an enormous subject! Understanding how light affects color was the goal of the Impressionist painters and is a major goal of many artists today. A way of honing this skill is to look analytically at all times. An interesting exercise might be

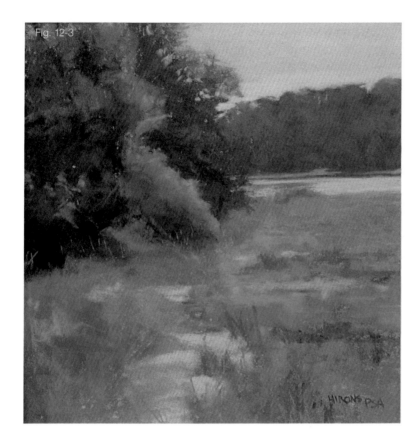

Fig. 12-2. *One Pear*, by Michael McGurk, 18" x 14" Wallis.

In this tromp l'oeil painting, McGurk captures the color and folds of the paper as well as the mottled colors of the board, by carefully examining the subtle differences in value and temperature. The shadow in lower left and the light on the paper give this painting a three-dimensional quality that can only be obtained by careful observation.

Fig. 12-3. *Light of an Overcast Day,* 11" x 12" Pastelmat.

In this plein air landscape, I took an observed color approach, trying to capture the colors as I saw them. The picture was broken down initially into four big shapes: the sky, the cool green trees and water in the distance, the mass of nearby warmer trees, and the ground. I began with colors other than what I observed in order to vary the greens. However, I used an observed color approach in the final colors that I applied.

to place a white object near a window and look at it at differing times of the day to see how the light changes the color of the object.

A very useful reference is James Gurney's *Color and Light*, included in Appendix B.

Use your knowledge of color theory to create believable color, even when you can't reproduce the exact color. The artist new to pastel may be at a disadvantage by not having just the right colors of pastel. This can be frustrating when trying to carefully observe and reproduce color. By learning to use the appropriate values, temperatures and chroma of the pastels you have, you can still create believable and beautiful paintings.

Observed Color and Subject Matter

The painter of still life or portraits is most likely to use an observed color approach. Indeed, it is easier to observe the color in such subject matter, particularly when working from life. The painter of children's or animal portraits will no doubt need to rely on good quality color photos. While reproducing color accurately is never easy, it may be more attainable in these subjects than in landscape painting.

The landscape painter is faced with a very different type of subject matter. Instead of discrete objects, faces or fur, the artist has masses of leaves and grass to contend with and often they are all green! Trees are made up of thousands of small planes (leaves)

that reflect light or disappear into shadow, along with trunks and branches. Thus, a certain amount of interpretation and simplification is an absolute must for successful landscape painting.

Observed color and styles of painting

An artist can employ observed color to create very realistic, detailed paintings, or looser, more impressionistic works. This approach to seeing and using color is not dictated by any one style of paint-

Fig. 12-4

ing. It's about the color itself and how it is represented in the painting.

The artist using a realistic style is more likely to start with the local color and focus on the hue and value. In a still life consisting of hard, shiny objects, folds of cloth, or other such items, it is possible to see and reproduce the colors by using direct applications of the color in the appropriate values. See Figure 12-4.

The artist who uses a more impressionist style is likely to use more color, perhaps small pieces of broken color, or at least an underpainting of contrasting color. As long as the final goal is to approximate the colors that are seen as closely as possible, the approach is one of observed color. Such paintings may look very different from those of the realist. See Figure 12-3.

INTERPRETED COLOR

Interpreting color involves seeing the possibilities in the existing color to become something more. Using this approach often involves *pushing* the color to become more vibrant or changing areas to reflect a specific palette.
Situations in which an interpreted color approach might be used include:

Fig. 12-4. *Incubate*, by Sarah Canfield, 42" x 30" Rives BFK printmaking paper.

Canfield uses careful observation of color to create her amazing still life paintings. Her color choices come at the beginning of the process, when she is setting up the still life. She likes to use a high degree of chroma and contrast and chooses her subjects accordingly.

She says: "I paint in the most direct way I can, taking a lot of time to find exactly the color I want from the beginning. This increases the sense of realism in the work."

- Working from color photographs that need enhancement, particularly landscapes where colors are dull or too much the same.
- Working outside with an all green landscape.
- Any situation where the color appears dull and you want to make it more lively.

Working with this approach often entails the following:

- Seeing the possibilities in a color photograph.

- Pushing color by using higher chroma or warming an otherwise cool picture.
- Establishing a color palette based on the subject but changing some of the colors to adhere to that palette.

Pushing color

Learning to see the potential in color often involves adhering to the values, while making subtle or

Fig. 12-5. Source photo for
Quiet Watch

Fig. 12-6. *Quiet Watch,*
20" x 16" Gatorfoam with
ground.

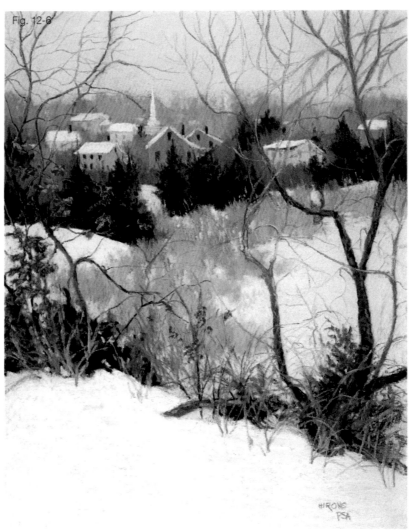

more serious changes to the temperature and chroma. In Figure 12-6, notice how the overall painting is warmer than that of the photograph, and that the chroma of the marsh grasses and oak leaves has been heightened. However, the painting is still believable. Value changes may also be needed when working from photos where the sky is too white, as in Figure 12-5. I painted the sky darker than the snow based on what I saw. Thus, the painting is a combination of observation of the scene and pushed color from the photograph. I made up the village!

How much one pushes color is a matter of style. For some time, I used very high chroma colors (see Figure 4-14). But now, I find that smaller amounts of high chroma color are more satisfying. To quote Duane Wakeham, "it's about the quality of the color, not the quantity."

Sometimes you have to push the color just to make the painting work. What looks good close up does not always work when you step away from the

Fig. 12-7

Fig. 12-8

Fig. 12-7. A typical beach in March—all browns and grays. I wanted this to look like a winter beach but I wanted to use more color in the trees, reeds, and foreground grasses. I saw the possibility of using subtle temperature differences with grayed violets and warmer earth tones, along with some blues.

Fig. 12-8. *March Beach*, 24" x 18" Gatorfoam with ground.

In the painting, violets and blues were used in the distant trees, and violets were used in the shadowed areas of the sand. I warmed up the grasses in the lower left, as well as the evergreens in the distance. The resulting picture is warmer and more colorful, while still retaining the essence of the winter beach.

Fig. 12-9. *Sun and Shadows*, 12" x 16" Pastelmat.

This plein air painting is of the same scene as Figure 12-3, but it was painted on a sunny day. In this case, I decided to take a more interpretive approach to the color. When I observed a cool green, I used a color that I thought would be more expressive. There are more violets evident in the dark areas of the foliage and the color of the sky and water were pushed to more vibrant colors.

Fig. 12-10. *Bush Lite,* by Michael Kolasinski, 16" x 20" Colourfix liquid primer rolled on foam board.

Kolasinski pushes the color for sure, but notice the balance of color due to the dominant blue violet, the closeness of value in the warm and cool colors of the water, and the small amounts of high chroma yellow greens against the lighter, more grayed background trees. The painting exhibits both calmness and excitement created by light.

Fig. 12-11. *Sunray Market,* by Michael McGurk, 16" x 20" Wallis.

McGurk also used an interpretive approach for this painting. The richness of color and the limited palette of complementary red orange and blue green give this gritty street scene both serenity and beauty. The black, gray, and neutral warm tones give the scene a sense of reality and keep it from being too "pretty."

Fig. 12-12. *Recycled/ Crushed Cans, Boxed,* by Robert Carsten, 22.5" x 29.5" La Carte.

In this colorful still life, it is obvious that Robert Carsten has pushed the color, while still creating a realistic scene of recycled cans. The can labels are high in chroma and probably pretty true to life, but notice the many colors used in the unlabeled metal surfaces.

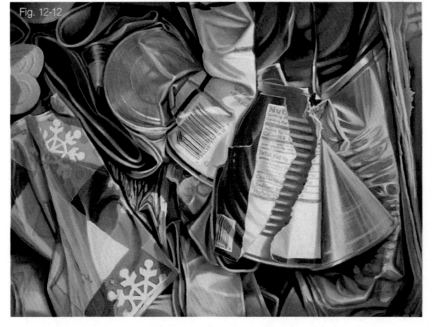

easel. For this reason, it is important to be able to get away from your work and view it from a little distance. It will quickly become apparent if the values or temperature contrasts are not strong enough, or if too much high chroma color has been used.

Interpreted color can be used when painting from life as well, particularly when the colors are too much the same, as in the greens of summer.

Many of the contributors to this book describe themselves as interpretive painters.

Tips for using interpreted color

When working from photographs, examine them for composition and color possibilities.

- Develop the composition through studies, if necessary, and do a values study.
- Determine whether the photograph suggests a particular color palette. If so, look for areas that might be changed to adhere to that palette. If necessary, do one or more color studies.
- Based on the chosen palette, determine what color the darks and lights will be. In a landscape, this will most often involve the darks in foliage and the lights in the sky. For an example, see Figure 10-2, in which I changed the colors of the sky to cool greens and pinks so as to comply with the overall color palette.
- Determine what colors to push and how. Where will the chroma be hightened or the temperature warmed? Will values be enhanced to provide more drama? Are there pure grays or browns that can be replaced with grayed colors or even more vibrant colors?
- Are there colors that can be supplied? Buildings in a landscape often provide the opportunity for color changes. A white building might be changed to yellow; or the white might be represented by any number of light cool or warm colors.

Working from photographs can be rewarding if one knows how to manipulate them. Remember that you are creating a painting, not copying a photograph.

When I use an interpretive approach, I am not as concerned with reproducing the color in the photograph as I am with creating a painting in which the colors work together to produce a unified whole.

When working from life it can be more difficult to change what is before you. Using an underpainting of opposing colors can be a good way of beginning a painting in order to push the color. Look for differences of temperature that can be enhanced and opportunities for bright, high chroma colors in the center of interest. Do not forget about dominance, contrast, and nuance when selecting colors.

INTUITIVE COLOR

Intuitive color comes from within or from sources outside of the subject matter. The color is *supplied* by the artist. Intuitive color can appear believable to the viewer or it can be completely detached from reality. This is, once again, a matter of style.

Intuitive color might be used in the following situations:

- In paintings that are abstract or non-representational.
- When painting from black and white sketches. When painting from a black and white photograph.

Painting with an intuitive color approach may involve:

- Envisioning color.
- Finding other sources of inspiration.
- Letting the painting and a possible underpainting speak to you as you progress.

Fig. 12-13. *Chimera*, by Deborah L. Stewart, 18" x 24" Wallis.

Stewart says "since my work is abstract, I choose colors very subjectively and based on intuition. I may start with an impulse that I want to create a painting with a large area of yellow green. It is also typical that what I am working on changes halfway through and goes in a different direction than what I first had in mind. I am open to surprises and experimentation."

Stewart does not do color studies for specific works but creates small experimental works in order to play with various color combinations. She enjoys combining neutrals with high chroma color.

Fig. 12-14. *Before the Ascent,* by John Davis Held, 16" x 20" Townsend paper.

Held also uses an intuitive approach for his abstracted representational paintings, which are based on his imagination.

Fig. 12-15.

Fig. 12-15. I took the photo for the shapes, certainly not the color! The colors I used were visualized prior to doing the painting. I saw the potential for dark warm and cool colors in the house, bright colors in the sunlit areas, a red roof, and a more brightly lit sky. A color study helped me develop the exact palette. In the study, I began the sky with warm green watercolor, which I might have been afraid to use without having tested it. Note that while the painting is much more colorful, it isn't totally beyond the realm of reality.

Fig. 12-16. *House on the Point*, 16" x 20" Pastelbord.

Fig. 12-16

Fig. 12-17

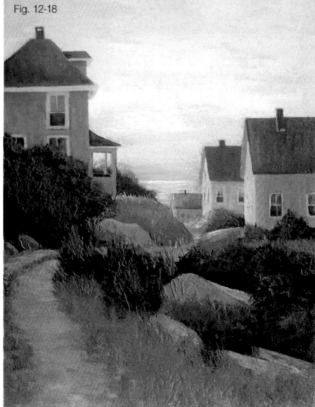

Fig. 12-18

Fig. 12-17. Source photo. The photo was taken at mid-day. Having observed the colors of early morning in another location, I decided to change the time of day. This meant changing not only the color, but also the values. I reworked and simplified the composition, making significant changes, and worked on the values and color. For the color studies, see Figures 10-20 and 10-21.

Fig. 12-18. *Daybreak, Stonington*, 28" x 22" Gatorfoam with ground.

Fig. 12-19. Reference photo of New Bedford mills. This photo was taken purely for reference. I needed the shapes of the buildings and placement of the towers. I didn't care about the color.

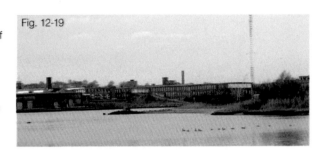
Fig. 12-19

Fig. 12-20. *New Bedford Reverie*, 9" x 24" Wallis "Belgian Gray."

I used the palette of greens, oranges, and reds from a painting of a figure that I cut out from a magazine. It created a completely different mood from the very cold day in December when I took the photo (textile mills with chartreuse windows!). I also added the 19th century sailing ship as a bit of nostalgia.

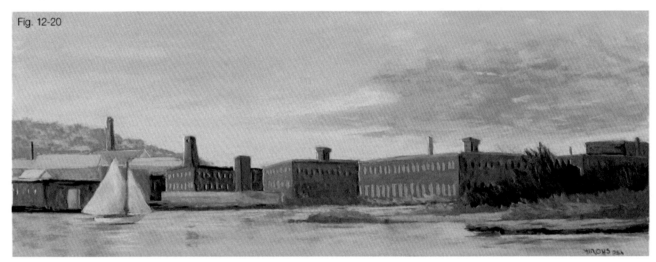
Fig. 12-20

• Doing one or more color studies to try out various possibilities.

When a limited color palette is desired, the use of an intuitive color approach allows complete freedom to choose the colors in the palette. Employing your knowledge of color theory is vital and doing one or more color studies can be helpful to the success of the painting.

I use intuitive color most often when the color in a photograph is found to be wanting.

Finding sources of inspiration

Whether working in a totally non-representational style from the imagination, or changing the color in a photograph, artists rely on various sources of inspiration for their color choices.

One source can be the paintings of other artists. A useful tool that I have been creating for years is an *idea book* of clippings from magazines such as *Southwest Art*. Making a quick decision, I clip pictures that I find appealing, either for their composition or their color. This has become a handy teaching tool, as well as helping me understand my own preferences in terms of color. It has also served as a source of inspiration when looking for color ideas.

Color ideas can come from anywhere. The important thing is to be looking for them--when driving in the car, walking through a store, or watching TV.

Fig. 12-21

Fig. 12-22

Fig. 12-21. Reference photo for *Spring Twilight.* Wakeham notes "*Spring Twilight* relates to a specific location that I have glimpsed for years while speeding by on a busy freeway. Finally, while riding in the passenger's seat, I had my camera ready when approaching the spot and managed to snap a single shot. The surprise was that what I wanted to photograph was much less interesting than another part of the image, which became the subject of the painting."

Fig. 12-22. Color study for *Spring Twilight.* He continues: "Yellow, at least a high-keyed yellow—is not a color that I use frequently. While developing the color study I felt the need to counter all of the yellow by introducing its complement purple, which explains the slash of red-violet along the top edge of the foreground hill at the left, as well as in the trees on the right, plus the introduction of it into the background mountains."

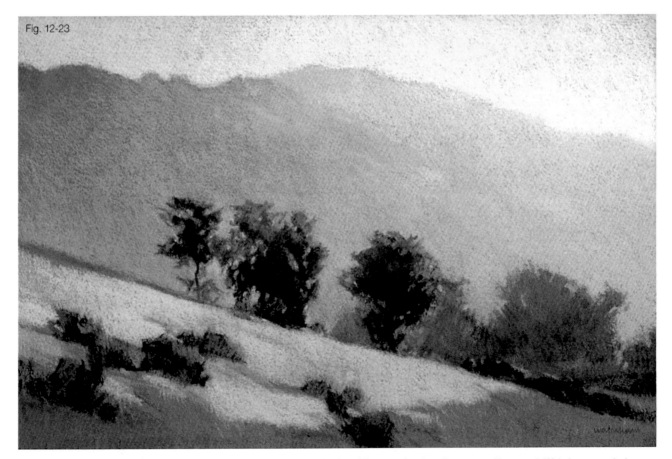

Fig. 12-23

Fig. 12-23. *Spring Twilight*, by Duane Wakeham, 19" x 29" Arches 300-lb cold-pressed watercolor paper with ground. Wakeham concludes: "The bold strokes of purple in the color study give way to much more subtle handling in the finished painting, but the impact of the color in establishing balance is not diminished and contributes significantly to the final image."

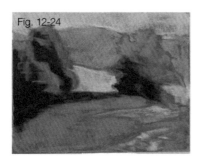

Fig. 12-24. Underpainting for *Late Day Light.*

In this dry underpainting, I chose four colors somewhat randomly that I thought worked well together and would add interest to the finished painting.

Fig. 12-25. *Late Day Light,* 9" x 12" La Carte.

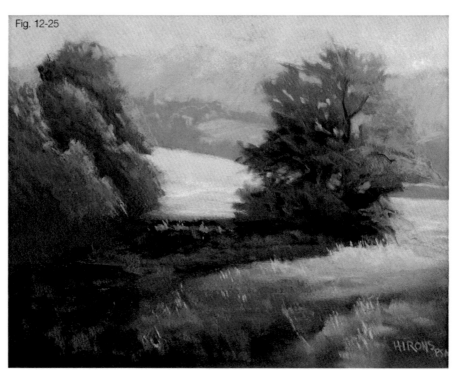

If the color combination is pleasing, ask how the colors might work in a painting. Are some of the colors complementary? Are there too many bright colors? Is there one color that is dominant?

Deciding on the mood you want to create is an important first step to selecting colors. What do you want to say about the subject? How do you want the viewer to feel when viewing your painting? Consider whether the picture will work best in warm tones or cool. Will it work best with analogous colors or those that are opposite or equidistant from the primary color?

Using color studies for intuitive color

Using one or more color studies can be an im-

portant tool in using intuitive color. But once the painting is under progress, other colors may be introduced and the study will be just that—a study. Duane Wakeham was influenced by one major color in the reference photo, but used an intuitive approach to create a balanced color composition (see Figures 12-21 to 12-23.)

Using an intuitive approach for underpaintings

Even when the goal is observed or interpreted color for the final colors, one may use an intuitive approach to the initial colors. (see Figure 12-24.) As we gain experience, we find colors that work well with others. I know that orange works nicely under a warm

Fig. 12-26

Fig. 12-26. *Patchwork,* by Lee Kimball, 20" x 20" gray mat board.

Kimball says "In my work I am reacting to color and light, frequently choosing to emphasize or push, one or the other, or both, depending on my initial reaction to the subject. I'll emphasize, diminish, or change things in the subject in order to produce my vision of the work. In the end, I want to produce a painting that is my reaction to the subject, not just a photograph."

area of green grass, and that red violet works beautifully in the shadowed areas of the greens. I like to use warm colors under cool and cool colors under warm when I'm creating the planes of a house in sun and shadow.

Letting the painting speak to you

While some artists do color studies, others would rather begin with a color or two and let the painting speak to them about what further colors are needed. Doing this, to some extent, is important for any painting. This approach works well for experienced artists who know how colors interact. The beginner may want to plan a little more to avoid too much brushing down.

Two paintings presented in previous chapters, *Eucalyptus* by Duane Wakeham (Figure 5-3) and *Good While it Lasted* by Lisa Shepperd (Figure 9-20) are examples of an underpainting that proved to be more interesting and successful than the colors originally intended for the final layers of pastel. The photo reference for Eucalyptus was all green and the pinks and reds were intended to be complimentary. But Wakeham liked the colors so much, he left them. In Shep-

Fig. 12-27. *Eclipse*, by Jimmy Wright, 35" x 21" Lanaquarelle 300lb hot press; Private collection, courtesy of the artist and DC Moore Gallery.

The black disk in the upper right is the sun during an eclipse. We all know we aren't supposed to look at an eclipse and Wright is looking away from it, his face in shadow. But his ear is picking up the light. "The pure red becomes light animated as an active player and as a physical object in the implied narrative of the pastel."

Wright says" Observation of the world around me is a starting point. I am not trying to reproduce what I see in front of me. Once strokes or areas of color are applied to a flat sheet of color, I observe their interaction with each other. This is an exercise separate from the observation of reality as a subject to represent. The observation of color on the flat surface is based entirely upon sight. Context determines the perception of color. One color against another determines how a color is perceived." He says: "In *my* color book there is no new theory of color. But, in it, there is a way to learn to see."

Fig. 12-27

perd's painting, the original scene was snow-covered and the greens were intended as an underpainting. However, she realized that adding snow would change the values and the painting wouldn't work. Both Wakeham and Shepperd began with one idea but knew when to leave well enough alone!

ANOTHER APPROACH

have defined three approaches to color: observed, interpreted, and intuitive. There are others and

Jimmy Wright proves the point. His color usage is based on observation, not of subject matter, but of how one color relates to another. His studies in art included an intense course of Joseph Albers' *Interaction of Color*. He says: "in doing exercises, one never actually mixes color. Instead you work with a color-pack of 300 silk-screened colors. This can be a frustrating experience for painters, but is ideal for pastelists, who do not have to mix color."

SUMMARY

- Observed color involves putting aside preconceived ideas to reproduce color as it is seen. However, one does not have to begin with the observed color.
- Interpreted color entails seeing the possibilities of the existing color to be more vibrant or harmonious. This can result in pushing the color or changing colors to fit a color palette.
- Intuitive color comes from within or from sources outside of the subject matter. How believable the color is depends on your style.

EXERCISES

☐ Set up a still life and do two small paintings. In the first, begin with the local color, working from dark to light and hard to soft. In the second, begin with an underpainting of opposing colors, then use local color on top.

☐ If you are a landscape painter who likes to work from photos, in addition to taking the photo, make careful notes on the observed color of various areas of the picture, particularly the shadows. Consider making small color "notes" outside.

☐ Examine other artists' work to determine your taste in color, how real you want it to be, and how comfortable you are in moving away from reality. Be honest with yourself and resist making a decision based on what you think it *should* be!

☐ When working from life, particularly landscape, do quick color studies to find ways to simplify the color and make it more expressive. Ask yourself what you like about the color you see. If there are areas that aren't interesting enough, how can they be made more interesting by pushing the color in some way?

☐ Try working from black and white, either a sketch or a photograph. Do various color studies to determine the color scheme that fits the mood that you wish to create.

☐ Find a painting by another artist that you particularly like because of the color, then use that color scheme in a painting of your own.

Chapter 13

PAINTING STAGES DEMONSTRATIONS AND PROBLEM SOLVING

In this final chapter, I discuss three stages of painting development once the surface selection, lay-in, and possible underpainting have been completed. Three demonstrations illustrate the decision-making process. Finally, a section on problem solving offers insight into the forgiving nature of pastel.

THREE STAGES OF PAINTING CREATION

Pastel paintings are usually created in stages. The first stage consists of the initial layers of pastel. These are often, but not necessarily, created with harder pastels. A wet or dry underpainting might precede this stage. The second stage develops the painting almost to its completion and is dependent on the color approach, as described in Chapter 12. The third stage is one of careful review and final touches and corrections. The process is one of constant refinement, from the most basic shapes to the tiniest details.

STAGE 1. **Initial layers of pastel**

How you select the colors for the initial layers of pastel depends on whether the initial layers are directly applied to a toned surface or whether they are applied over an underpainting. Other factors are the color palette, the type of pastels and stroke being used, as well as the chosen color approach.

Color choices for direct application of pastel on a toned surface

When applying pastel directly to a surface, choose the sticks first by value, then by temperature and chroma. If beginning with hard pastels, the choices of color will be more limited and colors are likely to be darker and brighter. Build color gradually, working up to the more subtle colors in the next stage.

Your stroke will make a difference as to color choices. When using a linear stroke, many colors might be used to build an area. A scumbled or block stroke may result in fewer colors being used. When selecting specific colors, use the correct or a little darker value, but to provide contrast, consider using colors that are analogous to the final color. For example,

Fig. 13-1. *Low Tide,* stage 1 12" x 12"
Pastelbord "gray"

In the first layers of pastel, I used bright Faber-Castell Polychromos to lay in the basic shapes and values. I chose a mix of warm oranges, reds, and pinks for the top of the marshes, as well as the sky and cooler blues and blue greens for the water. The bright colors provide an exciting first layer of color over which I can add a little grayer and more realistic colors, while retaining a certain amount of vibrancy.

you might begin the shadowed area of a green pot with blues or violets when using direct application. Avoid using heavy applications of complementary or other opposing colors, however, to prevent subsequent layers from becoming grayed.

My advice is to go slowly or incrementally to the final color. When painting snow, for instance, do not begin with white or your lightest colors as there will be no place to go. Think of this as a journey towards beautiful color. Don't end the trip while packing your bags!

Color choices for application over an underpainting

When beginning with an underpainting of contrasting color, the first layers of pastel will most often begin the development of the desired color, as determined by your palette and approach. Work lightly so as not to completely cover the underpainting. Focus on the big shapes that have been created in the underpainting and the introduction of some smaller shapes. In terms of color, you may want to begin a little darker at this stage.

The subject matter may determine the type of pastel initially used. The choice of colors for skies and clouds in hard pastels is often too limited and I sometimes begin immediately with soft Great American and Unison pastels, as shown in Demonstration 2 in this chapter, Figure 13-10.

STAGE 2. **Developing the desired color**

Developing the desired color is the heart of the painting process. The specific color choices are governed by your approach. Continue breaking down large shapes into smaller, more detailed shapes of color and value. Build the color by introducing softer

pastels. Correct the values, warm the temperature, dull the chroma or add pieces of saturated color. Pay careful attention to the center of interest and edges.

Keep stepping back to analyze whether the color is working. Is there enough contrast? Is there too much? Is the color what you envisioned?

STAGE 3. **Final details and analysis**

This stage is the same for all pastel paintings, regardless of application or color approach. The final highlights are added and the painting is analyzed to be sure that the color is balanced and effectively used.

Finishing the painting requires stepping back and giving it an honest self-critique. It may be wise to put the painting aside and view it after a week or more, when you are not so fully engaged and can bring a fresh eye to the process.

Ask the following questions regarding the color choices:

- Is the center of interest clear? Do I need to brighten or dull colors to make it more obvious? Are there sharp edges in other areas that diminish the impact?
- Is there isolated color in the painting? If so, where else can appropriate values of the color be integrated into the painting?
- Are the warms and cools convincing? Do I need to *push* the temperature with warmer or cooler color to strengthen the painting?
- Is there anything that is bothering me? If so, fix it; if not, leave it alone!

When you are not sure, ask someone else for their opinion. My husband is always my first consultant. After that, I ask artists whose judgment I trust. I have formed a critique group that meets several times a year. From time-to-time, I send images to a noted

pastel artist for advice. Do what works best for you. And always ask for honest and helpful critiques; praise is nice but it does not solve the problem!

If you receive suggestions from others, do not feel that you have to make every change. Weigh the advice against what you want to say in the picture and make the final decisions yourself.

DEMONSTRATIONS

In the following three demonstrations, I illustrate three applications of pastel, as well as three approaches to color. I finish each demonstration with a list of decisions in the order they were made for that painting which reflect many of the instructions in this book.

DEMONSTRATION 1. Observed color using a dry underpainting

Fig. 13-2. Still life set up. I selected objects in a limited palette of greens and warm orangey-browns. The objects were placed on a black cloth and I added a white plate to provide contrast.

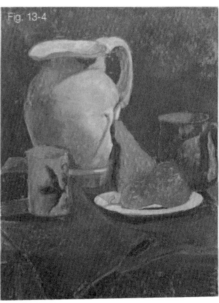

Fig. 13-3. Lay-in of composition. I used Wallis "Belgian gray" sanded paper for its tone and flexibility. I opted for a vertical composition to include the triangle of cloth at the bottom which leads the eye into the picture. A simple lay-in was added with a 2H pencil. I lightly added indications of value shapes and drew objects in their entirety to be sure they were correctly drawn. In this illustration, you can see the line of the lower left side of the pitcher behind the cup.

Fig. 13-4. Dry underpainting. Because I have chosen objects that are almost complementary in color, I wanted to begin by using colors that are opposing to the final color—oranges under greens and greens under oranges. This is best accomplished in an underpainting. When working on a neutral-toned surface, I don't feel the need to do a wet underpainting to cover up the entire surface and I have chosen to use a dry underpainting of hard pastels sprayed with workable fixative. (I have discovered that I love the tooth produced by workable fixative after years of not using it!)

I applied one color per value area, but did some mixing to keep the edges from becoming too hard. I also began the plate cooler than it will become. For the black cloth, I used various greens, using a very dark green for the blackest parts. In the background is a mixture of warm reddish browns and greens.

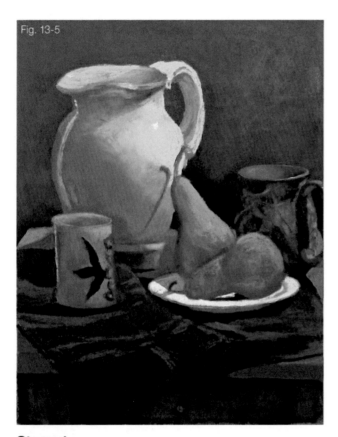

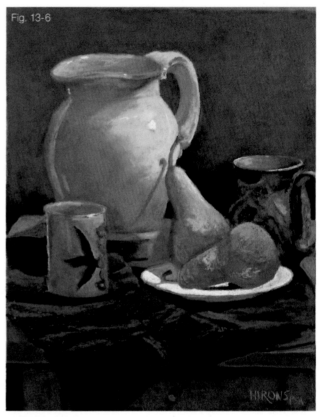

Stage 1

Fig. 13-5. After working quickly on the hard pastel underpainting, I took my time in completing this first stage of the painting. I used a variety of pastels in order to be able to reproduce the color as I saw it.

The pitcher has been painted with hard pastels and Giraults in a variety of greens. I added the highlight on the left in order to be sure the values are working. Blue green was used in the shadowed areas of the pitcher so that the blue green in the mug does not become isolated. The warm underpainting of the pitcher is revealed in places, as is the blue green of the pears.

The pears and cup have been painted with similar colors of hard pastels. I applied a warm pinkish orange to the lower left of the pitcher and to the top of the bottom pear, based on observation. The plate was painted with hard sticks of light blue and yellow, as well as a darker blue gray Unison in the shadow on the left.

The cloth, table, and background were painted using soft pastels. For the cloth, I used two values of a Schmincke dark grayed red violet. I also added a very dark grayed green Ludwig on top which further neutralized the color to read as "black." In the fold of the cloth at bottom and the crevices of the table, I used a little pure black. A mix of Ludwig grayed greens and browns were used for the background.

Stage 2

Fig. 13-6. I made corrections to the drawing of the top of the cup, paid more attention to the details, such as the stems and cast shadow, and added more highlights. I used soft pastels to add more color to the pears, particularly the upright pear. I also lightened and brightened the colors of the mug.

A number of edges have been softened to be sure that the eye goes where I want it to and to produce a more painterly look. A very pale blue soft pastel was used in the plate, along with a light warm yellow on the left side. The same grayed blue that I used in the shadow on the plate is used for the highlight of light in the mid left portion of the cup. In the background, I used a mix of reds, greens, and blue greens. I decided that the bottom has enough detail to be interesting but is dark enough not to draw too much attention.

I brought this version to my class for comments. One student noted that the dark spots on the lower pear make it look like a skull! The strong pieces of dark and light on the lower right side of the pitcher also don't work. From my own observation I think that the pitcher needs to lose a little of the orange coming through.

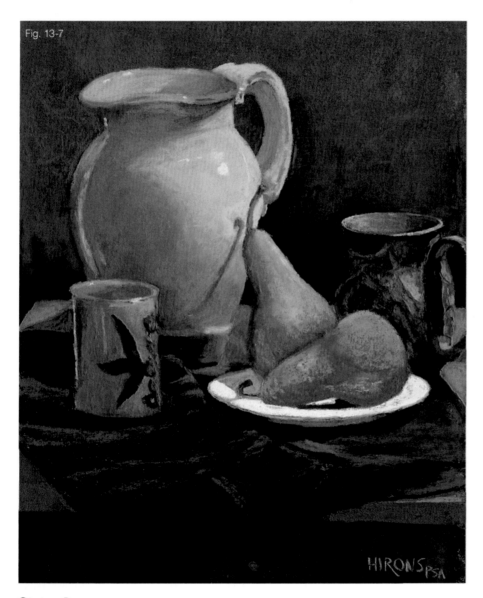

Fig. 13-7

Summary of decisions:

- SUBJECT: still life
- COLOR APPROACH: Observed.
- COLOR PALETTE: Near complements of orange and green.
- TYPE OF COMPOSITION: Big shape
- SURFACE: Wallis "Belgian gray."
- TECHNIQUE: Dry underpainting.
- LAY-IN: Graphite.
- PASTELS: Combination of hard, grainy soft intermediates, and soft.
- COMPOSITIONAL DECISIONS: Vertical, 11 x 14; center of interest: vertical pear and cast shadow.
- UNDERPAINTING COLORS: Complements and warm under cool/ cool under warm.

Stage 3

Fig. 13-7. *Green Pitcher with Pears,* 14" x 11" Wallis "Belgian gray."

This final version was completed almost a week after stage 2 had been completed. The pears were eaten but I was able to resolve the problem of the "eyes" on the lower pear and also softened the saturated and lighter pieces of color on both pears. More greens were added to the pitcher, including blue green in the shadows and lighter warm green in the lit area. There is less of the orange showing through at this point. The highlight on the pitcher was adjusted with a little brighter color and the pinkish color of the pear was softened.

This painting, while beginning with non-local color, now represents the colors I saw to the best of my abilities. It also satisfies my desire to have both nuanced and lively color.

DEMONSTRATION 2. Interpreted color using a wet underpainting

Fig. 13-8. Source photo. A farm in Maryland on a January day after a light snowfall. I like the colors in the photo, particularly the blue violet of the shadowed trees and red violet of the trees in light. But the buildings are all a grayish white and rather dull, as is the field in the foreground. I don't want to change the mood but I want to make the painting warmer and a little more colorful.

Fig. 13-9. Watercolor underpainting. After a number of compositional studies, I decided on a 12 x 18 format and worked on mounted white museum-grade Wallis. I did a careful drawing of the buildings with graphite. Because the surface is white, I did a wet underpainting. I chose to use watercolor, rather than pastel, so as not to lose my drawing and to keep the underpainting fluid and not too heavy. I used the local color for the background trees, but opted for warmer reds, oranges, and violets for the buildings. In the foreground, I used colors that I wanted to show through the patches of snow. I was disappointed with the watercolor application in the sky but knew I'd be covering it. I used several applications of watercolor to provide a rich enough underpainting.

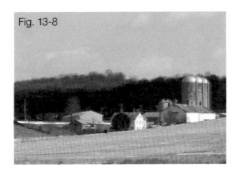

Fig. 13-8

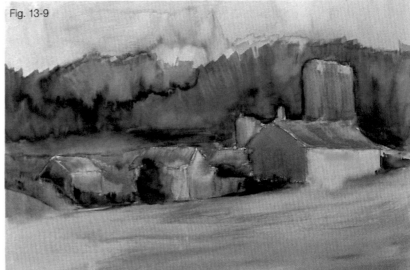

Fig. 13-9

Stage 1

Fig. 13-10. I began the sky with soft Great American pastels, as I prefer the colors that are available. Everything else is Girault with a little hard pastel in the trees. I used a combination of a dull grayed red and a grayed green in the foreground to represent the color of the fields under the snow.

When beginning the layering of pastel in the buildings, I applied a warm under cool and cool under warm approach, being careful to avoid heavy application. I started the shadowed side of the barn with a warm brown, adding blue violet on top. I used a warmer color on the lit side, then added a warm greenish blue. I didn't want this area to compete with the sunlit sides of the house and shed.

Determining the center of interest is a challenge for a picture like this, as there is a progression of buildings from left to right. I chose

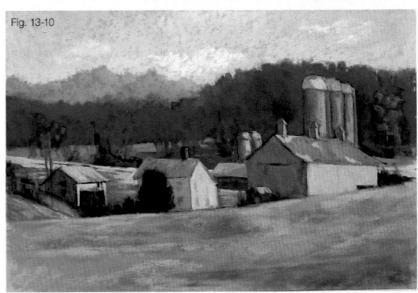

Fig. 13-10

the area of the house and shed where the darkest darks are located. But the barn and silos are strong shapes, so I made the lit side of the barn and silos cooler than the yellow of the house and shed.

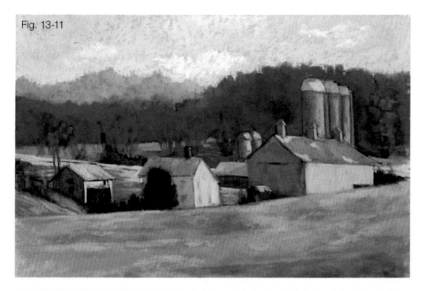

Fig. 13-11

Stage 2

Fig. 13-11. At this stage, I have added some light yellow and hints of lines to the lit side of the barn to break up a large shape. I simplified and refined the silos with soft pastel, and added snow to the foreground with a light blue Schmincke. I also broke up the distant trees with sky holes.

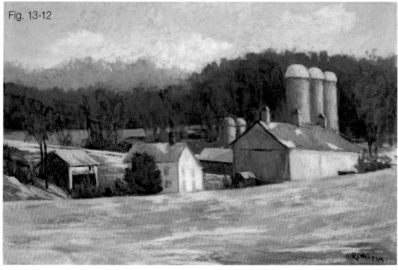

Fig. 13-12

Stage 3

Fig. 13-12. *Carroll County Farm,* 12" x 18" Wallis.

I made a number of color changes to the final version. First, I added the same blue violet from the trees to the shadowed side of the shed and softened some of the edges. Dark blue green was added into the dark band of distant trees to give this area more depth and interest. I also softened the yellow of the house with a lighter, whiter yellow, and added a light yellow to areas of snow near the house. These changes were relatively small, but I am much happier with the painting.

Summary of decisions:

- SUBJECT: landscape from color photo
- COLOR APPROACH: Interpreted.
- COLOR PALETTE: Complementary blue violets and yellow oranges, with other warms and cools.
- TYPE OF COMPOSITION: Center of interest
- COMPOSITIONAL DECISIONS: Horizontal, 12 x 18; center of interest: house and shed.

- SURFACE: Wallis museum grade white, dry mounted.
- LAY-IN: Graphite.
- PASTELS: Primarily intermediate and soft.
- TECHNIQUE: Wet underpainting using watercolor.
- UNDERPAINTING COLORS: Combination of local color and warm under cool/cool. under warm.

DEMONSTRATION 3: Intuitive color using direct application of pastel

Fig. 13-13. Source photo. For this painting, I worked only from the black and white photo of a scene from my home town. I have painted it many times before (see Figure 10-18), and thus, am familiar with the actual colors. I decided to use the black and white photo to free up my color choices. I include the color photo at the end of the demonstration.

Fig. 13-13

Stage 1

Fig. 13-14. Initial application of hard pastels. I used a direct application of pastel on "sienna" Pastelmat. I chose the warm tone to help warm up what was a very cold winter scene. After sketching in the basic shapes in charcoal, I used Polychromos and NuPastels for the initial layers. I chose not to do color studies because I had a vision of the color I wanted and just tested the initial colors on the side of the paper.

My initial thoughts on a color palette were to use reds and greens, but as the painting progressed I felt the need for cooler contrast, adding dark blues, which helped provide balance. The color that pleased me the most was a teal green Polychromos, which I used in the trees and water; I found that it had a good unifying affect and balanced the warmer colors in the trees and grasses.

I added a small house in the distance which automatically becomes a center of interest. However, I don't want it to be too prominent. What always draws me to the scene is the reflection of the trees and light in the foreground stretch of water.

Fig. 13-14

The orange light on the background trees gives the sense of late afternoon light. The darker areas in the sky are clouds, which are slightly darker than the sky in the photo.

Stage 2

Fig. 13-15.

Fig. 13-15. Here, I have added softer pastels and refined the color. I used Unisons and Schminckes in the sky and water, and Giraults for the trees. An ocher Ludwig soft pastel replaces brighter yellow greens in the central grasses and path. I added more detail, including the bare trees at left and in the background on the right.

The color of the roof has been changed to cool it down and make it less intrusive. I used yellow for the area of sky and now it looks more like clouds!

Stage 3

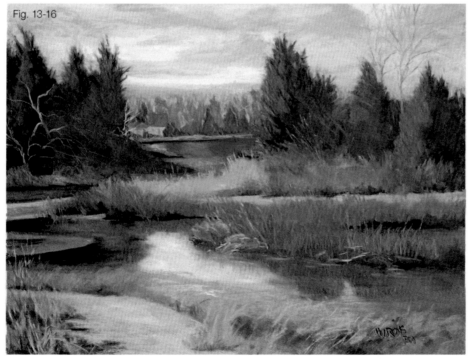

Fig. 13-16.

Fig. 13-16. *Eel Pond Revisited*, 12" x 16" Pastelmat.

In the final version, I decided to tone down the distant trees, and changed the color of the house to a warmer, more neutral color that makes it stand out less. I made further refinements to the trees and sky and made other small changes to balance the color.

By working from the black and white photo of a familiar place, I have created a painting with color that is vibrant and alive, without being unbelievable. Now, let's see what the color photo looks like.

Fig. 13-17. Color photo for *Eel Pond Revisited*.

The colors of the photo are much more in the blue and orange range, but pretty dull overall. By using more greens and ochers, I warmed up the picture considerably and pushed the chroma as well, particularly in the areas of the water and reeds.

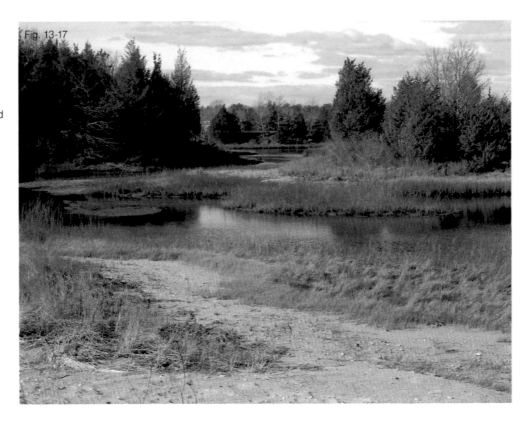
Fig. 13-17

Summary of decisions:

- SUBJECT: landscape from black and white photo.
- COLOR APPROACH: Intuitive.
- TYPE OF COMPOSITION: Big shape.
- TECHNIQUE: Direct application.
- COMPOSITIONAL DECISIONS: Horizontal, 12 x 16; center of interest: house and lower water.
- SURFACE: Pastelmat "sienna."
- LAY-IN: Charcoal.
- PASTELS: Hard, intermediate, and soft.
- COLOR PALETTE: Near complements of cool and warm greens and various earth tones with smaller applications of other colors.
- INITIAL LAYERS: Analogous colors.

PROBLEM SOLVING

Even the best-laid plans can produce unsuccessful paintings. Sometimes a few small changes will make the difference; other times more dramatic steps are necessary. In this section, I offer examples of *color fixes* and a *complete makeover*.

There are many possible reasons for a painting being unsuccessful. If the composition or drawing is poor and cannot be fixed, there is little hope for the painting, unless one begins again. Small compositional changes, however, are quite possible due to the forgiving nature of pastel. If these are not the problem, then some aspect of the color is probably in need of repair.

Color fixes

Many times the problem lies in the values that have been used. There is either not enough contrast or the contrasts are too extreme. If one has blindly copied a photograph, this may well be the case. Always look for incorrect values first as the reason for your dissatisfaction. If the value is too light, the pastel may need to be brushed off. If it is too dark, lighter colors can be added.

Secondly, examine color temperature. Are you trying to indicate light by using cool, whitened colors, instead of warmer, more yellow colors? Remember that lightened color does not always equate to warm color because white is cool. Perhaps the temperature is wrong for the area. It might appear as being sunlit, when you wanted it to read as being in shadow.

Next consider chroma. Are your colors dull and gray, or conversely, are there too many bright colors? Are there bright colors where they shouldn't be, such as on the edge of the painting? Is there the potential for graying color near colors of higher chroma to highten contrast?

Examine also the texture used in the painting. If most of the colors are broken, with a more varied look, and another area has flat, solid color, it will stand out and not appear consistent with the rest of the painting.

Fig. 13-18

Fig. 13-18. In this painting, the orange triangle is too prominent. After examination, I realized that the yellow color above was the culprit. I resolved the problem by changing the yellow to a more neutral green and adding a little of the orange. This is a very subtle change, but it made a big difference for me.

Fig. 13-19

Fig. 13-19. *Rolling Hills of Iowa*, 16" x 20" Pastelbord.

Fig. 13-20. Something about this plein air painting was really bothering me. Upon analyzing it, I realized that both the value and temperature of the water in the foreground didn't work. The background water is a light blue violet. The foreground water is warm blueish-green. While this was the color I observed at the time, it did not look right to me.

Fig. 13-21. Plein air painting, 9" x 12" La Carte. In the revised version, I added a darker and cooler blue violet in the foreground water. I feel that the blues work better now, leading in an arc to the small, brightly lit grasses at the edge of the trees and the lighter blue violet water in the background. Again, this was a small change that made a real difference.

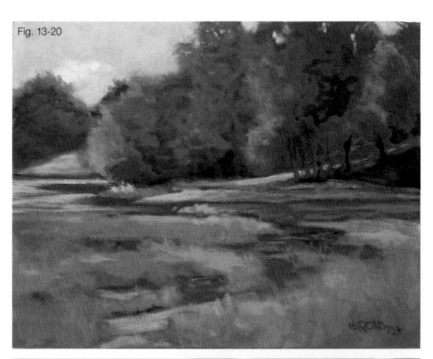

Fig. 13-20

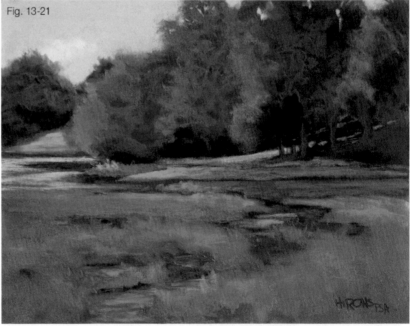

Fig. 13-21

Complete makeover

Pastel is a forgiving medium and some surfaces allow the artist to start over again. This is one of the things I love about Pastelbord, along with its surface texture. In the following example, I illustrate a number of problems and how I resolved them by washing off the original picture and starting over.

Fig. 13-22

Fig. 13-23

Fig. 13-22. Source photo. I took the photograph in my home town on a fall day. The late afternoon sun lit the grasses, and I particularly liked the back lit grass heads. But the color of the background trees is very dark and gray.

Fig. 13-23. Color study. My initial plan was to use blue greens, blue violets and yellow oranges. For the 4" x 6" color study, I used Gatorfoam with ground and toned it with a brown liquid acrylic.

Fig. 13-24. Toning and underpainting. I used a 16" x 20" white Pastelbord for the painting. I first toned it with green gold watercolor, then added a loose underpainting with liquid acrylic.

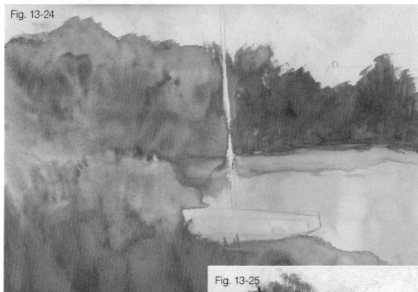

Fig. 13-24

Fig. 13-25

Fig. 13-25. I proceeded to add pastel, using primarily soft pastels. When I got to the orange grasses, I realized the painting was something of a disaster! The colors weren't working because the contrast was too great. The orange in the grasses appeared garish and very unreal. (In this illustration, the bright oranges have been brushed off; I couldn't bear to film it the way it was!) Furthermore, I had filled in the sky completely, losing the texture of the undercolor, which resulted in a flat, boring sky. Additionally, the mast divides the picture in half. I brushed off the pastel outside and washed the board in the sink. This felt really good!

Fig. 13-26. I added more liquid acrylic to the entire surface and brushed on a single layer of clear Colourfix Liquid Primer to give it more tooth and texture. Notice that the basic form of the trees, mast, and grasses is still evident, but the contrast is much reduced.

Fig. 13-27. I redrew the boat, moving it to the right and changed the color scheme to red violet and warm greens. These colors have both warm and cool aspects to them and the contrast is not as extreme. A cool green was used in the boat and house roof for contrast and to tie the two man-made objects together. I used only intermediate Girault pastels to begin with, beginning with more tonalist, mid-range values.

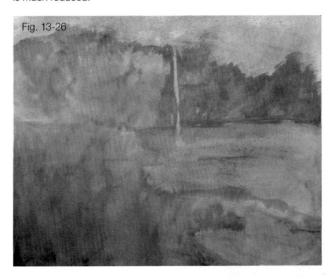
Fig. 13-26

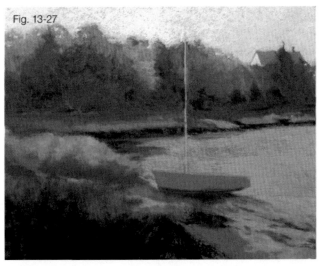
Fig. 13-27

Fig. 13-28. *November Light*, 16" x 20" Pastelbord.

In the final painting, the sky has been lightened, light yellow greens and oranges have been added in selected spots (very carefully), and the backlit reeds have been painted in. I am much happier with this picture. It has the sense of strong afternoon light, but it is more subtle.

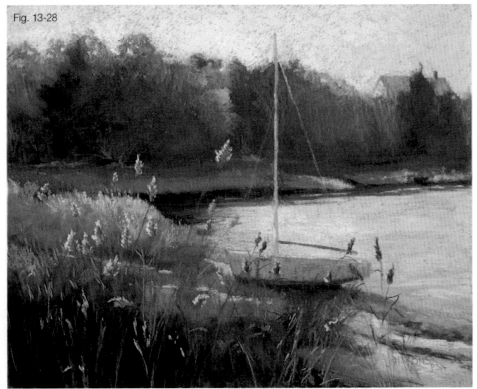
Fig. 13-28

SUMMARY

- Pastel paintings are created in stages. The types of pastels and the colors used at each stage will be determined by a number of factors, including type of application, surface, and color approach.
- When beginning directly on a toned surface, consider using analogous colors, rather than the local color.
- When beginning over an underpainting, start to develop the desired color in the initial layers of pastel. The choice of pastels (e.g., hard, soft) might be determined by the surface and subject matter.
- Spend time carefully analyzing your picture before considering it finished. If possible, get opinions from others.
- Pastel is a forgiving medium and allows for both small and large changes.
- Before making changes to color, determine whether it is the value, temperature, or chroma that is the problem.

EXERCISES

☐ Do three small studies, using a different application of pastel (direct, wet, and dry underpaintings) for each. Use opposing colors in the underpaintings. In the first, begin the pastel layers with analogous color, adding the local color on top. For the second and third, begin building the local color using hard pastels. Examine the results to see which you like best.

☐ Find paintings that you know are unsuccessful and examine them to determine the causes. Try making 'color fixes' or perhaps a 'complete makeover.' if the surface will allow it.

FINDING YOUR STYLE

It should be clear by now that your style comes from within. Thus, the title of this book is something of a misnomer! However, the development of a style takes time, practice, and a great amount of experimentation. Students sometimes ask me if they have a style, and I have often wondered the same thing myself. The answer is "yes," we all have a style of our own. It can be hard to see, though, like hearing the accent in our voices.

The next question is whether your style produces quality paintings. Most artists never stop trying to improve their work. But understanding what it is that makes your paintings distinctly yours helps in assessing what needs to change and what does not. I hope that the guidance in this book is useful for this purpose.

For the newcomer to pastel, experimenting with various techniques and surfaces is crucial to finding what feels right.

To assess your style, ask these questions:

- What kind of strokes do I use? How important are they to the look of the painting?
- Is there a specific look that I want to produce?
- Am I using the right pastels and surfaces to enable that look?
- Do my paintings exhibit a particular type of composition?
- Am I a high contrast or tonalist painter (most of the time)?

- How do I use edges?
- How would I describe my color usage? Do I use color as I see it or do I use color in a more interpretive or intuitive manner?
- Do I typically use a limited palette or do I more often use the full spectrum of color?

These are just some of the factors that become part of one's style. Some artists, such as Duane Wakeham and Lee Kimball, use a consistent set of materials and techniques that guarantee their unique style. Others, like Joyce Lister and me, prefer to use different materials and techniques; yet our work has a recognizable quality.

You may note that I have not addressed subject matter specifically. This is an issue of finding one's *voice*. By combining our distinctive styles with the subject matter that we feel strongly about, we find the key to expressing ourselves as artists.

As creative people, we do not like to be restricted. Once an artist reaches a certain level of success, the galleries that represent the artist expect to keep receiving the same kind of work. If your goal is to be represented by major commercial galleries, this is something of which you should be aware. If not, you are freer to keep experimenting and trying new approaches. And, of course, you can continue to paint within a style for galleries, while trying out new approaches on your own.

The beauty of pastel is that the possibilities are endless. Happy painting!

About the Contributors

The following contributors are award-winning pastel artists from around the country.

Sarah Canfield received her BFA, cum laude, in painting from Alfred University in Alfred, NY and a master's degree in art therapy from Concordia University in Montreal. Her oils and pastels have won awards in various regional and national juried exhibitions and she is a signature member of the Pastel Society of America. She currently lives and works in the New York metropolitan area. Her work can be seen at: www.sarahcanfield.com.

Robert Carsten attended the Art Students League of NY, the Rhode Island School of Design and the Academia di Belle Arti in Italy. He is a board member and signature member of the Pastel Society of America, editor of the *Pastelagram*, and is a Masters Circle Pastelist in the International Association of Pastel Societies. He is a contributing writer to the *Pastel Journal* and *The Artist's Magazine*. His pastel paintings have been shown in many museums including the Butler Institute of American Art, the Bennington Museum, the Mattatuck Museum, the D'Amore Museum and many others. His works are collected worldwide. His work has been featured in *Pure Color/The Best of Pastel*, the *Pastel Journal, American Art Review*, the *Artist's Magazine* and *Strokes of Genius/The Best of Drawing*. His work can be seen at: www.robertcarsten.com.

Betsy Goldsborough, who works both in pastel and watercolor, has studied with leading painters in both media and holds signature memberships in the Maryland Pastel Society, Baltimore Watercolor Society, the Maryland Society of Portrait Painters, and the Art Gallery of Fells Point, Baltimore, MD. Her award-winning paintings have been exhibited in many national and regional shows, including those of the Pastel Society of America and the Maryland Pastel Society.

John Davis Held is known for his portrayal of skies. Working largely in pastel for many years, he has won many awards and has had one man shows at the Antreasian Gallery in Baltimore, MD, and at the National Institutes of Health in Bethesda, MD. He is now working with both oils and pastels, and is represented by the Peninsula Gallery in Lewes, DE, the Riverview Gallery in Havre de Grace, MD, and the Antreasian Gallery. His work can be viewed at: www.johndavisheld.com.

Lee Kimball's art is a visual commentary on the land and the continuing cycles of life, particularly of his native Henry County, IL, and the surrounding Midwest in general. His attempt is to celebrate the beauty to be found in life and to embrace the words of the French impressionist Pierre Auguste Renoir, "There are enough ugly things in life for us not to add more."

Kimball's pastels have been exhibited widely and have won many top awards including those from the Pastel Society of America, in which he is a Master Pastelist, and the Pastel Society of the West Coast, in which he is a Distinguished Pastelist. He has served on the Jury of Awards for the Pastel Society of America. Mr. Kimball and his work were featured in the Nov./Dec. 2000 issue of *The Pastel Journal*. His work can be viewed at: www.leekimballart.com.

Mike Barret Kolasinski is a signature member of the Pastel Society of America, a signature society member of the Paint America Association, and a co-founding Board and Master Member of the Chicago Pastel Painters. He studied Illustration and Design at the Chicago Academy of Fine Arts, but is largely self-taught in his current career of producing fine art paintings called *WildScapes.* His work is included in many public and private collections and has won numerous awards. A feature article was written about his work in the February 2006 issue of *American Artist* and paintings appeared in the *International Artist* publication, "How Did You Paint That? 100 Ways to Paint Seascapes, Rivers and Lakes, Volume 1." His work can be viewed at: www.mikebarrett-kolasinski.com.

Joyce Lister. Joyce Lister lives in Timonium, MD and is a signature member of the Maryland Pastel Society, as well as holding membership in the Degas Pastel Society, the Pastel Painters Society of Cape Cod, the Maryland Art League, Women Artists' Forum, and the Miniature Painters, Sculptors, and Gravers Society of Washington, DC. Joyce teaches ongoing pastel classes in the Baltimore, MD area at the Zoll Studio and School of Fine Arts and at the Myerberg Senior Center. During the summer, Joyce also teaches a 5-day pastel workshop at the Mitchell School of Fine Arts. Her highly-acclaimed paintings can be viewed at: www.joycelister.com.

Michael McGurk is a retired fireman who has been a full time artist since 2005. He lives in Charlottesville, VA and is a member of the Maryland Pastel Society, Piedmont Pastelists, and the Art League of Alexandria, among other organizations. McGurk's paintings have been accepted into many juried competitions and he has won awards from the Pastel Society of America, Maryland Pastel Society, and the Art League monthly shows. His work has been commissioned by the Congressional Fire Service Institute in Washington, DC, the Baltimore City Fire Museum, and the International Association of Fire Fighters. View his paintings at: www.michaelmcgurk.artspan.com.

Lisa Sheppard is a pastel painter of rural landscapes. Her farm scenes have received local and national recognition, including the Maryland Pastel Society's Best in Show and First Place, as well as the national "Shades of Pastel" Best Landscape Award. Practicing interior design for over twenty-five years, Sheppard's artwork conveys an innate understanding of space and composition that has been gleaned from the multidisciplinary study of both spatial interiors and fine art. She teaches workshops and classes at Carroll and Frederick Community Colleges. Her art is represented by Gallery 99 in Westminster, Md. and can be viewed at www.lisasheppard-pastels.com.

Deborah L. Stewart is an abstract pastel artist living in Iowa. Stewart has a B.A in Art Education from the University of Iowa and an M. S. Ed. from Western Illinois University in Counseling. Stewart's work is in private and public collections including the University of Iowa Hospitals and Clinics. She is represented by Dubaigne Fine Art, Ltd., NY, Xanadu Gallery, Scottsdale, AZ, The Artful Home, Madison, WI, Corner House

Gallery, Cedar Rapids, IA, and Iowa Artisans Gallery in Iowa City, IA. She has exhibited at a number of leading Chicago galleries and in 2011 Stewart's work was included in a Pastel Invitational exhibit at Abend Gallery in Denver, CO, one of Denver's most prominent galleries.

Stewart has won awards from *The Pastel Journal*'s Pastel 100 competition in 2010 and 2011. Her work has been included in publications such as *Studio Visit* by Open Studios Press and *A Walk Through Abstracts Vol. 3* by Sue St. John. She is a signature member of the Pastel Society of America, Chicago Pastel Painters and the Iowa Pastel Society. She provides workshops in a variety of locations in the United States and Canada. Her work can be viewed at: www.deborahlstewart.com

Duane Wakeham became a Master Pastelist of the Pastel Society of America in 1995 and was inducted into the Hall of Fame in 2000. He is also a Distinguished Pastelist of the Pastel Society of the West Coast, as well as Pastel Laureate. He serves on the boards of PSA and IAPS, and the Editorial Advisory Board of *The Pastel Journal*. Wakeham earned degrees in painting from Michigan State and Stanford Universities. He taught drawing and painting at Stanford and art history and painting at the College of San Mateo (CA). He was the revision author of three editions of Mendelowitz's *A Guide to Drawing*. Publications include *American Artist; The Pastel Journal; Pure Color, Best of Pastel* and *Margot Schulzke's A Painter's Guide to Design and Composition*. He taught workshops, conducted master classes, and judged exhibitions across the U.S. and Canada before retiring in 2011. He lives in San Francisco.

Jimmy Wright's pastel work was on view at the Metropolitan Museum of Art, New York in the exhibition "The Lens and the Mirror: Self Portraits from the Collection," and a twenty-year retrospective of his work was held at the Springfield Museum of Art, MO. He has exhibited in numerous museums including the Art Institute of Chicago, National Academy Museum, New York and the Tochigi Prefectural Museum, Tochigi, Japan. DC Moore Gallery, New York and Corbett vs Dempsey, Chicago, have presented several solo exhibitions of his work. Wright serves on the boards of The Pastel Society of America and The International Association of Pastel Societies. Jimmy Wright lives in New York City. His work can be viewed at: www.jimmywrightartist.com.

The following contributors are some of the many talented artists who have studied pastel with me:

Sharon Butrymowicz has taken classes at Montgomery College off and on for nearly 35 years, including the last several years in pastel. She is a member of the Maryland Pastel Society.

Muriel Ebitz was primarily a watercolor artist but now has fallen in love with pastels. Ebitz graduated from Washington University School of Fine Arts, St. Louis and worked as an illustrator and graphic designer in a design studio where she became a partner. She worked for fourteen years at the National Wildlife Federation in Washington, DC, as a de-

signer and then art director. She has pursued her love of painting by attending classes at the Torpedo Factory in Alexandria, VA and Montgomery College, Rockville, MD. She is a signature member of the Maryland Pastel Society and the Baltimore Watercolor Society. Her paintings have won numerous awards and recognition.

Carol Greenwald, a Chevy Chase, MD artist, has studied pastel for five years at Montgomery College. She has also studied oil painting with Walt Bartman at the Yellow Barn Gallery at Glen Echo, MD. She has attended pastel workshops with Albert Handel, Richard McKinley and Doug Dawson. Her pastels have received several first place awards in local shows and she has had shows at the Yellow Barn Gallery in Glen Echo, MD. Her works can be seen on their website: www.yellowbarnstudio.com.

Grace Newcomer has pursued her love of drawing and painting since childhood. Initially, she studied oil painting and sculpture, then gave up art to raise her family. More recently she discovered soft pastel and began taking classes at Montgomery College in fall 2009. She is a member of the Maryland Pastel Society and the Gaithersburg Fine Arts Association.

Cam Ha Nguyen was born and grew up in Saigon, Vietnam, where she taught kindergarten for ten years and studied flower arranging. She immigrated to the U.S. in 1996 and enrolled in Montgomery College in 2001, earning an A.A.S. in Illustration in 2006 and an A.F.A. in Studio Fine Arts in 2009. Though accepted as a fine arts major at the University of Maryland in the fall of 2009, she decided to continue her study at Montgom-

ery College with Jean Hirons, who calls her a "master of composition."

Susan Due Pearcy studied art at Southeast Missouri State University and received a B.S. in Painting, Graphics and Sculpture at New York University. She continued her printmaking studies at the Art Students' League in New York City and the Graphics Workshop and Fort Mason Art Center in San Francisco. She moved to Maryland in 1979 where printmaking became her focus and was a member of the Washington Printmakers Gallery for 12 years and served as its president. While she incorporated pastels in many of her prints, it was not until 2008 when she first focused on pastels as a means of expression. Her work is included in numerous private, public, and museum collections. She has received Maryland and California State Arts Council grants and in 2009 was selected to be one of the "Top 100 Women of Maryland. She is a member of the Countryside Artisans, www.countrysideartisans.com.

Elroy Williams. A New York City native, Elroy graduated from the School of Visual Arts in Manhattan, where he majored in fine arts and painting as well as commercial art. The dual course of study provided the foundation for his multifaceted career as a painter, illustrator and award-winning advertising designer and editorial art director. He has won a number of awards for his pastels and did the graphic design for this book, www.elroywilliams.com.

Appendix A

Glossary of Terms Used in this Book

Note that the definitions, unless noted, are my own.

Analogous colors—colors that are beside each other on the color wheel; an analogous color palette can consist of up to five colors.

Analogous Color Wheel—a color wheel taken from the system developed by Albert Munsell that is based on five primary colors.

Atmospheric perspective—in landscapes, areas that are further away are cooler in color, have fewer value differences, lesser amounts of detail, and soft edges.

Big shape block-in—a form of underpainting that defines large shapes of varying values in one or more colors.

Big shape painting—a style of composition that focuses on the flow of shapes, values, and colors in a composition.

Broken color—describes a technique of applying the pastel so that the underlying surface, underpainting, or earlier layers of pastel show through.

Center of interest—the subject of a representational painting; the portion to which the painter draws the eye of the viewer.

Center of interest painting—a style of composition that focuses on the center of interest while diminishing other areas of the painting.

Chroma—a property of color that relates to the pureness or dullness of a color. It is also referred to as intensity or saturation of color.

Color—a specific hue.

Color harmony—the concept that certain colors, when used together, form harmonious combinations, similar to harmonic chords in music.

Complementary color—two colors that lie opposite to one another on the color wheel.

Composition—the shapes and lines that make up a painting.

Compositional studies—black and white studies used to determine the placement of shapes and lines, placement of the center of interest, omission or movement of objects, and the orientation of the painting.

Color studies—small studies that test color possibilities for 1) the final color palette or 2) the initial colors to be used in an underpainting.

Direct application—applying pastels to a surface (preferably toned) without the use of an underpainting.

Discords—On the Analogous Color Wheel, two colors that are equidistant to the complement of the dominant color.

Dominant color—the principle color used in a painting; the color is used throughout the painting in varying degrees of value and chroma.

Double complement—a color palette consisting of two sets of complementary colors.

188

Dry underpainting—Pastel applications that are smeared into the surface without the use of a solvent, or sprayed with a workable fixative.

Glassine—a slick paper that can be taped to unframed pastel paintings to keep the pastel from smearing.

Grainy soft pastels—a subcategory of intermediate pastels, containing pastels that are soft but not buttery.

Gray—a combination of black and white; gray is achromatic.

Grayed color—a hue that has been grayed by the addition of gray or the complement. Note that this is the equivalent of the term *tone* on the Triadic Color Wheel.

Ground—a gel, containing some form of grit, that is used to create a pastel surface. It can be purchased or made by the artist.

Hard pastels—pastel sticks with a higher amount of binder that feel harder and produce thinner applications of pastel.

Hard surface—a surface that is more resistant to applications of pastel, allowing for more layering.

High contrast painting—one that has a wide range of values, including areas of dark and light.

Hue—the basic family to which a color belongs, such as red, green, or blue.

Intermediate pastels—pastels whose degree of hardness falls in between hard and soft. There are two groups within this category: medium hard and grainy soft.

Interpreted color—an approach to color that begins with local color but pushes the color to be more expressive. Using an interpreted color approach may also result in changing some colors to fit a limited palette.

Intrinsic temperature—the basic warmth or coolness of a color depending on its placement in the spectrum and on the color wheel.

Intuitive color—an approach to color that comes from within or from sources other than the subject matter.

Lay-in—the indication of the major shapes of the composition, either prior to the addition of color or following the toning of a surface.

Limited palette—a painting that uses two to four hues in varying values and chroma.

Local color—"the intrinsic color of an object regardless of the momentary way natural light is affecting that object." This is a Bill Creevy's definition from *The Pastel Book*.

Lost and found edges—lost edges are those that are barely discernable; found edges are those that are sharp and eye-catching. Similar values create lost edges, while contrasting values create found edges.

Medium hard pastels—a subcategory of intermediate pastels which includes brands that are a little softer than hard sticks.

Mixed complements—grayed colors that are created by mixing complements of the same value and hardness of pastel.

Monochromatic color—a color palette consisting of one color.

Near complement—a color palette consisting of a dominant color and a color of opposing temperature that is not the complement (e.g., green and orange).

Neutrals—1) pastels: very light browns, such as tan or beige; 2) surfaces: brown or gray surfaces that are not one of the 12 hues on the Triadic Color Wheel.

Observed color—an approach to color that is based on reproducing colors as seen.

Orientation—the vertical or horizontal direction of the picture plane; also known as *portrait* or *landscape* formats.

Painterly color—describes strokes of opaque pastel that are akin to the brush strokes of oil paint. The pastel may or may not be blended.

Pastel—Pure pigments combined with a binder to create sticks of varying size and hardness/softness.

Plein air frames—wide frames (3"-4") that are used without mats; they generally come in standard sizes.

Plein air painting—painting out of doors.

Relative temperature—the perceived warmth or coolness of a color as it appears in its surroundings.

Saturated color—1) a high chroma color; 2) a heavy stroke of pastel that is very opaque.

Soft pastel—1) a generic term used to differentiate the medium of pastel from that of oil pastel; 2) a category of pastels defined as *creamy* or *buttery*.

Soft surface--one that readily accepts pastel; often referred to as a *pastel-grabber.*

Split complement—a color palette consisting of a dominant color and the colors to the right and left of its complement.

Substrate—the material (e.g., watercolor paper, hardboard, Gatorfoam) to which a ground is added to form a surface.

Surface--the product that is purchased or created on which pastel is added.

Temperature—the warmth or coolness of a color. Temperature is both intrinsic and relative.

Tetrad—a color palette consisting of four equidistant colors.

Tonalist painting—a painting where the values are mainly mid-range or primarily one value. Grayed colors may also dominate in such paintings.

Toning—adding one or more colors to a white or very light surface to provide an overall color foundation for a painting.

Toned surface—a surface that is not white. The surface may be purchased in a particular tone or be toned by the artist.

Travel box—a box that can be closed safely to protect and transport pastels.

Triad—a color palette consisting of a dominant color and two colors equidistant to it on the Triadic Color Wheel.

Triadic Color Wheel—the standard color wheel that defines three primary colors, three secondary colors, and six tertiary colors.

Underpainting—applying one or more colors that define the major shapes and values of the subject matter, over which subsequent layers of pastel are applied. The underpainting may be wet or dry.

Value—a property of color that relates to its lightness or darkness.

Value studies—small black and white studies that reduce the major shapes of a painting to three to four values.

Wet underpainting—1) pastel applications that are "melted" with the use of water or a solvent, or 2) a wet medium, such as watercolor, oil wash, or liquid acrylic, that is used to define the basic shapes and values of the composition.

Working box—a box containing pieces or whole sticks of pastel that one uses for painting, as opposed to storage boxes. The working box may also be a travel box, allowing it to be transported.

Appendix B

Resources for the Pastel Artist

The following journals, books, and online resources are some of
the resources I use and recommend. The list is by no means complete.

JOURNALS

The Pastel Journal. www.pasteljournal.com. Subscribe, if you don't already! This is the best journal and source of information on pastel you can purchase. It is issued bimonthly and contains articles, information on workshops and products. The Web site has links to pastel societies, resources, a Q&A, and blogs (see Online resources below).

American Artist. www.artistdaily.com. A journal that focuses on American artists creating representational paintings, with several featured each month. Pastel artists are often, but not always included.

The Artist's Magazine. www.artistsnetwork. com. This journal focuses on techniques in all media.

International Artist. www.international-artist. com. Published in Australia, this magazine has a much more international focus than the others on the list. I find it to also be focused on highly representational art.

Southwest Art. www.southwestart.com. One of the most comprehensive journals covering the primarily representational art world. While there is a focus on the West, there are some features on other areas of the U.S. Once a year there is a feature on watercolor and pastel. Contains great ads that can be cut out for your 'idea book.'

Plein Air Magazine. www.pleinairmagazine. com. This magazine was begun some years ago, but became *Fine Art Connoisseur.* The new version focuses on plein air painting, while covering painting in general.

Professional Artist. www.artcalendar.com. A useful magazine that covers the business side of art, including a listing of upcoming juried fairs and shows. Subscribers can also receive this information via email.

BOOKS

Color

Gurney, James. *Color and Light: A Guide for the Realist Painter.* Kansas City: Andrews McMeel, 2010. This comprehensive book covers every conceivable type of light and its coloration.

LeClair, Charles. *Color in Contemporary Painting.* New York, NY: Watson-Guptill, 1991. A very good review of how painters have used color from the 1960's to the 1980's.

McMurry, Vicki. *Mastering Color: The Essentials of Color Illustrated with Oils.* Cincinnati, OH: North Light, 2006. Uses a color-by-color approach for landscape painting.

Zhang, Hongnian, and Lois Wooley. *The Yin/ Yang of Painting.* New York, NY: Watson-Guptill, 2000. Zhang and Wooley cover the importance of contrast of value, temperature and chroma in this excellent book.

Composition

Dow, Arthur Wesley. *Composition: Understanding Line, Notan and Color.* Mineola, NY: Dover, 2007 (reprint).

Payne, Edgar. *Composition of Outdoor Painting.* 7th

ed. DeRue Fine Arts, 2005. One of the "Bibles" for landscape painters.

Roberts, Ian. *Mastering Composition.* Cincinnati, OH: North Light Books, 2008. This book is very comprehensive and has great illustrations, as well as an interactive DVD in the pocket. I highly recommend.

Schulzke, Margot. *A Painter's Guide to Design and Composition.* Cincinnati, OH: North Light Books, 2006. A really excellent book, including step-by-step demos from Duane Wakeham, Richard McKinley and others. Includes all media, but there is an emphasis on pastel.

Landscape Painting (oil and/or pastel)

Carlson, John. *Carlson's Guide to Landscape Painting.* Mineola, NY: Dover Reprints. Another "Bible" of landscape painting.

Griffels, Lois. *Painting the Impressionist Landscape.* New York, NY: Watson-Guptill, 1994. A lovely book on achieving impressionist color by the former head of the Cape Cod School of Art, who continued the teachings of Henry Hensche.

Handell, Albert and Anita Louise West. *Painting the Landscape in Pastel.* New York, NY: Watson-Guptill, 2000. A clearly written and very useful book.

Handell, Albert and Leslie Trainor Handell. *Intuitive light.* New York, NY: Watson-Guptill, 1995. An earlier book with similar focus on pastel painting of the landscape.

Kessler, Margaret. *Painting Better Landscapes.* New York, NY: Watson-Guptill, 1987. The illustrations are all oil, but the advice is sound. Kessler likes to begin her green paintings with lots of reds.

MacPherson, Kevin. *Landscape Painting Inside & Out.* Cincinnati, OH: North Light, 2006. Oil painting from life and from studies in the studio.

Maltzman, Stanley. *Drawing Nature.* Cincinnati, OH: North Light Books, 1995. One of the best books on drawing trees from an avid graphite and pastel artist.

Rohm, Bob. *The Painterly Approach.* Cincinnati, OH: North Light Books, 2009. The book covers both oil and pastel and has a lot of very useful information. Rohm discusses painterly vs. linear approaches to painting.

Painting (in general)

Henri, Robert. *The Art Spirit.* Words of advice and inspiration from a beloved art teacher of the early 20th century.

Schmid, Richard. *Alla Prima: Everything I Know About Painting.* Manchester Center, VT: Stove Prairie Press, 1999. One of the best books ever written on painting by one of America's top oil painters. Reading it is pure delight!

Pastel painting

Creevy, Bill. *The Pastel Book.* New York, NY: Watson-Guptill, 1991. A standard tool for pastelists with basic information on types of materials and techniques.

Dawson, Doug. *Capturing Light and Color with Pastel.* Cincinnati, OH: North Light Books, 1995. Advice

from one of the nation's masters in pastel, and one of our best teachers as well.

McKinley, Richard. *Pastel Pointers*. Cincinnati, OH: North Light Books, 2010.A compilation in book form of many of McKinley's popular blog entries that he shares online through the Artists' Network.

Mowry, Elizabeth. *The Pastelist's Year.* New York, NY: Watson-Guptill, 2001. A guide to using pastels in various seasons.

_____ *The Poetic Landscape.* New York, NY: Watson-Guptill, 2001. This is a personal treatise on her theory of landscape painting.

Price, Maggie. *Painting with Pastels: Easy Techniques to Master the Medium.* Cincinnati, OH: North Light Books, 2007. A great book for beginners.

Pure Color: The Best of Pastel, ed. By M. Bloomfield and J.A. Markle. Cincinnati, OH: North Light Books, 2006. A compilation of pastel paintings by subject matter that exhibits the variety of styles found in the medium.

SOCIETIES

International Association of Pastel Societies (IAPS). www.pastelinternational.com The primary function of this organization is to host a biennial convention in Albuquerque, NM. The Web site provides links to local pastel societies, making it is a great resource in which to browse.

Pastel Society of America. www.pastelsoci-etyofamerica.org The national organization, located in New York City, which grants signature and master pastel status. The Web site includes many pastel artists and useful information on pastel. It also hosts a Facebook page that anyone can join.

Local pastel societies. There are a growing number of local pastel societies that provide a wide opportunity for learning how to use the medium and sharing your work with others. For a complete list, visit the IAPS Web site (above).

ONLINE RESOURCES

Pastel Journal blogs. The Pastel Journal (www.pasteljournal.com) contains blogs from a number of artists. Richard McKinley's "Pastel Pointers" blog is available at www.pastelpointersblog.artistsnetwork.com)

For a list of "Top Pastel Painting Blogs," see: www.onlinegraphicdesigndegree.com

On Facebook, there are a number of pastel groups you can join, such as the *Pastel Society of America* page and *Passionate About Pastels.*

Appendix C

Sources of Materials

GENERAL

Dakota Art Pastels (www.dakotapastels.com). This is one of the most comprehensive stores for the purchase of pastels, surfaces, and many other related items. Individual pastels, as well as sets can be purchased. Service is excellent and the staff are knowledgeable about pastel. Dakota is located in Washington State.

Rochester Fine Art (www.fineartstore.com). Another excellent resource, located in New York State. Rochester carries a full selection of art supplies but also is very comprehensive and knowledgeable when it comes to pastels. Individual sticks can be purchased, as well as sets.

Jack Richeson & Co. (www.richesonart.com). Richeson is also a full service supplier of art materials. They have a focus on pastels, being the owner and importer of Unisons, as well as making three kinds of their own pastel. They sell the Roz box, an inexpensive metal travel box.

Other online stores: Dick Blick, ASW (Art Supply Warehouse), Jerry's Artorama, and Cheap Joes are just some of the many companies that carry pastel sets. However, individual sticks cannot be purchased from many of these stores.

SPECIALTY

Frame tek (www.frametek.com). A source for plastic spacers for use in framing pastels with or without mats.

Girault pastels (www.pastelsetc.com). This is the official site for Girault and contains many sets, and individual sticks. The Elizabeth Mowry poetic landscape set is available through this source.

Heilman Designs (www.heilmandesigns.com). The source for the Heilman pastel travel boxes. They come in three sizes: large, medium, and backpack. These are the most expensive but the best boxes on the market, from my perspective.

Penwa (www.penwa.com). The source for Tombow pens, a popular tool for values studies and quick sketches. The gray values I use are 95, 75, 65, and 45. You have to buy them in boxes of 6 of each number. Share with friends!

Appendix D

Preparing Your Own Surfaces

In Chapter 2, I discuss the texture and look of hand-prepared surfaces. This appendix provides more detail on the products and methods that can be used in preparing surfaces. A number of substrates can be used, to which a ground is added. There are different kinds of grounds and different ways in which to add them to the substrate.

The advantages are that you can have a sturdy surface that doesn't need mounting, and in the color, size, and degree of texture you want. It can also save money. One drawback, from my experience, is that

Fig. D-1. Materials for making a textured surface. Shown: Art Spectrum liquid primer in a liter can with mixing stick; disposable bowl and spoon, Gatorfoam, two sizes of Loew-Cornell acrylic brushes.

prepared surfaces don't accept as many layers of pastel as purchased pastel surfaces.

The substrate. This is the paper or board on which the ground will be applied. The substrate is important in that it determines, to some extent, the hardness/softness and roughness/smoothness of the surface. It may be watercolor or printmaking paper, mat, museum, or illustration board, hard board, or Gatorfoam.

- Watercolor paper provides a lot of texture, even with two coats of ground. It is great for paintings that rely on a texture of broken color, but not for those that require fine detail.
 - Mat boards differ. Some are textured; others like 8-ply, are very smooth. They are archival, but chose carefully, depending on the texture you desire.
- Museum and illustration board, along with printmaking papers, provide a less textured, softer surface for the application of ground prior to adding pastel. If you want to work large and float the finished work in a frame, a surface such as Rives BFK will work nicely.

All of the above produce relatively soft surfaces on which to work. They also have the advantage of being relatively easy to cut. The following substrates will produce harder surfaces.

- Gatorfoam is a hard but lightweight surface. It can be purchased in precut sizes from Dakota, or be cut by a local framer. Gatorfoam is sturdy and doesn't warp in a humid climate, and it is very lightweight. I add the ground to the edges to prevent possible off-gassing. Use with care: the edges can chip and I've even had one unframed painting ruined when something heavy fell and punctured it.

- Masonite and other hard boards can be purchased at hardware stores and cut by them or with a saw to standard sizes. The surface will be very hard and may require multiple applications of ground.

The ground. Three grounds with which I am familiar are:

- **Art Spectrum Colourfix liquid primer.** This is the same surface used to make Colourfix paper. It can be purchased in jars in the same colors as the paper. The white and clear can be purchased in liter containers from Dakota. Use the white if you plan to do an underpainting. The clear can be mixed with water color or liquid acrylic to create a toned surface of your choice, then brushed or rolled onto the substrate. I prefer the grit in this ground and now use it exclusively. I apply two coats, brushing in all directions.

- **Golden acrylic pumice gel.** I was introduced to this ground in a workshop with Susan Ogilvie. Susan mixes it with matte medium, Golden liquid acrylic, and additional pumice. It is a softer surface and seems less gritty than the Colourfix. See www.dakotapastels.com for Ogilvie's recipe for use of this ground.

- **Gesso with pumice or marble dust.** This is the hardest and most abrasive ground to work on, from my experience. The pumice or marble dust is added to the gesso with water. Pumice can be purchased from Dakota.

The application to the surface

Brushes. I use white acrylic brushes from Loew-Cornell that come in 3 sizes packaged together (1"-3"). These apply the ground more smoothly than a traditional paint brush (i.e., for painting the walls), creating soft strokes without deep ridges. If a bolder stroke is desired, use a paint brush, but be forewarned: the surface will *eat* your pastels!

Rollers. If you wish a less textured surface, you can use a regular paint roller to apply the ground to the substrate. This provides a surface that feels more like a purchased paper.

Index

Made in the USA
San Bernardino, CA
06 February 2018